DRAWING

by J. M. Parramon

Published by
H.P. Books
P.O. Box 5367
Tucson, AZ 85703
602/888-2150

ISBN: 0-89586-072-4
Library of Congress Catalog
Number: 80-82380

Publisher: Bill Fisher
Editorial Director: Jonathan Latimer
Editor: Randy Summerlin
Editorial Advisor: Donna Hoffman
Art Director: Don Burton
Design & Assembly: Patrick O'Dell
Typography: Cindy Coatsworth, Joanne Nociti

Published in Great Britain by
Fountain Press
Argus Books Ltd.

First Edition in English, 1971
Revised Edition 1976

Original title in Spanish
"Asi se dibuja"
© 1968 Jose M.a Parramon Vilasalo

Deposito Legal B- 27. 182
Numero de Registro Editorial 785

CONTENTS

Terms and Materials 5
Basics ... 6
Materials .. 13
Sight Training ... 22
Calculating Dimensions 23
Scaling .. 35
Boxing Up .. 39
The Hardest Task of All 41
Drawing A Posed Model 42
Preliminary Drawing 48
Boxing Up Masses 52
Drawing From Life 60
The Foreshortening Barrier 64
Drawing Faces .. 67
From Theory To Practice 70
Enclosing The Mass 75
Shading .. 86
Index .. 94

Lines can work together to give a sense of motion. The optical illusions on this page show the power of groups of lines.

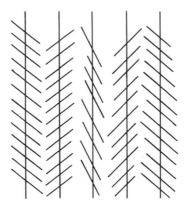

These vertical lines are parallel. The diagonals make them appear to lean.

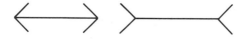

Both these lines are the same length. The direction of the lines at their ends affects how we judge the horizontal lines' length.

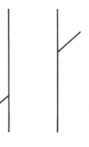

These verticals seem to push the two diagonals out of line.

Line and space—One of the problems in most drawings is creating the illusion of *depth*. One method is to create *perspective* in a picture by using an imaginary point, called a *vanishing point*, somewhere in the background, usually on the horizon. The lines of the objects in the drawing converge on this point and give the appearance of depth. You can use one or more vanishing points, depending on your subject. The subject of perspective is dealt with in more detail in another volume in this series.

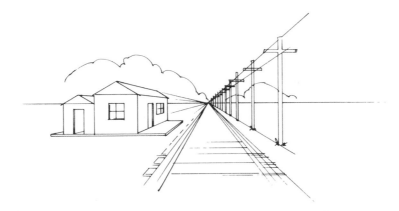

The classic demonstration of a vanishing point is railroad tracks meeting at the horizon. Remember, the horizon is always at eye level.

Line and emotion—You will quickly notice that different lines seem to have different characters. This is partially determined by the medium you are using. It can also be true of lines drawn in the same medium. Experiment with each medium and see what kind of lines you can create. As you improve your control, you will learn how to create and use expressive lines.

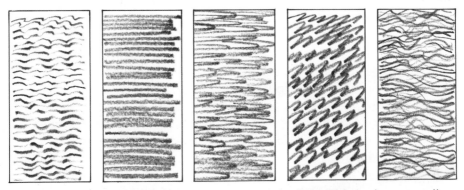

The character of lines can suggest mass, texture, light and shadow, as well as anxiety, calmness, motion and stability.

 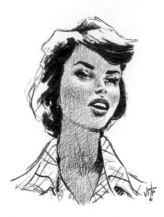

This is line This is value or tone This is mass

SHAPE

There is much disagreement among artists over three terms: *shape*, *form* and *mass*. A *shape* is any area with clear boundaries. It can be graceful or clumsy, rigid or fluid. Shape has only two dimensions, length and width. Positioning shapes, such as overlapping them, can sometimes give the illusion of depth.

Form is a broader term. Form can include a shape, but will also include related shapes and shadows that create a coherent whole.

Mass requires depth, unless the subject is viewed on edge. Mass has thickness or roundness. Artists produce the effect of mass with highlights and shadows, and by the placement of shapes.

It may seem odd at first, but each shape you draw will define the space both inside and *around* it. Learning to see shapes in this way can help you draw and paint. To understand this, think of the shape itself as a *positive shape*, and the space around it as a *negative shape*. Every positive shape makes a negative shape. Examining your subject in terms of its shapes can help you overcome the two-dimensional barrier described on page 65.

The shape of an object can be thought of as *positive* and the space around it as *negative.*

VALUE

Variations in lightness and darkness are called variations in *value* or *tone.* They are used to define shapes, to create mass, to emphasize special parts and to express feeling. *Modeled* light and shadow is used to reveal the shape and texture of an object and can give subtle or dramatic emphasis to various parts. Contrasts of light and dark shadows are often given the Italian name *chiaroscuro.*

TEXTURE

Texture is the pattern of contrasting surfaces found in every object. A surface can be rough or smooth, hard or soft. In drawing we capture texture with various techniques of *shading.* Cross-hatching, hatching and stippling are only some of the techniques available. With pencil, charcoal or crayon, you can shade by using the side of your drawing tool. You can also use your fingers to smudge your lines, or an eraser to lighten and spread them. All these techniques will help give your subject texture, and therefore volume. In painting, texture also refers to the quality of the paint itself and how it is applied.

As you can see, these terms are interrelated. It is difficult to talk about one without mentioning the others. As I discuss the materials for drawing in this chapter, I will give you hints on how to use them to control your line, shape, mass and value.

Shading

There are many ways of shading:

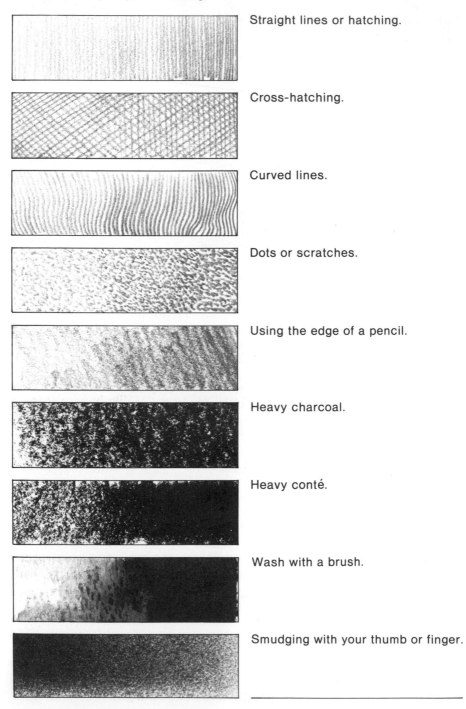

Straight lines or hatching.

Cross-hatching.

Curved lines.

Dots or scratches.

Using the edge of a pencil.

Heavy charcoal.

Heavy conté.

Wash with a brush.

Smudging with your thumb or finger.

Materials

Each year I start a new session of my drawing classes, and each year one of the first questions I'm asked is, "What shall I use?" Faced with the amazing choice available today, I can certainly understand my students' concern. You can draw with pencils, pen and ink, crayons, charcoal, conté, chalk or brushes. How do you decide?

I think I can answer that very simply: Try them all. Each medium has its own potential and challenge. Find the materials that you are most comfortable with and make them work for you. Whatever you choose, it is best to have a box to keep them in so they don't get lost or damaged.

PENCILS

Most of the *lead* pencils available today contain mixtures of graphite and clay that has been fired to make it hard. The amount of clay in the mixture determines the *hardness* of the lead, which is designated by a code stamped on each pencil. At first you may have difficulty telling the difference between the various grades, but as you draw you will notice more and more.

The hardest lead usually used in drawing is *6H*. The *H* stands for *hard*. It will give you a very sharp line that tends to be gray rather than black. It is useful for drawing precise lines and is unlikely to smear. In fact, a *6H* lead is so hard it will gouge or even tear your paper if you press too hard.

The softest lead used in drawing is *6B*, although occasionally you may use a *7B* or even *8B*. The *B* stands for *black* and a *6B* will give you a dark black line which will smear. It is best used for shading or in drawings where detail is not a major concern.

HB is a medium grade between these extremes, and is very useful in drawing, as is the *F* grade between *H* and *HB*. To increase your range as you begin drawing, consider using a *2B* and a *2H* with your *HB*. A *2B* is soft enough to give you freedom of motion, but is less likely to smear than softer leads. A *2H* will give you more precise lines than the *HB* or *2B*.

Whatever grades you choose, it is important to keep your pencils sharp. You can use a pencil sharpener, but you'll get better results if

6H

4H

2H

H

F

HB

B

2B

4B

6B

Drawing pencil leads range from very hard to very soft. Grades denoted by *H* are hard and *B* grades are soft. *HB* and *F* leads are in between. The hardness or softness determines the *tone* and *character* of your lines, as illustrated above.

you use a craft knife and sandpaper. Use the knife to trim the wood around your lead and then sharpen the lead to the exact shape you need on the sandpaper. You can make as sharp or as broad a point as you need. Special sandpaper blocks for this purpose are available at most art supply stores.

Pencil sharpeners give you only one kind of point, and they tend to devour pencils very quickly. The more you draw, the more you'll appreciate the control offered by a knife and sandpaper.

OTHER PENCILS

You can also buy various grades of lead for a mechanical pencil, but I find changing leads inconvenient. Colored pencils are available in a wide variety of shades, but that is the subject of *Drawing with Colored Pencils*, another book in this series.

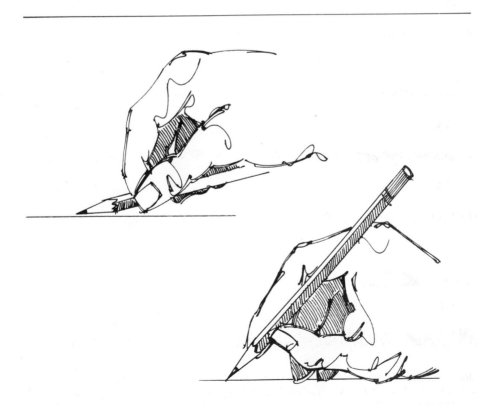

Holding a pencil below your palm at a low angle, shown at top, produces a more casual line in a shaded effect. Holding a pencil in a writing position, as below, gives a sharper line and more precise control.

PEN AND INK

Pens are also covered in detail in another volume in this series, but the techniques of visualizing presented here will certainly help you understand the techniques of pen and ink better. Often, pen and ink drawings are made on sketches drawn in pencil.

With pen and ink you work with a pen holder and replaceable pen points, called *nibs,* that come in a variety of point sizes. The width of your line depends on your pen point size. Start with a firm nib that will give you better control of your line. There is a wide variety of inks on the market, including black India ink, which is very well known. Advantages of using black India ink are its waterproof quality and opaqueness. But drawing in pen and ink does not mean working only in black and white. Transparent colored inks, including black, are also available on the market. Because ink is a liquid medium, it has the disadvantage of unintentional drips. Choose a smooth, nontextured paper to work on. A disadvantage of textured paper is that the paper acts as a blotter and spreads the ink, and pen point can pick up loose fibers from the surface and clog.

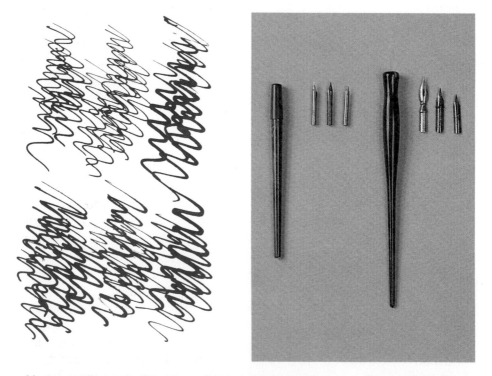

Various pens and nibs are available that will produce a wide variety of lines.

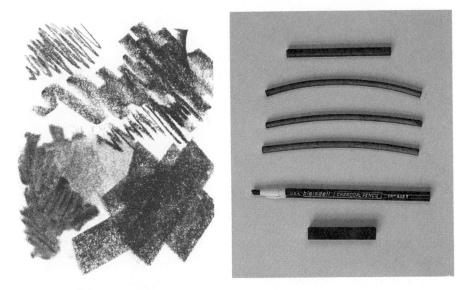

Charcoal sticks come in many sizes and hardnesses and can create a wide range of lines and shading.

CHARCOAL

Charcoal sticks are available in various sizes and hardnesses. By controlling the pressure of your hand as you draw, you can get an amazing range of lines and shading. By smoothing and smearing with your fingers, you can increase the range of values and tones. You can even go over drawn areas with an eraser and create your whites or highlights by removing some of the charcoal.

Sticks of *vine* charcoal give beautiful grays. *Compressed charcoal* sticks give strong, dark blacks. Both are available in hard, medium or soft grades.

Charcoal does have a tendency to smear easily and produces black dust when you are drawing. It also gets all over your hands. These drawbacks are small compared to the versatility of this medium. It is particulary good for quick sketches and studies.

Pencils with charcoal centers are available in various grades. This is an advantage because you can work in charcoal without the mess of sticks. White pencils can be used for correcting and shading. Special *charcoal paper* is available in art supply stores. When you have finished your drawing you can reduce the chances of smearing by spraying it with a coat of *fixative*, which is discussed on page 20.

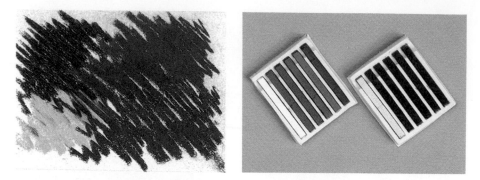

Conté crayons produce an effect in between charcoal and crayon.

CONTÉ

Conté crayons are made in France and produce a line and texture halfway between charcoal and crayon. They are square and available in white, gray, black and a range of brown earth tones called *sanguine*. All colors are available in three different hardnesses denoted by the numbers 1, 2 or 3 on the crayons, which indicate hard, medium and soft. Black conté may remind you of charcoal, but it is harder and less likely to smear. Very subtle tonal effects can be obtained with this medium. You should spray your finished drawing with fixative.

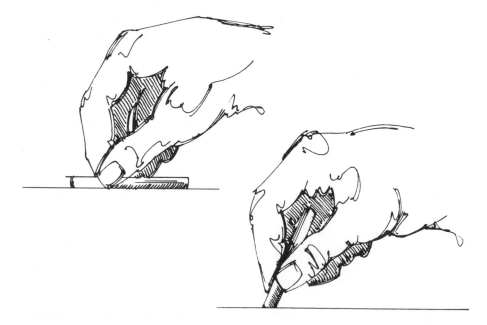

Broad conté lines can be made by holding the crayon flat, as shown at top. Using the tip from a higher angle, as below, gives a more defined line.

Pastels, crayons, oil pastels and markers (left to right) have distinct advantages, depending on the effect you want to achieve.

PASTELS

Pastels are similar to chalk, but the colors they produce are much closer to painting. Pastels can be bought in hard or soft grades. Hard pastels are similar to a conté crayon in hardness. Soft pastels are better known and more widely used. They are fragile, subject to smearing and produce much dust. But the soft, subtle effects obtained with soft pastels cannot be matched by any other medium. You should certainly apply a light coat of fixative to your completed work, and you may even use fixative during the course of your drawing. Sticks will usually break, but you can still draw with the pieces. Pastels do not fade or change color with time.

CRAYONS

What we call crayons are sticks of pigment held together with wax. They do not smear, but can melt in high heat. They are available in a wide range of colors, are inexpensive and require no fixing.

OIL PASTELS

These look like crayons and should not be used for projects that you want to last. They have brilliant colors and do not require fixative. The oil base will bleed through paper, so work on a heavy grade of paper.

FELT-TIPPED PENS OR MARKERS

These are widely available and vary greatly in color and durability. A variety of point sizes will enable you to produce many different lines and effects. They will dry out if left uncovered.

BRUSHES

Drawing with a brush is often associated with an Oriental style, but there are many different methods you should try. *Dry-brush drawing* is usually done with opaque ink or watercolor, and is easy to correct. *Wash drawing* is done with transparent washes of ink or watercolors diluted with water. These methods are described in more detail in *Watercolors*, another volume in this series.

FIXATIVE

Pencil lead, charcoal, conté crayons and pastels usually do not have enough adhesive power to bind them permanently to whatever surface you are drawing on. Therefore they tend to wear off after a period of time. Fixative is a diluted resin solution sprayed on a finished drawing to bind these mediums to the surface. Fixative can also be used on finished sections of a drawing so you can work on other parts without damaging what you have done.

If you are working in color, you should be aware that fixative can alter tones and should be tested first. Always spray fixative onto your work in very thin layers. Fixative is available in spray cans.

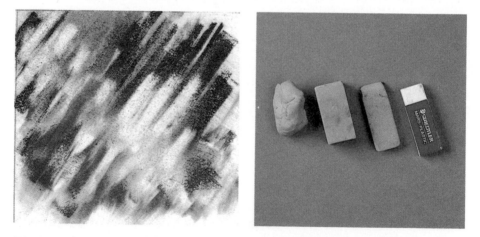

Erasers should be used sparingly in drawing, but when you need them there are several types from which to choose.

ERASERS

As you begin drawing, you should make every effort to avoid using an eraser. Too often you will find yourself erasing a line, only to

draw it again in the same spot. If you must use an eraser, there are three types to choose from. *Gum* erasers are soft and pliable and will not damage the surface of your paper. *Kneaded* erasers are so soft you can shape them like clay. They are well suited to chalk, pastel or charcoal. A soft *rubber* or *vinyl* eraser is fine for pencil or felt-tip pens.

PAPER

There is such a wide variety of papers available, it is best for you to experiment with many kinds before you choose one. The surfaces of papers differ and can make the same drawing medium work very differently. Good paper for drawing has a surface texture, called *tooth,* that holds the drawing medium. The thickness of paper is indicated by its weight. This is listed in pounds, which is the weight of 500 sheets, called a *ream,* of that paper.

Smooth paper is best for pen and ink drawings or felt-tip markers. Very light paper such as newsprint is useful for practice, but not for finished work because it tears easily and yellows quickly.

Sketchbooks or pads are very useful. Make it a habit to carry one with you and sketch whatever appeals to you. The only way to learn to draw is by drawing. These sketches will not only help you improve your technique, but will become source books of ideas and scenes.

DRAWING BOARDS

A piece of plywood or Masonite approximately 33 by 23 inches is necessary for supporting your paper. It should be light enough to be handled easily, but stiff enough so it won't flex when you're drawing on it. Drawing board clips are available for attaching your paper so you don't have to make holes in your board with pins or tacks.

CRAFT KNIFE

One additional piece of equipment you'll find very useful is a knife with changeable blades. You can sharpen your pencils to get the exact point you need, and you can cut tape, paper or cardboard. A single-edge razor blade will work just as well and is less expensive but demands a little more care when using it.

Now that we've talked about materials, let me introduce you to the fundamental requirement for any artist: learning to see.

2 SIGHT TRAINING

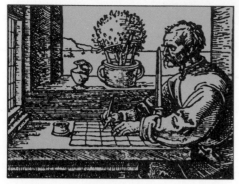

Calculating Dimensions
Correct Proportion
How To Measure
 and Relate Accurately
Scaling
Boxing Up

When we are first learning to draw, we usually try to trace the edges of our subject, but often without success. The problem is both in what we see and what we do with what we see. The object of the following chapters is to give you a method for putting what you see on paper. This is called *sight training*.

SIGHT TRAINING

Five hundred years ago the great master Leonardo da Vinci dealt with the question of sight training in his *Treatise On Painting*. He suggested that students "exercise your eyes and learn to see the true length and breadth of objects. One of you should draw a straight line on a wall with chalk, and the rest try to calculate its length from a distance of ten paces. Then measure the line. The one who has calculated its length most closely is the winner. Games like this one are useful in the formation of *judgment by sight*, which is the principal factor in drawing and painting."

THE WHITE PAPER BARRIER

I well remember how, when I first started drawing, I knew nothing of this "judgment by sight" of which Leonardo spoke. I sat in front of my subject staring at a sheet of blank white paper, without any idea where to begin. I had heard about *boxing up* and been told to "begin by thinking of all the main parts of the drawing as if they were boxes." But I still didn't know where to begin, how to draw the boxes and what size to make them. I felt sure something must precede the boxing up stage, that there must be some way of breaking through the "white paper barrier."

After a time I discovered what I was missing. I was not able to mentally calculate dimensions. Then I found a second problem lay in learning how to increase and reduce these dimensions without altering the relationships between them. It was not until some time later that I learned how to put the theory of boxing up into practice.

CALCULATING DIMENSIONS

To give you an idea of how to calculate dimensions, let's follow an artist as he sets out to make a drawing.

Carrying his portfolio and stool under his arm, our artist walks slowly along the street to his selected subject, the facade of an old house, shown on the following page. When he reaches the house, he stands in front of it for a full five minutes, staring at it.

Then, still gazing at his subject, he opens his portfolio, sets up his stool and sits down. Two boys wander up to him, waiting for him to take something out of his portfolio. "But he's not painting anything," says one of them, obviously implying that the artist must be crazy. Our artist doesn't hear them. He is absorbed in his subject.

Looking at the balcony, he half closes his left eye, as if trying to remember something.

Then, suddenly, he comes to life. He takes out a sheet of white paper, fixes it in place and chooses a pencil from the collection in his pocket. Then, and only then, does he catch sight of the two boys.

"Well," he asks, "do you like drawing?" But he doesn't wait for an answer before going back to work.

He looks the paper up and down, as though tracing outlines in his mind's eye. Then he raises his head and looks back at his subject. His gaze probes all the nooks and crannies in the doorway, the ironwork, the blinds and the balconies.

What is he doing? He is calculating, calculating mentally "the true length and breadth of objects," as Leonardo put it. He is comparing certain distances with others, looking for reference points to carry basic lines, drawing imaginary lines in order to determine the position of certain objects in relation to others.

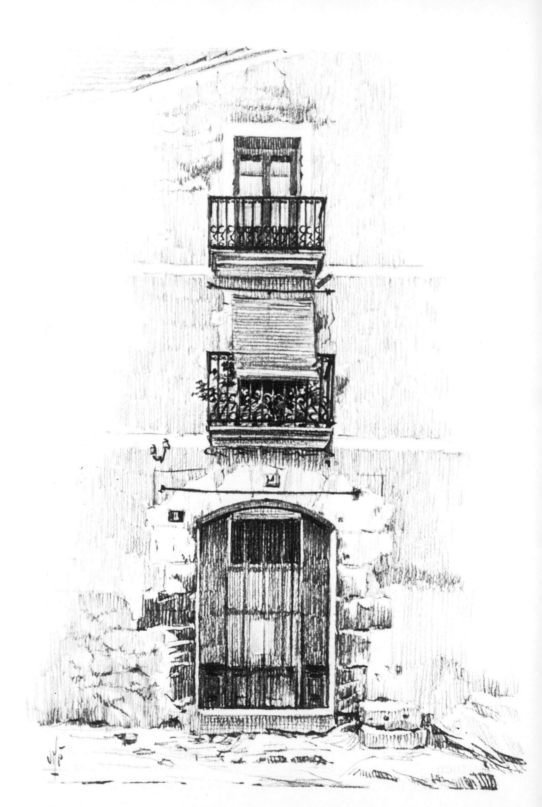

24

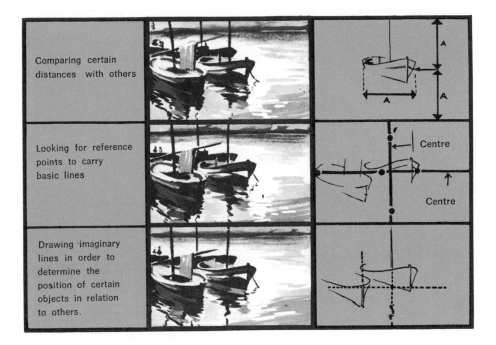

Comparing certain distances with others		
Looking for reference points to carry basic lines		
Drawing imaginary lines in order to determine the position of certain objects in relation to others.		

The first step in drawing a subject is to calculate dimensions mentally. The illustration above shows the steps involved. Following this procedure produces a more accurate and realistic drawing.

This is *the mental calculation of dimensions.* It is a basic way to start your drawing. It consists of looking for reference points to carry imaginary lines in order to determine the position of certain objects in relation to others.

How marvelous it would be to see into the mind of this artist, to follow his train of thought as he carries out his vital task of observation and measurement. Let's try.

"Good, this is just the kind of scene Jack wanted for his living room. Simple and easy—a doorway, a balcony and a blind. Not much perspective. This will look great. Doorway, balcony, another balcony and then a bit of roof. Easy, I'll charge him 100 bucks. I'm sure old Jack will agree to that. With his law practice, he can afford it!

"Let's see now, doorway, balcony, balcony. Are both balconies the same height? No, the top one's a little lower. Influenced by the perspective. Is the doorway the same height as the first balcony? No, it's higher. I need a reference point. Doorway, balcony, I've got it! The doorway is the same height as the balcony with the piece of wall under it. That's it. I'll charge him 150 bucks.

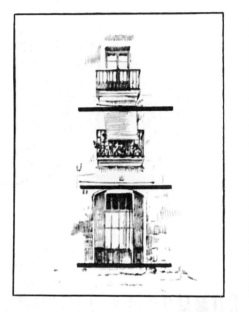
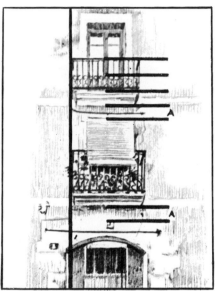

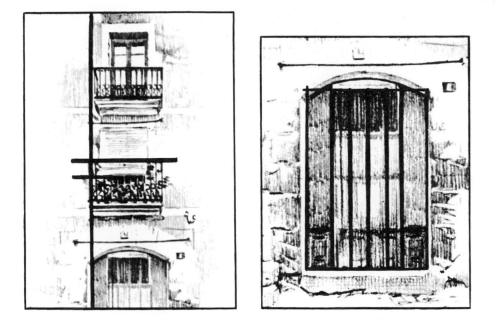

"How far from one balcony to the other? It's just half the distance from the top of the doorway to the first balcony, by the number of the house. And that's the same as the distance between the roof and the top balcony, and then another space the same, and another, and that's the railings.

"Doorway, balcony, balcony, that's it. A vertical line there! One more line right down, then that's it. Ah, that's better.

"Rectangular doorway. What about the height and the width? It's higher than it is wide, but how much higher? Let's see, if I make a square first, then put half the square on top, that's it. 'Easy and cheap,' Jack told me. Hmm. I'll ask him a leading question about last year's profits and he won't have the nerve to question the price!

"His law practice must have a pretty hefty turnover. Are both balconies the same width? Yes, and just a little narrower than the doorway. There, another vertical, cut in half and there's the other railing. The end of the blind lower down. Fine! That was simple.

"Doorway, glass panel, one, two, three, four. Four smaller ones, the same width, in the middle, there we are, that's the glass panel. His

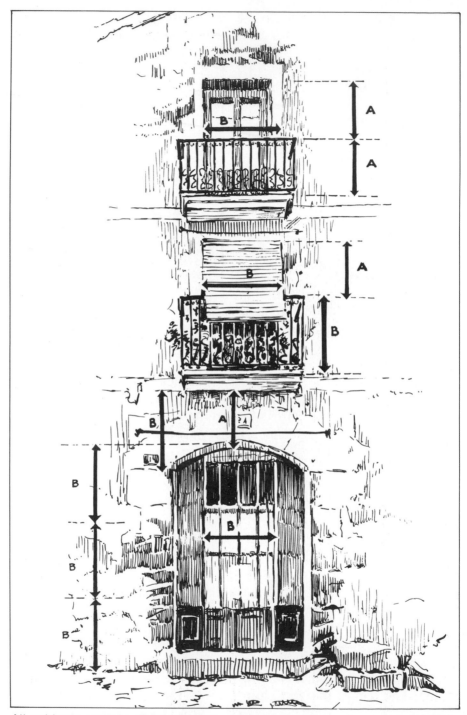

All subjects contain distances that correspond and can be compared. This drawing contains a number of dimensions that can be compared with each other, whether as equals, halves, thirds or quarters.

practice grew by 25 percent last year. Twenty-five percent! And I'm charging him only 200 dollars. I must be out of my mind! Not a penny less than 300 dollars.''

The artist made more than one calculation as he studied his subject. Some had nothing to do with dimensions! In all seriousness, though, this description of the artist's thought processes illustrates how to overcome the *white paper barrier.*

His approach to his subject showed that, even before he had taken the paper out of his portfolio, he was comparing dimensions, looking for reference points, drawing imaginary lines, positioning blocks and generally studying how he was going to start relating proportions and boxing up. Can these reference points be found in every subject? Yes. It is always possible—as it was in the case of the facade of the house—to find distances that correspond and can be compared.

You just need to be able to pick out such distances and measure them by eye, to be able to state that this distance is the same as that distance, or is twice as long, or three times, and so on.

The easiest way to learn how to calculate distances by eye is to follow Leonardo's advice, as illustrated on the following pages.

PRACTICAL SIGHT TRAINING EXERCISES

These exercises are endless and can be tackled in a variety of ways. I shall confine myself to describing a few basic ones in the hope that you will be able to work out others for yourself. They should form an important part of your training.

Use large sheets of paper. The longer the lines you draw, the more difficult it becomes and the more practice you get in calculating distances by eye.

It doesn't matter what kind of paper you use, nor what number pencil. I would, however, suggest that you work at a drawing board, sitting some distance away from it so that your arm is extended.

Practice these exercises in the order shown and check them with a ruler. Soon you will be able to calculate accurately by eye.

1. Draw a horizontal line about 6 inches long. Then, by eye, divide it in two with a vertical stroke.

2. Draw a horizontal line about 3 inches long. Then, still by eye, draw another line the same length.

3. Draw another horizontal line about 3 inches long and, next to it, another line half its length.

4. Draw another horizontal line about 3 inches long and, next to it, two vertical lines that combine to equal the length of the horizontal line.

5. Make a square, drawing its sides in the order shown.

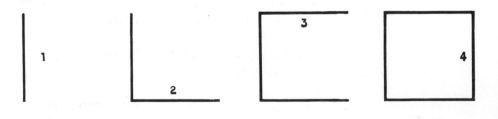

6. Make another square, this time using the letter H so that the completed square is divided horizontally.

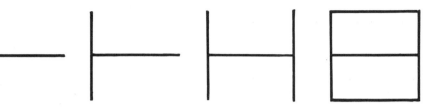

7. Finally, and this is the most difficult of these exercises, draw a vertical line. Then draw a cross over it so that the line joining A to B forms one side of the final square, the other sides of which you can now draw in.

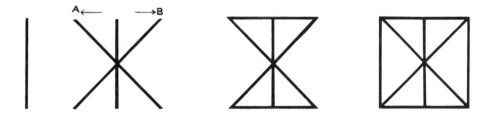

CORRECT PROPORTION

Look at the two drawings of Sir Winston Churchill on the following page. You will see that in one of them I have deliberately altered the distance between some of the features—there is an extra 1/8 inch or so between the eyes, for example, and the nose is about the same amount longer. I have also reduced the distance between the nose and the upper lip. The differences are intentional, but they illustrate how an error of fractions of an inch can change a drawing.

This is *correct proportion*, a principal factor in drawing and painting. It is, as you can see, very important.

Now look at the lower right drawing in which the features are accurate. This is a real likeness. No one can say, "Well, yes, it does look like him, but something isn't quite right."

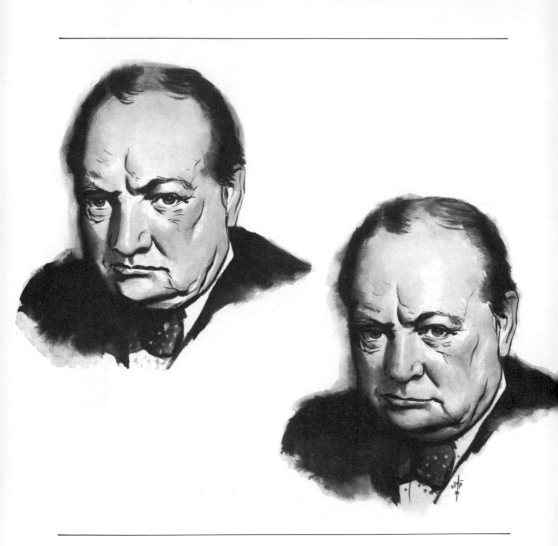

HOW TO RELATE AND MEASURE DISTANCES

Let's return to our friend the artist in front of the old house. This time we will ignore his thoughts about Jack and his law practice.

He has already taken up his pencil and drawn a few lines. Suddenly he stops, grabs his eraser and rubs out one of the lines.

Then, with his arm extended and holding his pencil upright, he raises the pencil to eye level and slowly moves his thumb upward, measuring some feature of his subject. When he has the right measurement, he turns his hand and, with his arm still extended, holds the pencil horizontally.

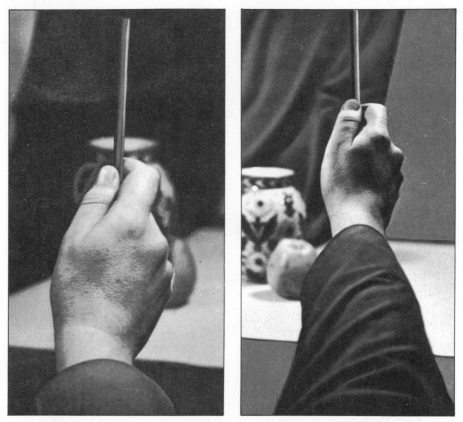

Hold your pencil with the point downward, so that as much of it is visible as possible. Close your left eye and extend your arm as far as possible in front of your right eye. Take care not to move your body forward.

The two boys look on in fascination. Then, exchanging bewildered glances, they run off, saying, "He really must be out of his mind."

How wrong they are! He is measuring, checking whether his mental calculations were correct, relating to the last fraction of an inch the width of the doorway to its height.

This is what you must do until you have mastered the technique. Try it yourself. Compare the dimensions of two objects in front of you. Check and recheck. Although you will see that the artist is using a pencil in the illustrations that follow, you can measure with almost anything straight, for example a ruler or a paintbrush.

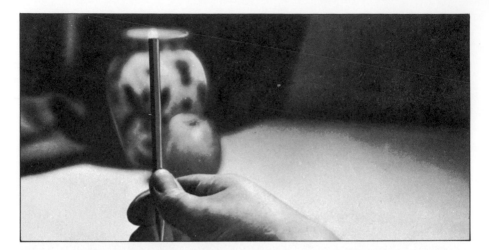

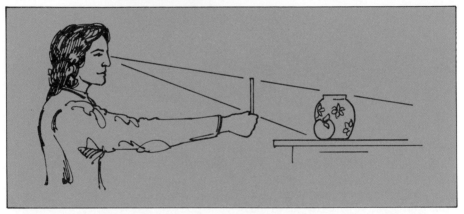

Hold your pencil in front on one feature of your subject and mark its height by moving your thumb up and down the pencil.

Then, without moving your thumb on the pencil, look for another measurement equal to the first. For the sake of accuracy, it is important not to bend your arm or move your body.

Our friend the artist is already drawing lines with complete confidence. Now and then he measures with his pencil, dividing the subject up and making marks on his drawing. He is measuring and relating simultaneously.

SCALING

Scaling is *the art of increasing or reducing the forms and dimensions of a given subject while maintaining its correct proportions.*

Scaling means reducing something to a smaller scale while maintaining the differences in size of the various components of the drawing. If, for example, you are drawing a vase and an apple, and the vase is twice the height of the apple, you must keep this same relationship in the drawing.

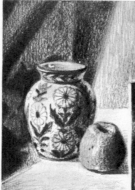

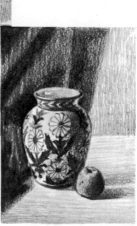

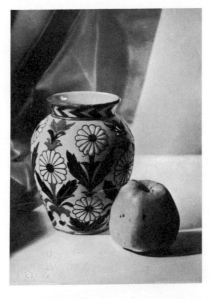

At left the apple and vase are shown in true proportion. Above left the subjects are scaled down in accurate proportion. The proportions above right are obviously inaccurate.

If someone has a very large head, we say that it is out of propor-
tion, both in relation to the dimensions of his body and to those of a
normal head. If you examine a classical Greek statue you will see that
the dimensions of the head, bust, arms, legs and other parts of the
body all correspond to certain ideal proportions.

So far, so good. Your problems start when you try to reduce your
subject to the exact measurement of your paper and, at the same
time, keep everything in proportion. This is the problem our artist is
in the process of solving.

Albrecht Dürer drawing with the aid of squares on a glass.

This problem fascinated Albrecht Dürer, one of the great 16th-
century draftsmen and painters. Dürer invented a number of devices
for overcoming the problem of transferring dimensions and propor-
tions. One device consisted of a pane of glass with squares drawn on it
which he placed in a frame between himself and his model. Then,
after drawing squares like those of the frame on his paper, he copied
from the glass with the help of the squares, keeping his eye at a con-
stant distance from the frame.

Not long ago I saw an ingenious device, not unlike Dürer's, for
adjusting while drawing from nature. It consisted of a frame made of
two pieces of cardboard crossed by four wires, forming a simple
system of squares. The artist drew corresponding squares on his can-
vas and then, fixing the model visually within the cardboard frame,
transferred the image by means of the squares.

I won't go into any more detail about such devices here because I
don't think it is a good idea to use them. Better to learn to scale by
eye. Let's return to the facade of the old house.

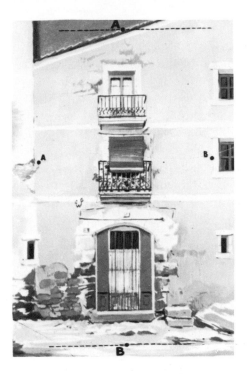

Here is what we can actually see, but we will draw only the part between points A and B. The first step in calculating dimensions and proportions is to divide the height into two equal parts as shown in the lower line illustration.

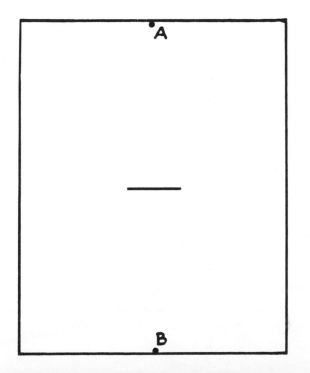

37

When drawing from nature, the first question the artist must ask himself is, "How much of the scene should appear in the drawing?"

As soon as you have decided this, you must choose reference points to determine the top, bottom and sides of the drawing. It is nearly always possible to pick out some little detail that will serve as a reference point.

Once you have established the edges of your drawing, start measuring with your pencil, dividing the subject into equal parts horizontally. Remember to keep your arm fully extended and your body completely still.

So far, so good. There are plenty of reference points in this particular subject. It is a good idea to start off with one obvious measurement. In this case the height of the doorway can be used. If you transfer this measurement upward, you will discover that the total height of the building is almost three times that of the doorway.

This is the first calculation of proportions you should transfer to your paper. To do this, you can use either a strip of paper or the pencil itself, fixing the measurement with your thumb. With practice you will soon be able to calculate dimensions and divide up a given space by eye. This, of course, should be your aim.

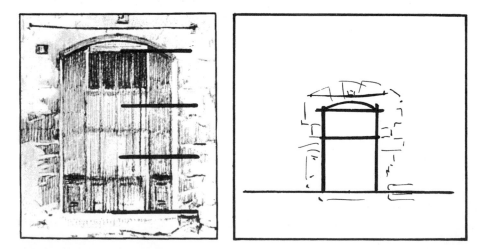

Next, measure the height of the doorway in order to help determine its width, which is two-thirds its height.

Now, continue the process of calculating the proportions and transferring them to your paper. Using the pencil as a measure, check whether the width of the doorway really equals two-thirds of its height. Then, still by eye, divide the height of the doorway into three equal parts and determine its width as shown on the opposite page. Continue this with the other major features of your subject.

There is no point in repeating all the artist's mental calculations and arriving at the same conclusions. Just remember that, using the pencil as a measure, you can relate, divide, double and transfer dimensions, using one measurement to build up others.

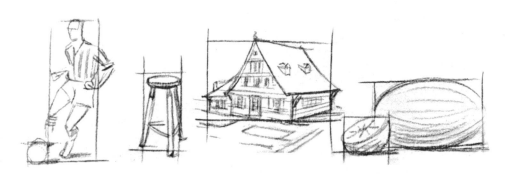

BOXING UP: ENCLOSING IN BOXES AND CUBES

As the drawings above show, you can enclose anything in square or rectangular forms, which we shall call *boxes*. Anything—figures, stools, houses, oranges, melons—can be *boxed up*.

In addition, every object, form or subject can be *reboxed up*. That means its component parts can be enclosed in smaller boxes.

Boxing up does not mean making a box big enough to enclose the whole subject. On the contrary, the artist must be able to use his judgment to make the box small enough to contain *only* the most important basic lines or forms.

As you can see, the calculation of dimensions is a simple matter once you have drawn the outer box and checked its measurements with your pencil.

Now let us watch the boxing up of the balcony of the old house.

The scaling calculations we have already made enable us to determine the position and dimensions of the box that will hold the balcony.

We then look for a horizontal line as near as possible to the center of the box. With the help of the pencil, we find one: the bottom of the blind.

You can see that the distance between the bottom of the blind and the top of the balcony railing is the same as from point A to point B, which represents the base of the balcony.

By transferring this measurement to the left side of the box, we can find the edge of the blind on that side. From here, using the same measurement, we can draw the right edge of the blind.

Still using this measurement, we can now position the ironwork and accurately draw in the iron bar above the blind.

How many vertical *spaces* does the balcony railing have in this exercise? One, two, three...twelve in all. And the division of a given length into twelve sections is simple. First divide by two, then divide each half by two. Then divide the resulting widths by three and you have it. All that remains is to fill in the surface details, the ornamental part of the ironwork and the flowerpots and flowers. Now we're ready to start shading, to give our drawing final form.

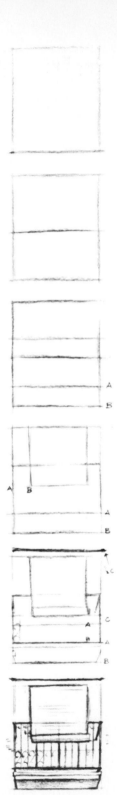

THE HARDEST TASK OF ALL 3

Posed Models
Simplified Forms
Preliminary Drawing
Masses
The Sense of Proportion
The Last Stage

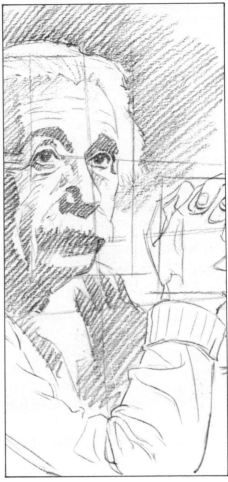

We began our sight training practice with an easy subject: the facade of the old house. The doorway and the two balconies were very pronounced and there was practically no interplay of light and shade. The principal features had an almost geometric simplicity and consisted mainly of straight lines. "Simple and easy," as the artist said.

This was, in fact, the best possible introduction to drawing from nature. It is wise, in the early stages, to stick to straightforward subjects. This will help you build up confidence and develop your skills. While the aim of most drawings is not to produce an exact copy of its subject, at first you should work to create as close a copy as possible. Once you have learned the basics, you can develop your own style.

As you practice more, you will find yourself tackling more complex subjects. You may try subjects in which perspective plays a greater part, in which dimensions are not hard and fast but must still be reproduced with the same accuracy, or in which the principal feature cannot be boxed up in the usual way.

The best example of this is a portrait. In a drawing of the facade of a house, or a tree, or a mountain or jug, little errors of dimension will go unnoticed. What does it matter, after all, if a door is a fraction too wide or too high? But, as we saw on page 32, these fractions of an inch matter considerably in a portrait. They may alter the whole likeness of the model. How can features so small, but nevertheless so important as an eye or a lip be boxed up? How can we box in the lines and wrinkles of the skin, or the prominence of the cheekbones?

All of these depend on the interplay of light and shade. Catching this is the hardest task of all. When you have mastered this you will be able to say with confidence that you have the professional's ability to calculate dimensions and proportions by eye.

DRAWING A POSED MODEL

Imagine that Albert Einstein, the great physicist and mathematician who was the father of the atomic era, is posing for you. To help your imagination, carefully examine the photo of Einstein on the facing page. I have the picture in front of me as I write.

I suggest that, as a start, you read completely through the process I am going to describe, and then try to put it into practice. Although you may not get very satisfactory results at first, you will still be able to use these lessons when you draw less complicated subjects.

TEN-MINUTE OBSERVATION

The paper, pencil and eraser are all ready in front of you. But before starting anything, you must observe your subject closely. You must begin that process of assimilation that will enable you to capture every little detail and produce an exact likeness.

The first stage in the mental calculation of distance is to work out a satisfactory formula for dividing up the area. This simplifies the measuring and scaling of proportions, and the location of reference points from which to begin boxing up.

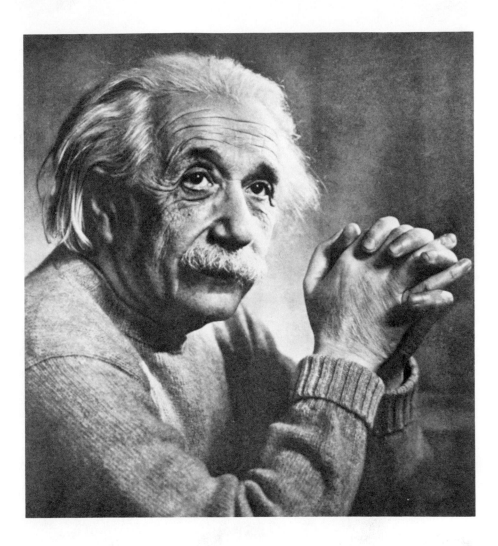

While I study the picture, my thought processes go something like this:

"If I divide the area into four equal parts, the head will be in the top left square and the hands almost in the bottom right square. These are the two principal features. Now I can work out the approximate distance between the head and the right edge of the picture (A to B in the illustration). It looks as though it's roughly the same as the total width of the head—although the head may be a little broader.

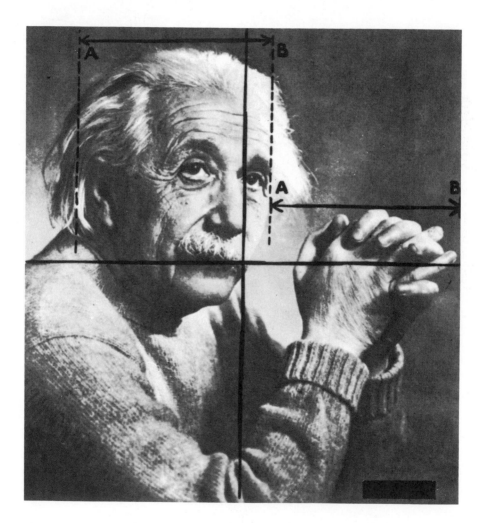

"Next, the head would fit roughly into a square box and so would the hands as shown above on the facing page.

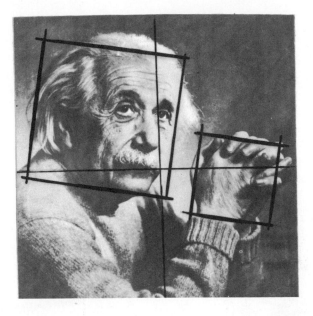

"Both the head and the hands are inclined slightly to the right. If I draw a sloping line at eye level across the whole page, it will give me the position of the ear on the left and the tops of the fingers on the right. Another line crossing the page horizontally at the level of the seam of Einstein's sweater will give the position of the cuff as shown on the right."

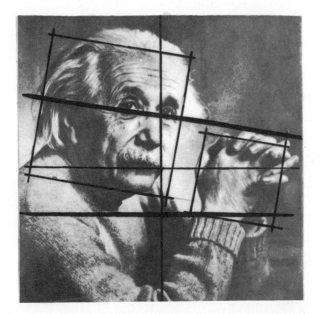

SIMPLIFIED FORMS

At this stage you can leave the mental calculation of distances and go on to something equally important: The search for *simplified forms* and the comparison of dimensions among these forms. This sounds more difficult than it is.

Every subject, however complicated, can be analyzed as though it were a jigsaw puzzle. The problem, of course, is to locate and separate the pieces that form the whole.

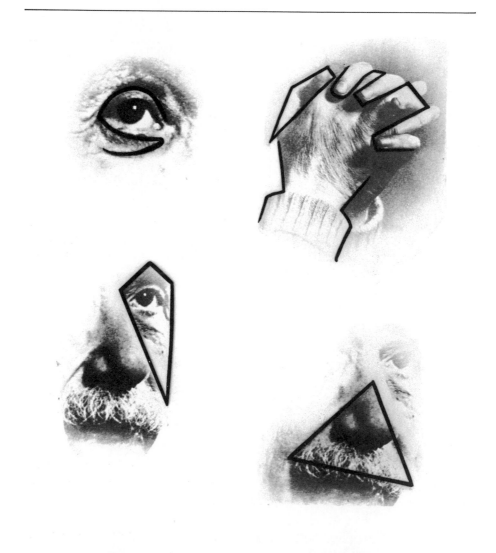

As you can see in the illustrations on the previous page, it is easy to find simple forms that are almost geometric in shape. Start with basic features and areas of light and shade.

If you can analyze these forms as isolated features, you will find it very easy to relate dimensions and proportions. Comparing the form as it appears in your drawing with the real form as you can see it in your subject will enable you to adjust it to create an exact likeness.

As an example of this, look at the area of the face around Einstein's right eye, the eye on the left side as we look at him. Can you see a semicircle in the combined form of the eye and the eyebrow?

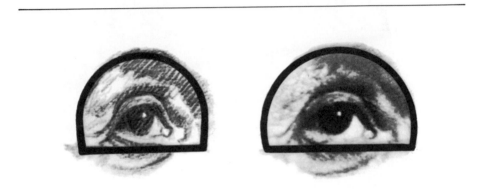

If this semicircle on the left is *your* semicircle, and the one on the right matches the model, you can see that you have not captured a good likeness. The semicircles are not of identical shape.

Imagine that you have already drawn this part of Einstein's face. When you compare your portrait with the photo, you can see that the likeness has eluded you, as shown above. The drawing is not quite accurate and will have to be corrected until the semicircle corresponds exactly with that on the photo.

The advantage of this system is obvious and can be summed up as follows: *It is easier to calculate and compare dimensions starting with simple forms than with more complicated ones.*

Now we have finished our preliminary observation, and we can begin to draw some lines.

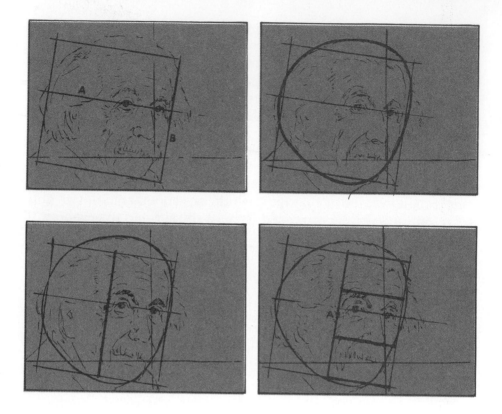

PRELIMINARY DRAWING

Dividing the space into four squares enables me, with the help of my previous calculations, to determine the position and dimensions of the box that is to enclose the head.

What I have done is to draw line A at eye level and then line B at right angles to it. These lines determine the inclination of Einstein's head and enable me to complete the box enclosing it as shown at the top left.

Measuring with my pencil, I compare the total height of the head with its width. I find that the height is greater because the hair at the top of the head goes beyond the edge of the box. I can enclose this by drawing a rough circle indicating the outline of the head.

The next step is to find a reference point near the center of the head. This is not difficult. The right end of Einstein's right eyebrow is almost the center of the rough circle containing the head. I check it with the pencil and adjust it precisely. Then I draw a new box inside the first that will contain the principal features of the face: the eyes, nose and mouth, as shown at lower left, preceding page.

To determine the approximate position of these features, I measure the height of the forehead and repeat it twice. This divides the face into three parts. It does not matter if they are not exact. The important thing, determining the height of the forehead, has been achieved as shown in the illustration on the lower right, preceding page.

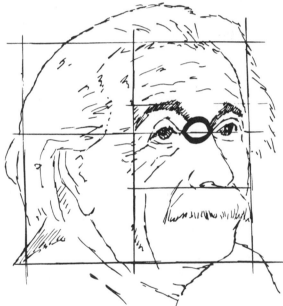

I draw in the eyebrows using the line at the bottom of the forehead and point A. Then I draw the eyes. This is no great problem because the right eye is contained by its own eyebrow and, according to the rules of anatomy, the eyes must be separated by a distance equal to the width of an eye, as shown above. The left eye comes next.

Then I discover that the length of the nose is equal to the width of the eyes. I draw the outline of the nose and fix the position of the mustache by eye, and then the corners of the mouth, the point of the chin and the outline of the left side of the face.

HOLD IT!

Before going any further, we will examine and correct what we have done so far. The best method is to look for simple shapes in the places that seem most complicated and, like the professional, draw imaginary lines.

Have another look at the photo of Einstein on page 43. Notice the following:

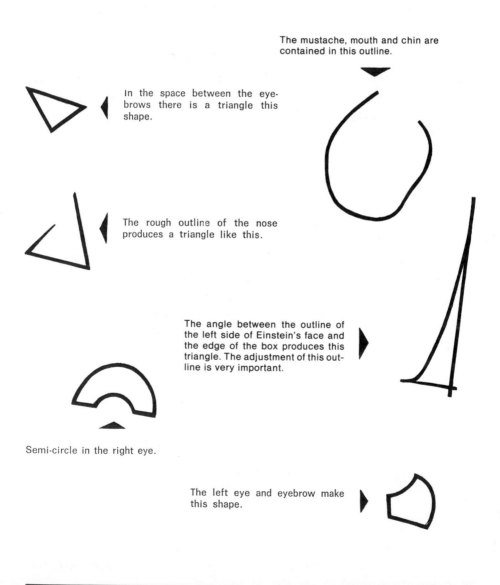

The mustache, mouth and chin are contained in this outline.

In the space between the eyebrows there is a triangle this shape.

The rough outline of the nose produces a triangle like this.

The angle between the outline of the left side of Einstein's face and the edge of the box produces this triangle. The adjustment of this outline is very important.

Semi-circle in the right eye.

The left eye and eyebrow make this shape.

Let's go back to drawing imaginary lines to determine the position of certain features in relation to others.

For example, in the figure below the total width of the nose is shown by the two marked points. Two lines drawn downward from these points will establish the exact position of the lower, wider part of the nose.

Another imaginary downward line drawn parallel to the first two from the right end of the model's right eye fixes the position of the corner of the mouth.

All that is necessary to determine the curve of the corner of the mouth is to draw another imaginary line to point A in the figure below. Finally, using this system of imaginary lines, which you can actually put on the drawing if you wish, you can check the exact position of the eyes, eyebrows, nose and mouth.

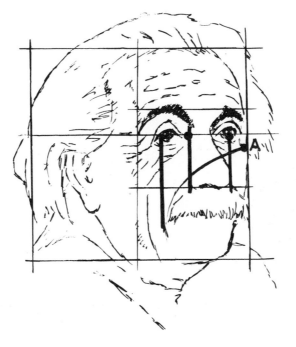

Once the principal features of the face have been adjusted, we can get on to the *boxing up of masses.*

BOXING UP MASSES

As I said on page 10, mass is the shape of an object, including its third dimension. Mass has shape and form.

For our purposes here, the masses determine the composition of a work. They are simply blocks of light and shade.

Boxing up by masses is a simple matter. If mass can be described as the arrangement of light and dark within the picture as a whole, then boxing up by masses means determining the dimensions and proportions caused by the interplay of light and dark on the subject, as shown on the facing page.

Boxing up by mass gives the satisfaction, at last, of starting to bring the subject to life in the drawing. Shading the eyes, nose, cheek and chin gives the work volume and makes it easier to analyze. Now you can begin to see the structure and proportion of your subject.

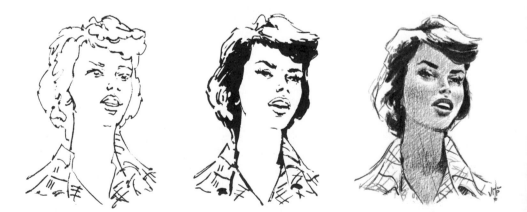

These drawings illustrate what we discussed on pages 6 through 11. At left is a line drawing. The center face shows value, and the face at right shows mass.

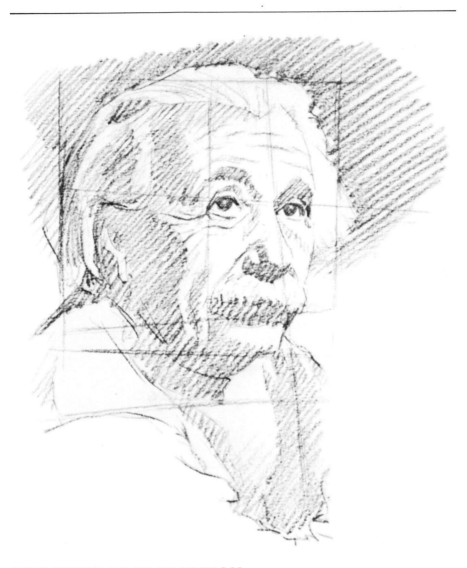

THE SENSE OF PROPORTION

If you draw methodically—continually comparing distances, drawing imaginary lines, and using reference points—the time will come when you can transfer measurements almost instinctively.

At first you may feel you are up against an immovable barrier. Proportions refuse to be scaled, one feature is too small in relation to another, a box will turn out to be too big, and so on. With practice you will find you can overcome this barrier and, once this is done, everything becomes easy.

You will have developed what I call *the intuitive sense of proportion*. Thanks to this we can determine distances and measurements with increasing ease as we compare our drawings with their subjects.

To return to our drawing of Einstein, the line drawn at eye level gives us the position of the box that is to contain the hands. Determining the dimensions of this box and its exact position is simply a matter of drawing imaginary lines and comparing measurements. Transfer the lines we already fixed for the face to the height and width of the hands. Having made a quick sketch of the position of the fingers and the rough shape and outline of the hands, look for simplified forms in the structure of the hands.

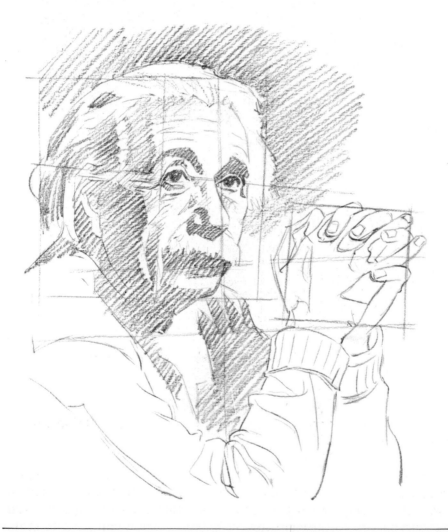

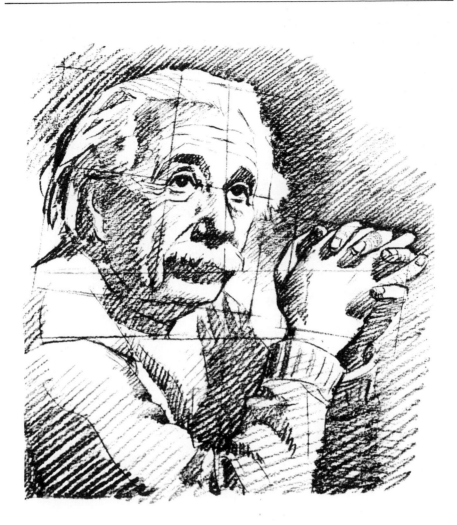

Finally, following the same pattern, I draw the basic lines of the body and box up the shapes according to the masses, above.

THE LAST STAGE

Are we ready to begin shading, appraising and building up the final picture?

Not quite. The last and most important stage, which will give us a perfect likeness, is still to come. This does not refer exclusively to portraits. In every drawing, whether it is a figure, a landscape or a still life, there comes a moment toward the end, when you have to stop.

"If you want to be able to discover the errors in your work, you have to give them time to show up," is what Titian used to tell his pupils. And Titian followed his own advice very rigidly. Once he had finished a painting, he turned it to the wall and did not look at it again until, as he put it, "My ego has gone to sleep and I can see things clearly again."

This may be a bit extreme, but I think it is good advice. You should put down your tools at this stage and leave your work for a while—until the following day, if possible. Then you will return with a clearer mind and be able to evaluate your work more objectively.

After this brief rest, you must spend as much time as possible comparing distances. This is your chance to make small corrections and changes that improve your drawing. Check the dimensions of everything you have drawn against the subject.

Place yourself so that, by rapidily moving your eyes, you can see both the drawing and the model without moving your head. Look at your drawing and try, for example, to gauge the length of the nose in relation to the space occupied by the eyes.

Look at these parts of the drawing really hard, trying to commit every aspect to memory. You should be able to close your eyes and retain the image, as though it were photographed on your mind.

Then, quickly look at your model. Try to superimpose the image of your drawing over the relevant features of your model, in this case the eyes and the nose. See how they compare. If there are small errors, correct them.

Then look back at your drawing, and back at the model, and back at the drawing again. Keep repeating this process of comparing and correcting until each feature of the drawing is as close as you want it to the corresponding feature of the model.

Compare and improve, time and time again, until it becomes an obsession. You will find, however, that this process becomes thoroughly enjoyable as you gradually impose your will over the drawing and finally conquer it!

This is when you will experience that curious sense of rightness, so hard to explain, that comes with completing a drawing or painting.

You learn to draw by drawing and, best of all, by drawing from nature. This folded paper bird was created to illustrate how you can practice estimating proportions and dimensions. By lighting it with a draftsman's lamp, we get simple planes in highlight and in various shades of darkness. It's ideal for practicing the techniques of shading. You can use any object that has fairly simple lines but which will reflect light on different planes.

After you've chosen an object, draw it first in profile, then in three-quarter position. You can repeat this exercise with many objects until you've mastered proportions and dimensions.

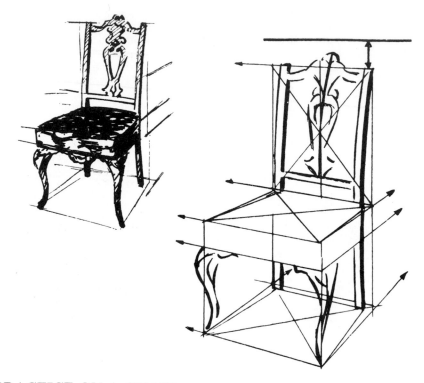

PRACTICE ON A CHAIR

This is a practical exercise in drawing a chair. Choose any chair in your house. These instructions are good for boxing up all kinds of chairs, stools, benches and even sofas. As you will see, the problem can be solved with the techniques you have already learned. First, examine the chair carefully. Now construct your imaginary lines.

The figure above right shows the system of lines I have devised for drawing this chair. The three figures on the facing page show the sequence I followed to develop these lines.

You can see that I first constructed a cube in perspective. If you were to move in front of the chair and draw a horizontal line just above its back, you would find, of course, that this line runs parallel to the top of the chair. This *horizon* line enables you to draw your shapes in correct perspective. I drew this line, and with the cube already in position, the next step was to draw a rectangle above the cube to contain the back of the chair. This gave me the basic outline and enabled me to finish the chair without difficulty.

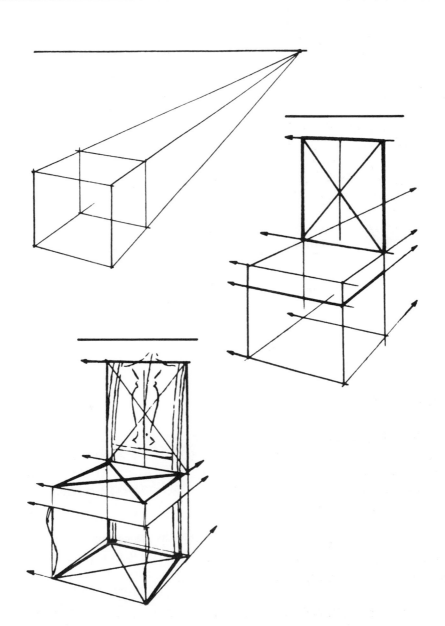

Chairs in your house offer a variety of models to help you learn the art of boxing up shapes. The step-by-step exercise illustrated above shows how you first create a cube drawn in perspective, top left, which represents the seat and legs. Next, a rectangle is drawn above the cube to represent the outline of the chair's back, top right. With these basic proportions established, it is a simple matter to proceed with more of the chair's details and form, as shown in the lower drawing. As you can see, it is a matter of boxing up the main shapes of your model and proceeding from there.

4 DRAWING FROM LIFE

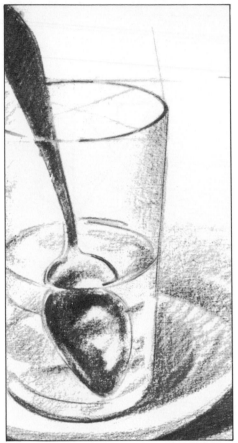

Foreshortening
The Two-Dimensional Barrier
Drawing Faces

WHEN THE MODEL OBJECTED

The scene was a life drawing class at the art school. The teacher was showing the model, who was new, how he wanted her to stand. "Arms to the side, head a little higher, knees together with your feet flat on the ground. Stand at attention." The thirty or so students looked on in silence.

"That's fine, hold it like that," the teacher said at last.

The model stayed just us she was, standing stiffly at attention, and we all began drawing. Then, suddenly, she got down from the model stand in a very determined way, and without a word, disappeared through the door at the back of the classroom.

We didn't have to wait long for an explanation. She came out after a few minutes, fully dressed, and said shakily, "It's not that I mind standing up in front of you stark naked, and I can put up with your cracking jokes. But when you start drawing a coffin and putting me inside it, well, that's the limit. I'm not going to stand for it."

"But my dear girl," said Bob, one of my fellow students, "that's simply the boxing up process. The first stage is to box up, after which..."

"Well, you're not going to box me up, do you hear?" and out she stormed, slamming the door behind her.

WHY BOX UP AT ALL?

I left the class thinking about that incident and wondering what would have happened if the ending had been different.

Suppose that the model had asked, "Why box up at all?"

Bob would probably have answered, "We box up to find the proportions and dimensions of the subject we are drawing."

Then I think I would have given her an example of what can happen if you don't begin by boxing up.

Think of an inexperienced amateur trying to draw a figure from life without boxing up. Do you know what he does? He looks at the face and calculates the dimensions of the head: so wide and so high. Then he draws the face. Next he looks at the neck, compares its dimensions with those of the head and proceeds to draw it. He goes on to the shoulders, calculates that they are wider than the neck and draws them.

He continues this way until he has completed the whole body. He then stands back and looks at his work, and if he is capable of seeing it at all critically, he realizes that the legs are too long or too short and are out of proportion to the rest of the body. Why? Because his errors increased as he progressed. He got the length of the neck slightly wrong and, because he used the neck as the basis for calculating the size of the shoulders, he got them wrong, too. This, in turn, affected the hips and so on.

"To sum up," Bob would probably have concluded, "there was no control over the proportions of the body as a whole."

A box is *a simplified system of lines used to check the measurements and proportions of the subject within it.*

This means that in drawing the box, we consider the total measurement of the subject. In drawing the subject inside the box, we check and revise the calculation of dimensions made in the first box. As you can see with our amateur, this is particularly important when you are drawing from life.

Imagine that the same inexperienced amateur starts out by considering the model as a whole, from head to foot and from one side to the other, and draws the box, by comparing its total height with its total width. Then, still considering the model as a whole, he determines the position of the principal features such as the shoulders, the navel, the knees and so on. It is then a comparatively simple matter to start drawing the body accurately.

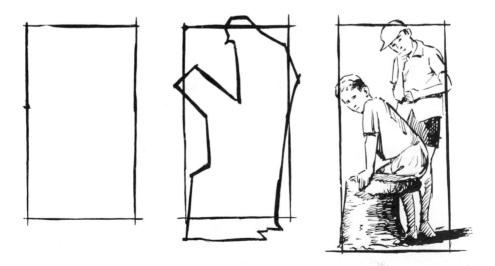

Suppose the artist can't see the box?—This is a problem that took me some time to solve. At that time I was teaching beginners who were encountering great difficulties in drawing from life, despite the fact that they could all copy drawings and paintings very well. I remember how, on the first day, one of them appeared with a perfect

pencil drawing of the head of the film star Charles Laughton. But not one of them, when confronted with a real model, was able to choose the basic outlines. There was no point in talking about boxing up. It meant nothing to them.

I tried to understand what it was that created this barrier between the model and the students and prevented them from capturing the basic outline. Why was it that these students were able to copy a drawing perfectly but were defeated by a real model?

I thought back to my own student days, when I had the same problem, and I finally arrived at a series of conclusions that I now use in guiding my students. There is a world of difference between copying a flat drawing and drawing from life. And the interplay of dimensions is a vital part of that difference.

In the next few pages we will put these ideas into practice.

THE FORESHORTENING BARRIER

Foreshortened is the description of our view of a body or object placed perpendicularly or at oblique angles to our level of vision. The object seems to be compressed. We speak, for example, of a foreshortened arm when the arm of the model is raised and pointing toward us. Similarly, a figure on a diving board seen from below will be foreshortened. A vase or a jug lying on its side on a table is also a foreshortened form.

64

In fact, any body with volume can create an impression of foreshortening. A book, a horse or a woman's head will always have one part or another foreshortened, no matter how they are viewed.

Foreshortening has been a subject of considerable study and research by artists. Museums and private collections contain hundreds of drawings, almost always preliminary studies, of foreshortened hands, feet, arms and heads.

Why all this fuss and bother? Because, quite simply, foreshortening presents more difficulty to the artist than almost any other aspect of drawing.

Try it yourself. Point at yourself with your right hand, with your forefinger exactly at eye level. Now imagine trying to draw this hand. How will you reproduce the foreshortening of the finger? How will you highlight it so that it is obvious that it is a finger?

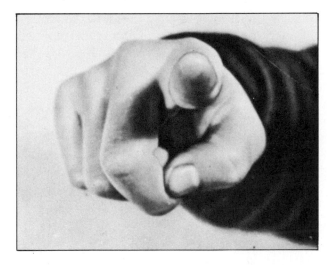

THE TWO-DIMENSIONAL BARRIER

Let us imagine the same hand reproduced both by an artist and a sculptor. The sculptor would mold the hand with complete realism, giving it body and volume. In physics we would say that the sculptor is working with the three dimensions existing in all bodies situated in space: height, width and depth.

The artist, on the other hand, must reproduce the hand on a flat surface, his paper or canvas, without actually being able to reproduce

the hand's depth. In order to achieve this, he would have to draw in all the subtleties of light and shade to create the illusion of relief. In physics terminology again, he would be described as working in two dimensions: height and width.

Now back to your own finger. You have no difficulty in recognizing its position, because you can see it coming straight out of your hand toward you, with the nail in the foreground. Despite its being completely foreshortened, your eye can, in fact, run over its entire length. At the right distance, your eye can see the three dimensions, height, width and depth.

But the artist works with only two dimensions, and he cannot reproduce bodies as he sees them in relief. He works on a flat surface on which the third dimension, depth, does not exist.

This is where the real difficulty begins for the student who finds himself in front of a model for the first time. Like you, he has been accustomed all his life to seeing in three dimensions. His eyes and his brain are so used to positioning the different parts of a given object at a different distance, that even when he looks with only one eye he continues to see in relief.

Therefore, when the student finds himself confronted with a model, he sees it in three dimensions, which he tries to transfer to his paper. Predictably, he finds himself completely at a loss, unable to reduce what he sees in three dimensions to only two.

Copying a drawing or photo is a straightforward matter because the problem of three dimensions does not arise. In a drawing the features are flat. There are no problems of foreshortening or depth. Everything can be measured in terms of height and width. It is simply a question of transferring these measurements with the correct interplay of light and shade to achieve the same results.

BREAKING DOWN THE BARRIERS

If we want to break down the foreshortening barrier and the two-dimensional barrier, we need to be able to see the subject without its third dimension. That is, we need to be able to see it as a flat object, totally without relief or depth. This involves a complete change of outlook on our part, the creation of a new habit.

Is this difficult? Well, yes and no. It depends on how much effort you are prepared to make. With time you will come to master and enjoy it, and it will become a habit. The more you draw from life, the sooner this will happen. But let me give you this word of warning. Start by choosing subjects in low relief and gradually progress to objects with more volume. Finally you will reach the stage when you are ready to tackle the real stumbling block, complete foreshortening.

Let me emphasize that point: start by choosing objects in low relief.

DRAWING FACES

Why do you think it is easier to draw a face in profile than full-face? Because of the two barriers we have been discussing. When you see your model full-face, the nose is completely foreshortened and we have to create its form simply by a variation of value. The same applies, though to a lesser extent, to the ears, the cheekbones, the temples and the hair.

The answer, then, is to start off by drawing faces in profile, working gradually to three-quarter views, semi-profile, and to full-face drawings.

During these early stages, while you are trying to acquire the habit of seeing things flat, always choose the aspect of the model with the least amount of foreshortening.

In addition, try to forget that the model has volume. Try and see it flat without its gradations of distance.

Finally, try and see it as an unknown body. For example, don't immediately think, "This is a nose." If you do, your habit of seeing in three dimensions will instinctively make you see it in three dimensions and all will be lost. Try to look at it as you would a piece of white paper. Think, "Here I have an area of value of this shape and this intensity. Here I have a slightly longer, lighter value..." and so on.

Think of it like this and it will be just like copying a photograph.

The exercise that follows will help you acquire this habit.

PRACTICE WITH FORESHORTENING

The best way of learning how to see objects without the third dimension is to practice on easy models. This illustration of a spoon, a glass, a plate and a box of aspirins is a simple and easily arranged still life that makes an excellent practical exercise.

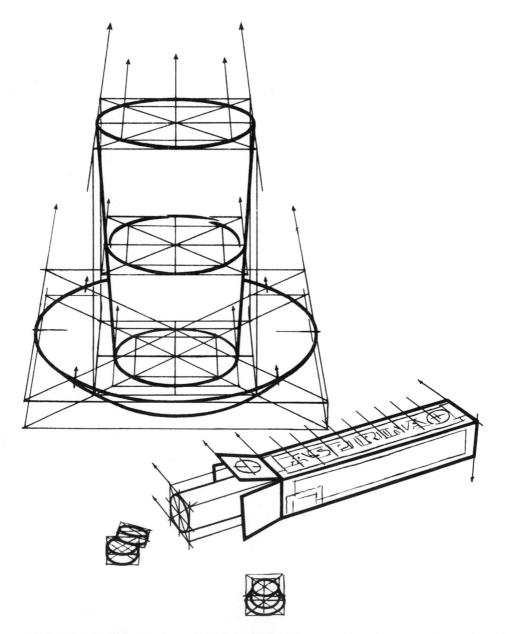

Constructing the skeleton of the drawing requires a knowledge of the rules of perspective as shown on the previous pages. In this drawing, study the direction of the shading and the rather casual execution. This drawing was done with a 2B pencil.

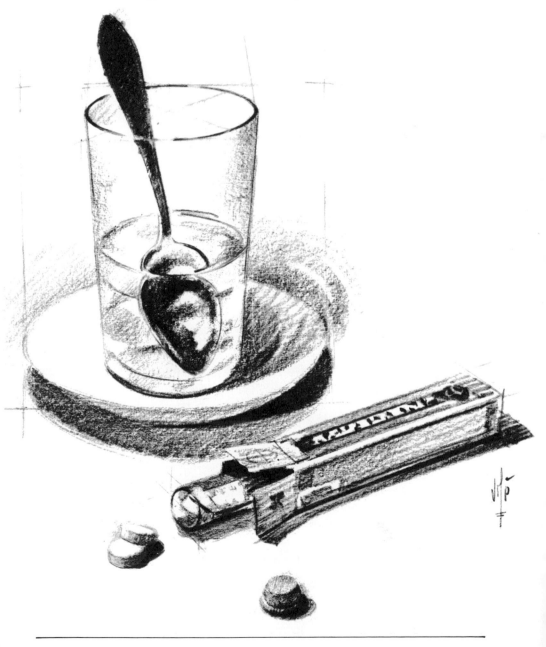

5 FROM THEORY TO PRACTICE

Different Boxes
Enclosing the Mass
The Modified Box
The Real Box

When learning to draw from nature, it is important to remember that the artist's whole task depends on a continuous process of observation and comparison. This is true both in the early stages of construction and boxing up, and in the later stages of evaluation and analysis of the interplay of light and shade.

The efficiency of this comparison depends largely on the position of the artist in relation to his subject. He must be able to see both his drawing and his subject simply by moving his eyes, if possible without moving his head.

Look at the illustrations on the next page. The first shows the drawing board in the wrong position. The artist has to raise his head in order to see the subject. The second illustration shows the drawing board in the correct position. The artist can see both the board and the subject without having to move his head.

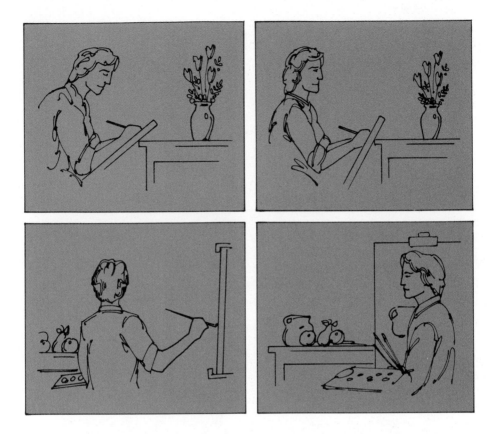

The third illustration shows an incorrect position when using an easel. The artist has to turn ninety degrees in order to see the subject. The correct position is shown in the fourth illustration where only a slight movement is required. Here he can draw and compare distances *with maximum output for minimum effort.*

DIFFERENT BOXES AND METHODS OF BOXING UP

There are three basic types of boxes.

The Flat or Two-Dimensional Box is based on a flat figure. As we shall see, it is a kind of all-purpose box.

The Block or Cube is useful for subjects in which perspective plays an important part.

Boxing Up Lines can be used both as additions to existing boxes and in their own right.

Artists usually work with the flat or two-dimensional box, which can be used with any kind of subject regardless of whether or not

perspective is involved. I shall, therefore, devote particular attention to the construction of this box although most of the rules for this box apply equally to the block or cube.

● The flat or two-dimensional box, right, is based on a flat figure and, as we shall see, is a kind of all-purpose box.

● Boxing up lines, lower right, can be used both as additions to existing boxes and in their own right.

● The block or cube, below, is useful for subjects in which perspective plays an important part.

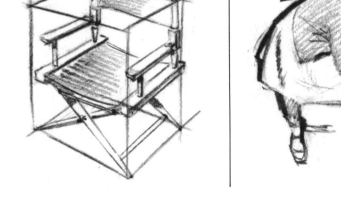

THE FLAT OR TWO-DIMENSIONAL BOX

The first step is to simplify the subject as much as possible so that the principal features can be reduced to a few outlines.

You may remember studying relief maps in high school that showed all the mountain ranges, rivers, cities and national borders. This is the kind of image that professional artists have in mind when they stand in front of their drawing board or canvas. They see the subject exactly as it is, in all its detail.

In your early years at elementry school, however, you may remember seeing simpler, more elementary maps in which the coastlines and frontiers were reduced to straight lines and islands were reproduced as little squares or circles. This is what we might call *the boxed version* of the relief map, a simplification of the subject.

How is this simplification achieved?

STAGE ONE: THE RECTANGULAR BOX

Every subject, however complicated, can be boxed up inside a square or a rectangle.

If this first rectangular box is perfect, it follows that the measurements and proportions it encloses will also be perfect. It is, therefore, important to calculate its measurements very carefully.

First, decide how much space the drawing will occupy and its position on the paper or canvas. This is a straightforward calculation, provided we start with a rectangular box.

The difficulty lies in determining the measurement and proportions of this initial box.

The answer is to try and visualize the subject in a kind of imaginary wire frame and consider and compare the height and width of this frame. This, of course, involves seeing the subject without its third dimension.

You know the rule already. Take a pencil, paintbrush or some other similar object in your hand and extend your arm fully so that you can measure one part of the subject, the total width, for example. Then compare this measurement with another, the height. This is how you determine the relationship between the width and the height. All you do is transfer this calculation to your paper.

This system of calculation is only an *aid* and should be treated as such. Do not place too much reliance on it because a slight movement while passing from one measurement to another—a contraction of your arm or a movement of your body or head—can alter the measurement.

You must also calculate by eye and visually compare each measurement with the others.

Practice this sight training as often as possible. Draw as many of these rectangular boxes as you can, sketching the outline of the subject inside them. Use the basic boxing up lines to check the accuracy of your rectangular box. Learn to do this by eye, without the help of the measuring pencil.

You should have no difficulty in finding subjects on which to practice. In your own home, for example, when one of your family sits or lies down, or bends over to do something, you can take a pencil and paper and draw rectangular boxes to enclose their shape, and practice calculating the relationship between the width and the height.

Why not begin right away by boxing up the subjects on the facing page, calculating the height and width of each box by eye? Then draw the subjects enclosed in the boxes to check the accuracy of your measurements. For now, don't worry if your drawings are not perfect.

ENCLOSING THE MASS

One common situation you'll find is a subject that consists of a *main mass* with incidental details around it. This may occur in the case of a figure with an arm outstretched or a house with a tall chimney.

In such cases it is obviously the main mass that must be boxed up. The rest of the subject can be excluded from the box. Any other procedure would make calculating the dimensions of the rectangular box so complicated you would lose the advantages of boxing.

The calculation of the dimensions of the parts of the subject outside the box is not a problem because, once the basic box enclosing the principal mass has been determined, the other calculations can be made from this.

This scheme will enable you to achieve, bit by bit, a box that gets tighter and tighter, thus increasing its usefulness. As your boxing up technique improves and becomes more professional, you will leave not only the obviously projecting forms outside the box, but also any slight depressions or indentations.

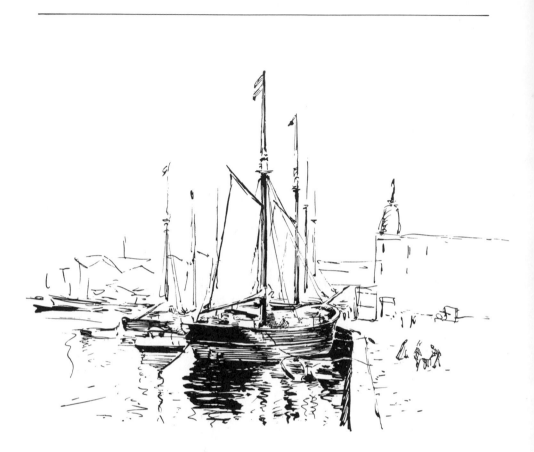

But don't do this until you have had plenty of practice. For the moment you should enclose the whole of the basic form, omitting parts that are obviously secondary. After a time you will achieve, almost unconsciously, a more systematic selection of the basic lines and forms of the subject.

STAGE TWO: FROM THE RECTANGULAR TO THE MODIFIED BOX

We have already drawn the rectangular box that encloses the basic subject very simply. We will now progress to a tighter, more precise scheme of boxing up with such forms as triangles and rectangles.

The professional artist frequently omits stage one and goes straight to stage two, the modified box. With his experience, he can

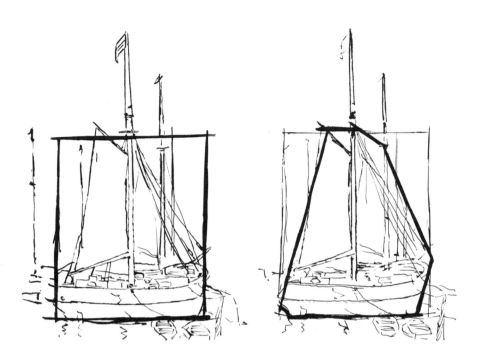

Stage One: The rectangular box Stage Two: The modified box

imagine the first rectangular box without having to draw it. In this case the subject lends itself to a more direct form of boxing up.

With practice, you will be able to tell which kind of box to start off with. I have discussed the rectangular box first because it logically precedes the modified box.

To develop a modified box for your subject, look for one really dominant line on which you can base a tighter box or boxes. This line may be curved or broken, but try to make it into a straight one.

Ignore any little details and irregularities. Try to simplify them as much as possible and achieve a single, straight line.

Use this line as the basis for all the others, however many boxes you may decide you need.

Getting the exact dimensions and proportions always requires care. If you want complete accuracy, you must stick to mental calculations, checking each distance with your measuring pencil.

Bear in mind that the new, tighter box must fit *inside* the rectangular box. This is where the control of dimensions mentioned earlier is important. If one of your tighter boxes does not fit into the earlier, carefully calculated rectangular box, then one of our calculations must be wrong. Some readjustment will obviously be necessary in order to give the correct dimensions and proportions.

Agreed? And does your box contain the same proportions as the model? Let's find out.

A FRESH REAPPRAISAL

We are not only going to appraise what we have done so far, but also erase it. Everything, that is, except those parts that will give us some reference to what we have already done. Then, we can build our drawing from a few lines that simplify the subject for us.

STAGE THREE: THE REAL BOX

We have finally arrived at the *real* box, the one that most closely follows the simplified outline of the model.

It is, of course, impossible to make hard and fast rules for each stage. Each subject has to be tackled according to its individual elements and you are the only one who can decide which course of action to take. There are, however, some rules that are always applicable and which are summed up on the next page.

GENERAL RULES FOR BOXING UP

Simplify the subject with broken lines. In some cases one of the dominant outlines of the model may be long and curved. If this is the case, it is best to study it carefully and draw that line first, adapting it as closely as possible to what you see in the subject. But usually the subject's outline will be made up of small angles and tiny curves. It is vitally important to simplify this form by ignoring these little curves. Try drawing broken lines over the outline to form the box.

Decide on basic outlines. When drawing broken lines, don't always stay outside the form, going along the outer surface. Go straight through any little bumps, just as if you were drawing that elementary map we mentioned earlier.

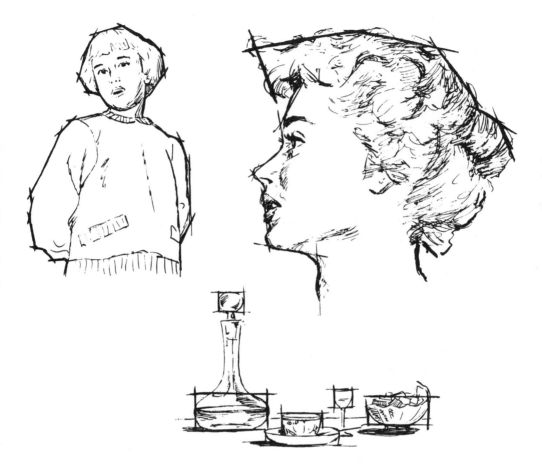

Circles begin in squares — ovals in rectangles or quadrilaterals. Beware of oversimplifying some subjects with broken lines. If the subject contains anything circular, it should be boxed up in a square, provided it is not too big.

Make sure the dimension of each line is correct. Don't think, like so many beginners, you'll correct it later. You can't build well on bad foundations. Sir Joshua Reynolds once told his pupils, "You will hardly paint very well if you pay no attention to the form while you are drawing, intending to construct your painting later with the brush."

It is essential to build properly from the very start. One line should support another and the dimensions of one form can provide a reference point for the construction of others. This, incidentally, is how you can keep a continuous check on what you have already done and control what you are about to do.

STAGE FOUR: BOXING UP THE FLAT OR TWO-DIMENSIONAL BOX

Now we are going to get *inside the box*.

An examination of almost any subject will reveal that it contains certain dominant lines. Many of these will be definite lines in the figure, for example an arm, the neckline of a woman's dress, a man's tie, and so on. Other dominant lines may be created by the interplay of light and shade. The edges of shaded areas often form excellent lines for boxing up. This is especially true of subjects containing strong contrasts of light and shade.

It is important to remember that our objective is to box up and therefore to simplify. There is nothing to be achieved by drawing these lines with complete precision. We should treat them in the same way as the ones we drew earlier, following the general rules for boxing up on pages 78 and 79.

The exact position of the boxing up lines is, of course, important. It is here that the *likeness* to the model begins to take shape. If you are working on a portrait, for instance, the position of the boxing up line corresponding to the chin could give you a longer or shorter face. If you are drawing a woman, the boxing up line determining breasts would also determine whether you would give the model a high or low bust. While it is possible to correct such errors at a later stage, perhaps when shading, it is infinitely preferable to do it now. It is like learning a song with a wrong note. Chances are that when you try to sing the song correctly, you will keep on getting it wrong.

THE FINAL STAGE: ANALYZING THE CONSTRUCTION

The end of the process is reached by constantly trying to make tighter boxes. By reboxing up and gradually *analyzing the construction* more deeply, we get closer to the final details.

This is the right moment when working on a face, for example, for positioning the eyes, nose and mouth. With a still life or landscape, it is the moment for putting in the non-structural lines.

In order to get a clearer understanding of the phrase *analyzing the construction*, let us assume that we are drawing a face. We might begin by recalling Ingres' advice: "The beginning must always be the expression of the end. Everything should be begun in such a way that it can be presented to the public at any stage, showing already that characteristic of 'likeness' that is to be perfected in the end."

This is easily understandable when you have been subjected to the discipline of an art school, seen how famous artists work and acquired your own experience.

It is advice of this caliber that makes nonsense of inept statements like, "Begin at the top and work downward." One teacher even proposed that his students do this "to avoid soiling the paper by rubbing your hand against the parts you have already drawn!"

The truly artistic drawing is the one that is *finished* at each stage in its development—as an initial sketch, at the outline stage, when it is almost complete and when it is actually finished. It should proceed as a whole, not in sections.

No professional artist will draw one particular feature, say an eye, and stay on it until he has completed it, tackling the whole drawing in this piecemeal fashion. This is the amateur approach. The professional will take the subject as a whole, so that it gradually evolves from one step to the next.

This, then, is what is meant by analyzing the construction. It does not mean completing one feature before moving on to the next. It means *drawing the outlines of the features in their correct positions and with accurate proportions.*

The boxes containing the eyes, mouth, nose and ears in a drawing of a face must all be in position and accurately proportioned so that, following Ingres' advice, the rough likeness can be seen even at this early stage.

Visual Process of Boxing Up Using A Two-Dimensional Box

Stage one: Enclose the model in a rectangular box leaving the less important parts outside.

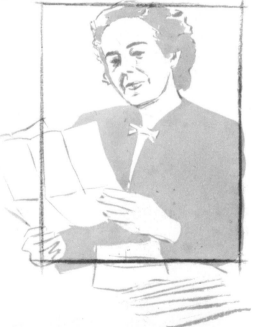

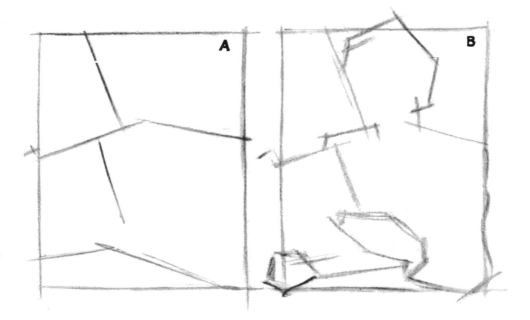

Stage two: To draw a modified box, we must look for one or more dominant lines in the model (A). Use these to construct the box (B), keeping rigid control over the dimensions and proportions (C and D).

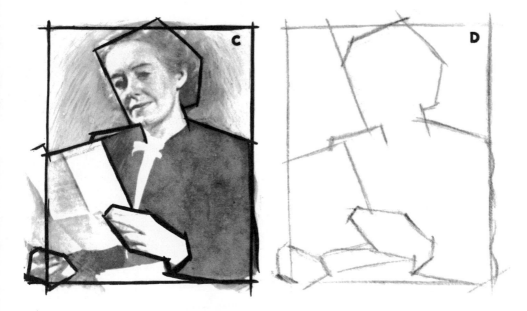

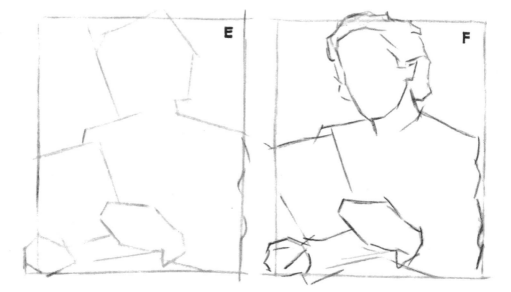

Stage three: Rub out the rectangular box (E) and start again with the real box, simplifying outlines with broken lines (F) going through any protruding features of the subject (G). Then study the exact dimensions of each line (H).

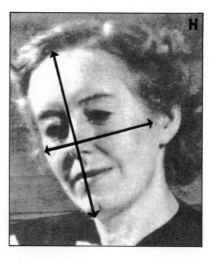

Stage four: Continue boxing up within the outline, positioning basic lines (I). Construct, in simplified form, the principal features and details (J) and finally add value (K).

SHADING AND BOXING UP

It is advisable, during the process of analyzing the construction, to begin shading—in some cases boxing up by means of shading.

Hold the pencil obliquely to the paper so that your strokes are as broad as possible and start shading. Do not attach too much importance at this stage to the exact size of the shaded areas nor to achieving just the right value—these details will follow.

This is another process of analysis. This time you are analyzing the interplay of light and shade. It is a question of seeing whole areas of light and shade, by reducing them to the smallest number of values—if possible, white, gray and black.

This does not, however, mean that your shading should be completely black. You should always shade lightly.

Find an area of shade where the average value is a medium gray. When you come to build up the shades definitively at a later stage, there will be room for intensification.

You can naturally heighten the value range within these areas by boxing up the values in the subject, but do this lightly and carefully.

Boxing up by means of shading enables us to start seeing volume. This gives us a greater understanding of the subject and consequently, helps us to achieve a more accurate construction.

THE MENTAL ATTITUDE OF THE ARTIST
WHILE BOXING UP

This is a subject I should like to touch on briefly before going on to the block or cube.

What is going on in the artist's mind while he is boxing up? Does he work quickly, slowly, lightheartedly or what?

It is a sobering thought that, after several days spent planning, consulting and experimenting, it has taken me four hours to write about a process which, in practice, lasts only about ten minutes or so.

This leads me on to the first prerequisite for successful boxing up and construction: *SPEED.*

It goes without saying that the professional must concentrate on what he is doing rather than how to do it. He has to draw with light, sure strokes and with considerable mental agility and manual speed and dexterity. This does not mean, as so many many amateurs seem to think, you have to behave like some kind of juggler. The professional is completely absorbed and carried away by his work. He works quickly but with precision, combining this speed with the second basic prerequisite: *MENTAL CALCULATION.*

As we have seen, the artist must be capable of continuous comparison of measurements and proportions. This must be a constant process, backward and forward from drawing to subject.

He must, as I have already said, be capable of shutting everything else out of his mind. Artists sometimes adopt strange poses and find themselves screwing up their faces in order to concentrate better. This is an aid to the third and last prerequisite: *SEE AND BE PART OF THE SUBJECT.*

This means embracing the whole subject with your gaze, and at the same time, seeing through it and around it. Ingres was right when he recommended to his pupils, "Draw at a distance from the model, making yourselves giants who can dominate and see everything." In everyday life we are not used to seeing things like this and we have to make a considerable effort to do so when drawing. While drawing one line, we must be able to visualize the others. We must see partial volumes and relate them to the total volume. We must continually compare the height and width of the parts we are drawing with the height and width of the whole.

If you follow my instructions, you will not go wrong. But remember these three basic points:

SPEED.

MENTAL CALCULATION.

SEE AND BE PART OF THE SUBJECT.

THE BLOCK OR CUBE

Whenever you come to draw something above or below eye level, you are confronted with perspective. With boxing up, you must use a cube or a rectangular cube. This occurs in the following cases:

With objects small enough to be placed on a table—jugs, glasses, jars, bottles, boxes, books and so on.

With all medium-sized objects standing on the ground, whose height is less than that of a human being—chairs and most other furniture, cars, carts, and so on.

With the human figure seen from above or below.

With bodies in general—including houses, buildings and monuments—whose shape is basically a cube or one of the basic geometric figures, such as a cylinder, cone or sphere, which derive from a cube.

On the other hand, a figure seen at eye level is not suitable for boxing up this way. Nor is a flower if it is above or below eye level, because its complex, uneven form will not easily fit into a cube. The same is true of stones, trees, rocks and other similar objects.

SEEING A CUBE IN ALL OBJECTS

Remember Cezanne's well-known formula, "The trick is to reduce the form of objects to that of a cube, cylinder or sphere." Remember, also, that the drawing of a cube, cylinder or sphere is bound up with drawing in perspective. By this stage, providing you have practiced all the exercises, you should have no difficulty in drawing a cube in perspective. All you need now is to be able to *see a cube in every object.*

You should be able to visualize the cube which, like a kind of glass case, encloses the object in question. The cube is a particular shape of rectangular block just as a square is a particular kind of rectangle. As you start with a square and proceed to other shapes, so you can start with a cube and arrive at a cylinder, cone or sphere.

These basic shapes are the source of an infinite variety of objects as can be seen on the opposite page.

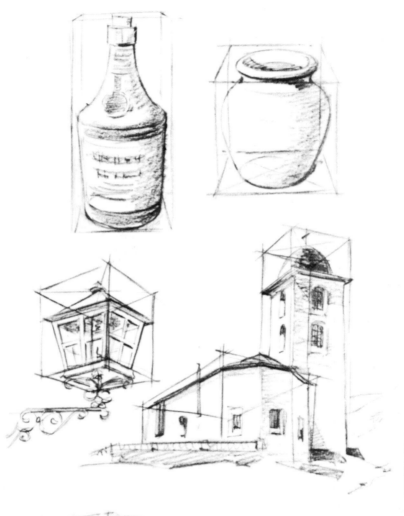

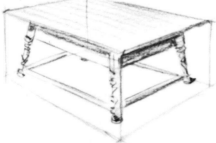

An almost unlimited number of objects, ranging from vases to buildings, consist basically of a simple cube or rectangular cube. As you can see, the cube is the basis for a variety of cylinders and spheres.

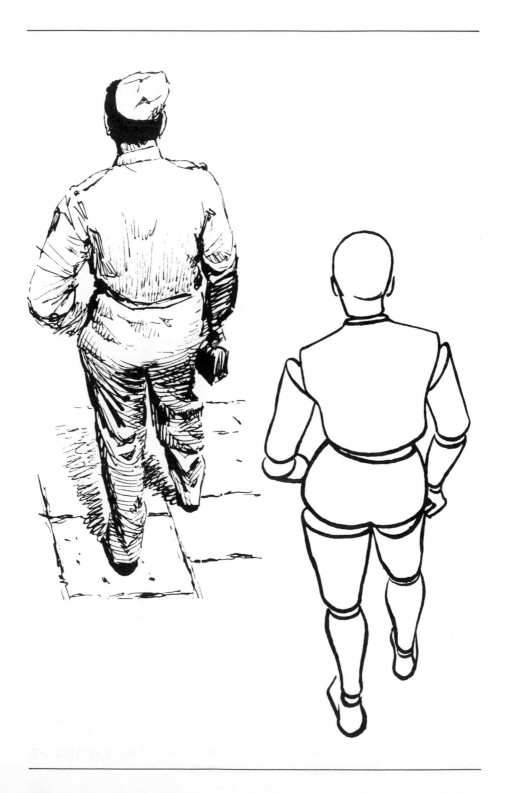

FIGURE DRAWING WITH THE BLOCK

Whenever the human figure is drawn from above or below eye level, perspective is involved and the cube or one of its derivatives should be used as the basic form.

Boxing up a series of cylinders and circles, and considering the whole human body as a series of *cylinders* as shown on the facing page, is also the best way of overcoming the problem of foreshortening.

THE GLASS CUBE RULE

When building up a drawing with a flat or two-dimensional box, or with a block or cube, you should apply the *glass cube* rule. That means you should construct the bodies *as though they were transparent.*

This applies not only to a single model, but also to groups of people, or a still life containing more than one object such as the interior of a room.

Above is a typical case — a still life with some objects half-hidden. In order to ensure the correct calculation of dimensions and proportions, all the objects must be drawn in full — both during boxing up and when drawing the objects themselves.

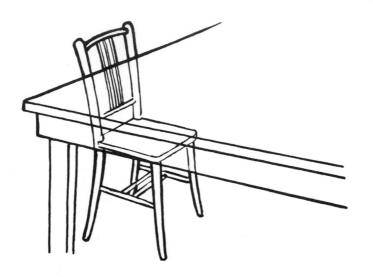

The only way to draw this chair correctly and realistically is to imagine that the table is transparent. Then draw both table and chair with absolute precision. The hidden parts of the chair can then be erased.

Even when drawing superimposed figures, it is best to draw those in the foreground as though they were transparent. This ensures perfect proportions for those in the background. A detailed drawing of the hidden parts may not be necessary. This depends on your experience. It *is* advisable to draw at least some lines of reference to ensure greater accuracy.

KNOW YOUR MODEL

"Know your model before drawing it."

This was the advice of the great French painter Delacroix, and it sums up the whole art of constructing and drawing.

This explains why Constable, for example, painted so many East Anglian landscapes; why Claude and Poussin tackled so many classical landscapes; why Murillo was called the painter of the Virgin; and why Dali has produced such a large number of daringly foreshortened religious figures. They all worked at their best when painting the subjects they knew best.

The great 18th-century painter George Stubbs is famous for his paintings of horses. I can imagine him standing in front of a horse and, in his mind's eye, looking beneath the flesh and studying the skeleton, thinking to himself "There is a tendon here, a muscle here," and so on. It is this kind of profound knowledge of the subject that produces the specialist painter in various fields. Some painters can tackle a variety of subjects with equal ease, but most tend to specialize. With time and practice, you will certainly feel drawn more toward some subjects than to others.

Meanwhile, as a general rule, try to really get to know the subject you are going to draw. Look at it not only from the position from which you are going to draw it, but from as many other angles as possible. Absorb its every feature. Try to discover how it is made and what it is made of. The American artist Lawson, who was a master of perspective and construction, used to say that before drawing a stool, you should lift it and try its weight. Study your subject as though you were going to make an identical copy.

The student who combines his love of drawing with an urge to know his subject thoroughly and completely can certainly become an accomplished artist.

__INDEX__

A Analyzing the construction, 80
Art teachers, 6

B Block, 88
Block or cube box, 71
Boxes, 39
Boxing up, 22, 23, 39, 51, 52, 59,
 60, 61, 62, 71-91
Breaking down the barriers, 66
Brushes, 13, 20

C Calculating dimensions, 23, 25, 40, 46, 47
Cezanne, Paul, 88
Chalk, 13
Charcoal, 11, 12, 13, 17
Charcoal paper, 17
Chiaroscuro, 11
Clay, 13
Colored pencil, 15
Composition, 6
Compressed charcoal, 17
Constable, John, 93
Conte crayons, 12, 13, 18
Copying, 63, 64, 66
Correct proportion, 31
Craft knife, 15, 21
Crayon, 11, 13, 18, 19
Cross-hatching, 11, 12
Cube, 39, 59, 88, 89
Cylinders, 91

D Dali, Salvador, 93
Delacroix, Eugene, 93
Depth, 9
Develop your drawing ability, 5
Dots, 12
Drawing a posed model, 42
Drawing board, 21, 70, 71
Drawing board clips, 21
Drawing faces, 67
Drawing from life, 60
Dry-brush drawing, 20
Dürer, Albrecht, 36

E Easel, 71
Enclosing the mass, 75
Erasers, 17, 20
Exercises, 29, 57, 58, 59, 68, 69

F Felt-tipped pens, 19
Figure drawing, 91
Fixative, 17, 18, 19, 20
Flat or two-dimensional box, 71, 72, 80
Foreshortening, 64, 65, 68

Form, 6, 10
Formal analysis, 6

G Glass cube rule, 91
Grades, 13, 14
Graphite, 13
Gum erasers, 21

H Hardness, 13, 14
Hatching, 11, 12
Highlights, 17
Horizon, 9, 58, 59

I India ink, 16
Ink, 16
Intuitive sense of proportion, 54

J Judgment by sight, 22

K Kneaded erasers, 21
Know your model, 93

L Lead, 13
Leonardo da Vinci, 5, 22
Light, 6, 52
Line, 6-8, 11, 12, 15-17, 30, 31
Line and emotion, 9
Line and space, 9

M Markers, 19, 21
Masonite, 21
Mass, 6, 10, 11, 52, 75
Masters, 6
Materials, 13
Matisse, Henri, 5
Measuring distances, 32
Mechanical pencil, 15
Mental attitude, 86
Michelangelo, 5
Modeled light, 11
Modified box, 76, 77
Moore, Henry, 5
Murillo, Bartolome Esteban, 93

N Negative shape, 10, 11
Nibs, 16

O Observation, 42
Oil pastels, 19
Optical illusions, 8

P Paper, 16, 21

Pastels, 19
Pen and ink, 13, 16, 21
Pencil, 11-15, 32-34
Perspective, 9, 58, 59, 88, 89
Picasso, Pablo, 5
Point, 15
Portraits, 42
Positive shape, 10, 11
Poussin, Nicolas, 93
Preliminary drawing, 48
Proportions, 31, 35, 53, 62, 63

R Real box, 78
Rectangular box, 73, 77
Rubber erasers, 21

S Sandpaper, 15
Sanguine, 18
Scaling, 35
Shade, 52
Shading, 11, 12, 17, 86
Shadow, 6
Shape, 10, 11
Sight training, 22-40
Simplified forms, 46, 47, 50
Sketchbook, 6, 21
Smudging, 12
Stippling, 11
Stubbs, George, 93

T Terms and materials, 5
Texture, 6, 11
Theory to practice, 70
Titian, 56
Tone, 10, 11, 14
Tooth, 21
Treatise On Painting, 22
Two-dimensional barrier, 65

V Value, 11
Vanishing point, 9
Vine charcoal, 17
Vinyl erasers, 21

W Wash, 12
Wash drawing, 20
White paper barrier, 22, 29
Whites, 17

HOW TO let your parents RAISE A MILLIONAIRE

let your parents HOW TO RAISE A MILLIONAIRE

A Kid-to-Kid View on How to Make Money, Make a Difference and Have Fun Doing Both!

Jack James

Illustrated by Kevin Coffey

New York

HOW TO *let your parents* RAISE A MILLIONAIRE
A Kid-to-Kid View on How to Make Money,
Make a Difference and Have Fun Doing Both!

ISBN 978-1-61448-248-2 paperback
ISBN 978-1-61448-249-9 eBook
Library of Congress Control Number: 2012932229

Morgan James Publishing
The Entrepreneurial Publisher
5 Penn Plaza, 23rd Floor,
New York City, New York 10001
(212) 655-5470 office • (516) 908-4496 fax
www.MorganJamesPublishing.com

Illustrations by:
Kevin Coffey
Cover Design by:
Rachel Lopez
www.r2cdesign.com
Interior Design by:
Bonnie Bushman
bonnie@caboodlegraphics.com

In an effort to support local communities, raise awareness and funds, Morgan James Publishing donates a percentage of all book sales for the life of each book to Habitat for Humanity Peninsula and Greater Williamsburg.

Get involved today, visit
www.MorganJamesBuilds.com.

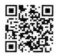

Dedication

To all my school friends from:
Milpitas Christian Pre-school
Noble Elementary
San Jose Christian School

And my fellow Scouts

Table of Contents

ix		Foreword
xi		Introduction
1	*Chapter 1*	You have to know me before you can hear me
15	*Chapter 2*	Bully Bully go away… No one needs to hear what you have to say
23	*Chapter 3*	Starting Your Own Business
29	*Chapter 4*	Deciding the First Three Things
39	*Chapter 5*	Getting the Word Out
53	*Chapter 6*	Doing the Job
61	*Chapter 7*	Being Paid and Getting Referrals
67	*Chapter 8*	Getting New Customers
73	*Chapter 9*	Doing Something for Others
79	*Chapter 10*	The Big Warnings
85	*Chapter 11*	Been there, know how it feels
89		Conclusion
91		My Personal Mission
93		Photo Gallery

Foreword

This is a wonderful book, written by Jack James, a remarkable young man. It is a pleasure to be able to write this foreword.

Perhaps the most important gift you can give your child, aside from unconditional love and approval, is financial literacy. This book shows you how to do it.

Throughout your child's life, he/she will have to earn money, spend money, conserve money and solve money problems. The ability to go into any marketplace or economic situation and earn good money will have a profound effect on his/her life.

I have personally started, built, managed or turned around 22 businesses. I have made more than a million dollars in ten different businesses, and taught key business ideas to more than 10,000 business owners.

In Jack's book, you learn how to help your child to develop a "prosperity consciousness" and to see himself/herself as the master of his/her financial destiny.

Even if you have not yet prepared your child to be financially smart and achieve financial independence, you can learn and pass these ideas along to him/her.

let your parents

Only 5% of people who start work today will end up financially successful. When you read and teach the principles in this book to your child, you will dramatically, increase the likelihood that he/she will be among that 5%.

Good luck to you!
Brian Tracy
Solana Beach, CA

Introduction

My name is Jack James. When I was ten years old, my mom helped me start a business. I am twelve now, and I wanted to write a book to tell other kids about starting their own business.

Even if you think you can't do this, I want you to believe you can because I *know* you can!

I call my business Jack's Garbage Valet. I take my neighbors' garbage cans out the day before garbage day and take them back after the garbage man comes. If you listen to your parents and start a business, first you will decide what business you want to start. You will want to come up with a good name for your business, and then you'll start working

on getting the word out. I will talk to you more about this in Chapter 3.

One of the hardest parts to having your own business is selling it to your neighbors.

My business, Jack's Garbage Valet, is a small company. I take my neighbors' garbage cans in and out for $10 a month.

That is my introduction, or "sales pitch." If you are like I was before I started my business, you don't feel very comfortable talking to adults.

Say, isn't that Jack, the Garbage Valet?

Once you get your sale pitch down and do it a few times, you'll be wonderful and make a lot of new friends. I say it to everyone I meet in my neighborhood, because they may be my client one day. We'll talk more about sales pitches in Chapter 3 too.

In my book, I talk about all the things it takes to run a business, and from reading this book, you'll see it is not such a hard thing—and it is really fun. I'll show you what I did to get the word out about my business. I'll tell you how I work with my customers, how I get new business, and how to ask for payment. I'll also tell you what I did after I had my business going for a while. Once you have your business going and your customers begin to trust you, you can ask for other work around their house. This is how I make extra money.

Any kid can start a business on their own. My mom helped me start my business. My mom asked me for a while before I let her help me. Don't do what I did—learn from my mistake. Start right away if your parents ask—or better yet—*ask* your parents to help you start a business.

You won't be sorry. Having your own business is great. Besides, if your parents are reading my mom's book, she is going to tell your parents to nag you until you agree, so make it easy on yourself and say yes! You won't be sorry you did.

My favorite chapter in my book is Chapter 10. Before she wrote her book, my mom came to me and asked if it was OK if she told other parents a few of the things she has done with me. I said, "Yes," but I also wrote a chapter to counter some of what she wrote in her book. In Chapter 10, I wrote some things for you to read to warn you about what is coming your way. My mom can get kind of creative, so be sure to read that chapter and follow the Boy Scout motto: Be Prepared!

I also wrote a couple of chapters about my personal challenges in life. I have been bullied and I have Dyslexia. I wrote a chapter about each.

The reason I did a chapter about being bullied was so I could help other kids like me. I wanted parents to know

how their kids feel, and I wanted kids who have been bullied to know they are not alone and can survive it. Surprisingly enough, I also wanted to let the bullies of the world know what it is like to be bullied. Bullying someone is a choice. Bullies don't *have* to bully. It does not matter what drives someone to bully another person, it is wrong. There are other ways to solve problems. Maybe they think it is cool. Maybe they think it makes them better than others. Maybe—just maybe—they are hurting inside too, and making someone else hurt makes them feel stronger. I don't know why and I don't care. I hope my book will help bullies see what it is like on the other side.

Maybe if they know what it is like, they will look for another way, ask for help, or do something to build their

own self confidence so they don't have to tear down others to feel good.

The reason I wrote a chapter about Dyslexia is kind of like the bully chapter. I wanted other kids out there with learning problems like mine to know they are not alone. I am lucky. My mom and my Uncle Buck have Dyslexia too. They know how I feel. They also know I can learn to deal with my Dyslexia and be a success in life. Having a learning problem does not mean you are dumb. It means you have to work harder. It does not seem fair and it is not very fun at all, but it is the way it is. The truth is, you can either deal with it and win, or you can wallow in it and lose. I want to win. How about you?

I hope you like this book. I hope you read it and are inspired to start your own business. We might be kids, but we can change the world.

Chapter 1

You have to know me before you can hear me

*Y*ou know what, I am writing this book for you, and I would like to tell you who I am before you embark on your huge journey that will take you places you never have dreamed of.

I want to tell you a few things about myself. If I do, then you'll realize I am just like you. I am a normal kid. If I can do this, so can you!

I was born in Los Gatos Community Hospital on April 26, 1999. I don't remember it, but my mom and dad have told me stories about it. For instance, my mom told me this story. When I was born, my doctor, Dr. Hughes, said immediately when I was born, "It's a boy and he has RED HAIR!" She was right. I have red hair and for many people, that is the first thing they realize about me. My mom had red hair just like mine when she was growing up and she was teased about it. Nowadays, people want my color of hair. So I am lucky, that is one thing I have not been teased about, or at least I don't think I have.

The first person who came to visit me in the hospital, besides my father, was my Uncle Buck. He is a loving, crazy man and I adore him.

My mom and dad told me they held me like I was a crystal glass that would break if it was touched. They were afraid I would get hurt easily. Which was right in some

regards, but when my Uncle Buck got ahold of me, he was holding me like a pro. He was holding me and flipping me around like a flapjack, giving me kisses, and loving me like I was his son. I guess that is where some of his craziness rubbed off on me.

My mom and dad told me when they saw how Uncle Buck was holding me, they started to relax because they realized I was not a fragile crystal glass and was not going to break.

I grew up just like a normal kid.

I had two cats and two dogs. Bug, our oldest dog, thought I was her baby. She always protected me as if I was a little member of the pack. As a little kid I started to like trains. I was very into Thomas the Tank Engine and steam locomotives. I also liked Sesame Street and Zaboomafoo with the Kratt Brothers. I also really loved the Koala Brothers. I went to Milpitas Christian Pre-School when I was three. I made a lot of friends at that school. My best friend was David. We loved

to hang out together. We did lots of fun thing with his mom, dad, and his brother Jonathan. I also met my friend Randy. Randy and I were also in Cub Scouts together and went to the same school after preschool. He is one of my oldest friends.

After Milpitas Christian School, I went to Noble Elementary School. Randy, Kaitlin and I all went to the same class, from Milpitas Christian School. It was nice to have friends in my new school. My kindergarten teacher was Mrs. Wilbanks. She was a very nice teacher; she was a little stern when needed, but she was terrific. She did this very special thing when you had a birthday. She really made a big deal out of it. I was in her first kindergarten class. I was in a program called Alternative, which meant we got to do extra stuff and our parents helped in class. My Mom always taught art class.

I was at Noble School until I was going into the third grade. In second grade I was having trouble reading, my parents decided to move me to a different school because they thought it would help me. I won't say the name of the school because that would not be right. I'll just tell you what happened.

Just before the end of second grade, I went to the new school for a shadow day. That means you try out the school before you are positively sure you want to go to it. The shadow day was great. I did work and all the students were nice to me. So, I got into the class and the school. When I started school, about two weeks into it I started getting bullied. The bullying started slowly, but escalated effectively—at least, for them.

At first they were just saying bad things. Let's clarify. Not everybody was bad. In fact, one of the students, Ethan, became

a very good friend and a very good guy who would actually tell me if he overheard something from one of the bullies. It was mostly done by six boys. There were other new students, but the boys seemed to like to pick on me best. Like I said, it started out with kids just saying mean things, and then it went to saying very nasty things. I am not a wimp; I can handle the nasty things being said to me, because I know not to let those things get me. I originally thought it would not get much worse...but saying nasty things to me was just an appetizer.

Soon they started threatening me. There was one kid who kept threatening to poke me with a pencil. Each time I would say, "OK do it, but you are going to get in trouble." This stopped him for quite a while, but then he actually did it! The thing that amazed me the most was it was right in front of the teacher. He actually jabbed me in the arm—right in front of the teacher! I cried out, "Ow!" He and I were the only two kids in the room. He was holding a blue pencil in his hand. It was pretty obvious to anyone what had happened. He held the pencil in his hand like a spear, as if he was going to jab me again. I even remember the lead had broken and it made a really sharp end. The thing that amazed me most of all was the teacher was sitting directly behind us at her desk. He usually threatened when she was not in the room— now he did it when she was sitting five feet behind us. The second thing that amazed me was she barely did anything about it. She heard the "Ow," she looked up, and she saw me holding my arm where he had stabbed me. I told her what had happened. I don't remember if he denied what I said, or if he took credit for his deed. She just said "Do not do that again,

that is not nice." Yada yada yada.... and two seconds later, it was as if she never heard a peep out of anybody. When he stabbed me it punctured my skin, for heaven's sake! One of the funny things was 95% of the time you see me wearing a long sleeved shirt. That day I decided to wear a short sleeved shirt. Dang Murphy's Law!

The good news about all this was that while those six boys were teasing and bullying me, I was becoming friends with the other kids in the class. By the end of it all, the other kids were good friends. A couple of them even tried to protect me. I really appreciated that kindness. The first one to take the step was Emma. Liza was another very good friend.

By spring, the girls were all playing with Ethan and me. I had told my mom and dad about the bullying and they quickly took action. They talked to the teacher and the director of the school, but the bullying kept escalating.

It kept getting worse. We moved seats every two months or so, and the next thing I knew one of the worst bullies was sitting directly behind me in class. He kept saying stuff to me in class about how he was going to run me over with a car. I tried to ignore it, but it was getting too hard. He started to interrupt my school work. He was saying snide remarks all during class and the teacher did nothing. I guess she didn't hear it. There were a few times when she was almost next to us and I could not believe she didn't hear him. I think she did at least once. I finally told my mom and dad and they told me to tell the teacher when he was bothering me. So I did the very first chance I got, and the teacher did the same thing to him she had done to the pencil poker. "Do

not do that again, it is not nice." Yada Yada Yada. The kid didn't care.

It was hard to understand the teacher's reaction when it came to the pencil poker; I mean, the kid actually hurt me. I could kind of understand it for just words, but I could see that no matter what the bullies would do to me, the only thing she was going to do was say, "Do not do that again, it is not nice." Yada Yada Yada. That kind of wimpy reaction does not give a kid being bullied a whole lot of confidence in their teacher.

He kept bothering me in class and I had a hard time concentrating on my school work. My mom and dad met with the teacher and the director again. The teacher told my mom and dad to talk to the parents of the kids who were bullying me. Dad talked to the mom of the kid who was threatening me in class. He told her what the kid was saying and she told my Dad, "I can't control him at home, how do you expect me to control him in school?"

After they pulled me out of the school, my mom started homeschooling me. It was very fun. At first we were getting the hang of things, but soon we were doing wonderful. We had a name for our school. It was called Home Sweet Home Academy (HSH Academy). We did a curriculum that included the software program I used to help write this book. I studied a lot of cool subjects. We studied history, math, grammar, language arts, science and more. Science was my favorite subject. We even bought a microscope so I could examine things.

We also did science classes with a homeschool program. There were lots of kids. I took four classes in all with that group:

- Animal Studies
- Oceanography
- Cause and Effect
- Gear Systems

For oceanography, we got to *dissect* a shark. It was very cool.

The next week, we dissected a squid. I got to write with the ink from its ink sac.

At times, homeschooling was lonely. I don't have brothers or sisters like most kids in the world, so I didn't have anyone to play with, except my two dogs. I told my mom about being lonely and she worked at making it so we did things with other people more often. We joined a homeschool play group; that was fun. I was also doing Cub Scouting once a week so I did get to see people, I just missed being in a class room with other kids.

Now down to business. My Mom had been nagging me to start my own business for perhaps a year. Finally, after the sixty millionth time, I said "Yes." Mom didn't waste time—as if aliens were coming—she sprang into action.

OK, MOM – LET'S START THAT BUSINESS!

First, we talked about what business I was going to start. I agreed to start *Jack's Garbage Valet*. Then we went into her office and made up a flyer. She printed out a million of them,

and we went out into the neighborhood and started to hand them out. She had me practice a big spiel I should do if I saw someone. The spiel was hard to do at first, but I got used to it and it was actually fun. Meeting my neighbors was fun, but I have to be honest, the most fun was when I got my first customer. I was on one of the streets near my house and I saw a lady taking her garbage cans in and I said,

> "Hi, my name is Jack James. I am your neighbor; I live on XYZ Street. My business name is Jack's Garbage Valet. I take your garbage cans in and out for $5 a month. Would you like me to take your cans out?"

When she said "Yes," I was so happy. I had my first customer! We will talk more about this in the chapters to come.

We were going along just fine and all of a sudden one day, Dad told Mom he wanted a divorce. I felt terrible. I didn't know what to do; I was scared. I had been with my dad for my entire life. I didn't know what was going to happen. I had friends whose parents were divorced, but I didn't think my parents would ever get divorced. I felt horrible.

My dad moved out and Mom and I stayed at our house. We started to put our lives back together.

I don't really like talking about this, but if my writing this helps other kids it is worth it. Sometimes it really helps to know other kids who are in the same situation feel the same way. Sometimes is helps to know you are not alone.

After the divorce, my mom and dad decided to put me back into a regular school. I got into a great school called San Jose Christian School. It is the best school I have ever been to in my life, which is only twelve years, but I have been to a few schools, so it qualifies. My teacher was very nice and the kids were very kind to me. I am still with the same kids now and it feels like a big community.

My mom decided to write her book, and it was while she was writing her book that she got the idea for me to write one too.

At first, I didn't believe her. I didn't know if it was a good idea or not. It felt right—it really did—but since you are holding this book in your hand, you already know the answer.

I did write it and I feel wonderful about it. I can't wait to find out what the future holds for me.

Chapter 2

Bully Bully go away...
No one needs to hear
what you have to say

I n Chapter 1 I told you about how I was bullied, I told you a little about my life in several schools, but in this chapter, I want to talk to you specifically about the school where I was bullied. I want to talk you about this for two reasons. First, if there are other people out there being bullied, I hope this chapter will help you a lot. You are not alone. There are lots of kids in the world that are bullied. There are several degrees of bullying. You don't have to get beat up; you don't have to be abused. To be bullied, you are—at the very least—made fun of and the person who is doing the name calling—or even worse—is the bully. Don't mistake that person for anybody else. Don't become paranoid like I did and hit your best friend because I thought he was one of the bullies shoving me. Stop and think, turn around, and look before you strike.☺

That is one side of the coin. The other reason I am writing this chapter is for the bullies out there. I want them to understand what it feels like to be bullied. I want bullies to realize what

they are doing is wrong. I want them to understand we are all people; we should never treat each other like punching bags.

I told you my bullying started in my new third grade class. I was one of four new kids in the class. Being new in school is hard. It takes a long time to get to know people and for them to get to know you. Teasing is just a part of daily life. Most of the time it is just meant to be fun and to have you be part of the group.

Bullying is when they put angry intent into the teasing. If you are just being teased and you are teasing back, it is not bullying. If you are mutually just teasing each other it can be for fun; but if you are teasing with mean influences and desire, that is bullying. You can call it anything you want, but if it is meant to really hurt someone, the real word for it is bullying.

Let's talk about how bullying works. It's pretty simply, really. The person starts teasing someone with a rude intention. The victim gets used to the bullying, so the bully has to do

something worse to get their kicks. It just keeps on escalating from there. The thing about a bully is that making someone else feel bad makes them feel like they are powerful. Maybe they don't have power someplace else in their life. Maybe at first they don't realize what they are doing. But because the victim gets used to it, they just have to get meaner. I mean, let's face it: the bully has to keep working at being mean or it looks like the bullying they did in the first place is wrong. None of us like to be wrong, so they keep bullying, and pretty soon they don't know how to stop.

Bullying is like a steam train. The steam has to build up before the train can start moving. The engineer has to keep shoveling coal into the engine to really get the steam built up so the train can really start to move faster. The faster you want the train to go, the more coal you have to shovel into the fire so you can build up the steam. You have to keep the engine full of coal to keep the train going.

Just like the engineer has to keep shoveling the coal, the bully has to keep the bullying going, so they go from just mean words to angry hitting—physical stuff. That why it is so important for parents and teachers to know what the kids are going through, and to stop it before it escalates too far. Many parents and teachers don't know what it is like to be bullied. Maybe they remember what it was like when they were kids, but bullying has escalated through the years. The more places to bully someone, the more the bullying escalates. Look at how many kids are bullied on-line these days. I mean, computers are supposed to be fun. They can be a great place to learn stuff, but they can be a great place for bullies to hide too. Think about it: most bullies don't speak up in class. They don't bully in front of an adult because most adults will tell them to knock it off. They say stuff behind an adult's back. Bullying on-line is like saying stuff behind an adult's back. Bullies get real gutsy on-line.

If you are bullied yourself, then you know it just feels bad. It makes you feel like a piece of dirt, in a way. You start

to think you don't really matter. It is really hard to talk about this, but I am doing it because I hope if someone who reads this is being bullied they will know they are not alone. They will know that someone else knows exactly how they feel, and maybe it will help them. If my being honest and saying how it really feels helps someone, then it will be a really good thing.

The feeling bad about yourself does not happen instantly. The truth is, it happens over time. If your bully is at school, you know you are bound to see them every day. It makes going to school feel like going to Hell. I don't really want to swear in my book, but it does feel that way. It is important for parents to understand how hard it is for their kids who are bullied. If you are being bullied too, show your parents this chapter. Let them read it from me; I'll tell them how it feels and all you have to say is, "Yep, Jack is right. That is just how it feels." Then I will be the one who swears—not you!☺

The thing is, you act like a duck at first. You let it roll off your back, but then the bully sees it is not working, so they get more advanced. Now you are starting to expect it, so every time they say something to you, you are waiting for the bullying. The truth is, sometimes they are not bullying; sometimes they are not even *talking* to you. After awhile, you start to get paranoid and everything seems like bullying. That is why I say, look before you hit.

I had very low self-esteem after I got out of that school. I was homeschooled after, so I was not really connected with my friends very much. I didn't believe what the bullies said about me, but it really got to me. It made me feel really bad about myself. Just because my parents pulled me out of the

school, I was not just automatically un-bullied and happy. I still felt like someone was beating on me with a hammer. It is important for me to write this because parents think it should just be over, but it isn't. If you have been bullied, you know what it feels like, and it is important that you know others out there know how you feel. I know I am repeating myself, but I really want you to know you are not alone.

Here is the hard fact: you have to overcome this stuff. You can't live with your self-esteem gone. You have to get it back somehow. If you don't do something to overcome being bullied, you let the bullies win. I didn't want my bullies to win, so here is what I did.

When I started my own business, it brought my self-esteem back up—actually better than it used to be. It made me feel better about myself because I became an expert on something. Not a lot of kids have a business. It is actually very unusual to

find. You don't hear it every day, and that makes it special. My self-esteem did not immediately come back when I started my business; in fact, my old self-esteem didn't come back at all. Instead, I found *new* self-esteem. It was even better!

I want to talk a little about how important it is to inform your parents you are being bullied. The earlier you tell your parents, the better. You can't tell them if it is not actually bullying, so be careful. Just be sure they are bullies.

One of the most important things is to remember to stay positive. Bullies don't last forever. They will eventually move on, and if you do everything you can to stop being their target, hopefully they will move on faster.

For all the bullies out there:

What the heck are you doing?

When you treat someone badly, you are not bringing your own self-esteem up. When you are feeding off of another's self-esteem, you are just chewing it up and spitting it out. It is not making you look better at all. I'll bet you are bullying because it makes other feel the way you do about yourself—bad. How about trying it a different way? How about finding a way to feel good about yourself? Why not try out being nice? You would be surprised how people will react. You'll be surprised at how powerful you will feel if you spend your energy on making others feel good instead of making others feel bad. Give it a try!

In the past three years, I have really learned how to stand up to bullies. It is actually pretty easy, once you figure it out.

let your parents

What I have not been able to figure out is how to help them stop being a bully. I wish I could. I wish there was a school for that, or a magic way to wave a wand and make them feel better about themselves so they would just be better people. After all, that is part of why I am writing this book.

Chapter 3

Starting Your Own Business

Starting your own business is simple. It does not take long to get started, and it's fun. You'll learn self-confidence without arrogance, get to know your neighbors, and—most importantly—earn money! I didn't realize how much fun I would have owning my own business. Like I said before, not a whole bunch of kids have one—especially today. Kids used to deliver newspapers; now adults do that. Kids used to mow lawns; now adults do that. A lot of parents hover over their kids, like a helicopter.

let your parents

They think the world is scary and unsafe, so they don't let their kids do anything five feet away from them. It is like they want to tie their kids down or keep them safe in a little bubble. The problem is, this is not how it should be. Kids need to do things to be able to be successful in life. Kids need to be able to learn. So, if you are lucky enough to have parents who want you to start a business, jump on it.

You might not think there are very many fun things about running a business—most kids think that way—but you are not most kids: you are reading this book.

Many kids think it would be boring and think only their parents can run a business. The truth is, you get to meet new people and make friends. You are doing something worthwhile, and you are doing something that many kids aren't doing. When I started my business, I didn't know many of my neighbors. Most people in my neighborhood are busy and don't spend time together. I had to get out and meet people to get clients. I had to learn new things;

my mom taught me how to run a business, and that was something I was not learning in school. And like I have said before, not many kids get to do this, so it is just fun to do something special.

Learning self-confidence is a key part of any business; you need to show you are confident in yourself and about your job. Your clients are going to give you money for your services, and they expect 100% in return. Even though you are a kid, you are still a person who can run a successful business.

At first, it is hard. You have to learn how to give your sales pitch to your potential customers. Let's face it, this business will be brand new and you have not been doing it a long time. It can be scary to talk to adults sometimes, there are all kinds of reasons it is hard. The important thing is to act as if you have been doing it for years. The way to get confidence is to be confident. Believe in yourself, and others will believe in you too.

One of the great things about running your own business is you earn money! You need to be successful and confident

let your parents

about earning money. When a client paid for my services the first time, it was a very cool feeling. It is not all about the money, but let's be honest: we need money to live. When you have money, you can help others who don't. When we are older, we will need money to buy a house. We will need money to buy food. We will need money for our families. It is important we learn how to make money no matter what the economy is. Parents believe kids don't think about this stuff, but the truth is we do. We hear the news. We hear our parents. We hear other adults talking. We know what the economy is. What starting my business taught me is that I do have control over what I do. People spend money, even in a bad economy, so what you need to do is figure out what they will spend money on and start a business so you can sell them *that* thing. It is actually pretty powerful, when you think about it. Once you figure out how to make money, you can save money.

I opened a savings account and got my own share of interest (money the bank gives you so they can use your money). You don't get a large amount of interest, but you are still making money from your money. The more money you make and put in the bank, the more interest you'll get. I also got my own automated teller machine (ATM) card. That was pretty nice. I don't say this to show off, it is not a thing to show off about; my ATM card gives me the ability to check my account on the computer.

As kids, we all know the world will be full of choices. When you start your own business, you'll gain self-confidence. I don't mean it is anything to get arrogant about, it is just true. You start to realize you can really do cool stuff. You begin to believe in yourself. More thoughts will come into your brain, and you'll realize you can make your dreams come true. After I started my business, my mom encouraged me to write down my goals. At first I thought it was kind of a crazy idea. I mean, I had never thought about writing my goals down before. I am a kid, right? But really it is the best idea. I have written down my goals and I am working to make them come true.

Having my goals on paper and out in the world has made me feel like I have already completed them. It is kind of funny, I know they are not done, but working on them makes me know inside they really will happen. Like this book: at first, I didn't think it was a really good idea, but you can tell I changed my mind. I started to believe in it, and that helped me make it come true.

When you decide to start a business, a whole bunch of good things will start to happen in your life and, believe it or not, you'll have fun along the way! In the next few chapters of this book, I am going to tell you what I did to start my business. You don't have to do exactly what I did. I am telling you about it so it will inspire you to get started.

Let's go on to Chapter 4.

Chapter 4

Deciding the First Three Things

*G*etting started is easier than you might think. It is really very simple. You need to do three things before you try to get customers:

1. Decide what business you want to start
2. Choose who your clients will be
3. Figure out how much you want to charge for your services

If you look at all the businesses you can start, there are some good ones and there are some bad ones. Why they are

let your parents

good or bad might not be obvious. Here is what I mean. When you start your own business, think about how often your customers will need you. This is really important because you need to pick a product or service people need on a regular basis. What I mean is you want your main business to be something you get to do all the time.

For example, I like dogs, so at first I thought about starting a dog care business. I love to take care of my dogs. I love to walk them, feed them, and play with them. I thought a dog sitting business would be a great idea. I figured my neighbors would really like it and it would be a good business. But people only need dog service when they have a dog. Even more, they only need help with their dog when they are on vacation or can't take care of the dog themselves. That would have meant I could only sell my main business to my neighbors that had dogs.

On the other hand, the garbage man comes every week. If you start a business with a service that your neighbor needs every day or week, it is called a "cash machine". It is called a cash machine because it makes cash for your business on a

regular basis. It might not be as glamorous as dog sitting, but your clients will pay you more often. The important thing is to think of a main business that pays you every week.

The idea of a dog sitting business is also good idea if you want to make some extra money. Once your customers get to know you because you are doing something for them every week, they will start to trust you. They will know you are reliable. Then they will start asking you to do other stuff for them, like dog sitting or taking in their mail when they are on vacation. A lemonade stand is OK too, but it is not a regular income because not everybody wants lemonade every day. It is another great way to make extra money in your business, but it should not be your main business.

Here are some suggestions for businesses you could start (beyond the lemonade stand):

> **Garbage Valet:** Take your neighbors' garbage cans out the day before pickup and then in after pickup. This is my favorite and my main business. I am doing it as we speak!
>
> **Lawn Care:** Mow your neighbors' grass.

Even though there are a lot of adults who do this for a living, some of your neighbors might really like paying a kid to do this. Some of them might have even had a business mowing lawns as a kid, and they would probably love to pay another kid and help them get a start in business, just like they did.

Pet Valet: There is just no elegant way to say this one: Pick up your neighbors' dog poop. Poop isn't pretty, but cleaning up after a dog is one of those things that has to happen. Your neighbor might love having someone do this for them.

Pet-Walking Service: Take your neighbors' pets for a walk. This is a great job for kids who live in the inner city. It is also a great job if you live in a neighborhood with elderly people. They might

not be able to walk their dogs anymore, and they might really like having someone who is willing to help them out.

Grocery Valet: Carry your neighbors' groceries. We all have to eat and, if you live in the inner city, helping people take their groceries home from the store is a great idea. You might not have a lot of neighbors who need this, but they would be loyal clients and, when they get to know and trust you, you can offer them other services to grow your business.

Compost Creator: Take your neighbors' compostable trash, make compost for them, and sell it back. "Compost" is anything that comes from a plant—even inedible things like napkins. This would be great for neighbors who like to

let your parents

garden but don't want to do the work to make the compost. It could be a big money making maneuver and might be a great business to add on to your main business.

Recycle Valet: Ask your neighbors if you can collect their cans and bottles. Then, turn them in for cash. Collecting bottles and recycling is good for the planet and is a good way to make extra money. But it takes a lot of cans and bottles to make even a dollar. Imagine how much more money you could collect if you got your neighbors to let you recycle their stuff. It would multiply your profits for each neighbor you could get to work with you. The one thing you have to remember is you'll need a lot of room to store the cans and bottles.

The second thing to consider before you get started is to decide what neighbors you are going to ask to be your customers. If you start a lawn mowing business, you would obviously need to look for people with a lawn. If you start a business about dogs, you will obviously need to have a neighbor with a dog. You have to have a business that adapts to your customers. What if your neighborhood didn't allow dogs? It would not be very smart to have a business that required a dog like a dog walking business. What if you lived in an apartment with big garbage bins that everyone put their trash in? My garbage valet business idea would not work, but you could change it to adapt. How about this idea:

you could design a two or three bin system that you could put outside your customer's door. That way, they would not have to walk all the way to the trash cans to throw away their trash. You could empty them each day and even recycle their cans and bottles. It would take extra effort, but what a great business for someone in an apartment. The key is to think of things people need. Think of things your neighbors need or want.

You should also be thinking carefully about the places your parents will allow you to go and who may need your services. It is really best if your parents go with you and help you do your job. You want to make sure you are always safe. Think about the time of day; who is around; what your surroundings are like.

Be smart. As far as thinking about your services, remember: what you offer might be very helpful to some people. For example, a lady in my neighborhood hurt her back and really needed and appreciated my services because she could not take her garbage cans in and out herself. I am not saying to take advantage of people, but instead, remember: what you are doing can really help people.

Old Customers: $5.00

NEW CUSTOMERS: $10.00

let your parents

Setting your price is one of the most difficult things about running a business. If you set it too high, people won't buy your services; if you set it too low, people will probably buy your services, but you won't make much money. My mom calls this "what the traffic will bear," which means you want to set your price within a reasonable range. When I started my garbage valet business, at first I charged only $5 a month. It seemed like a good price to me, but the more I talked to people about my business, the more people would say things like, "Gee, I would pay $10 a month for that." This made me realize I was charging too little, so I changed my price to be $10 a month.

Now, it is important for me to tell you I didn't change the price for my old customers, only my future customers.

When you set your price too cheap, people will think it is a bad service or not necessary. This is a principle of economics. If you raise the price on something, that is when people will buy it more - not because it is worth more, but because it costs more and they think it is a better product. Really, it is exactly the same product, but the higher price made them think about

it differently; they think it is worth more. It makes them want it more. But be careful not to overprice your product.

Once you have decided these things, you are ready to roll. It's time for Chapter 5!

Chapter 5

Getting the Word Out

*N*ow that you have decided what you are going to do, you need to "market" those services, which means getting the word out and selling your services to your customers. There are lots of ways to do this; here are four:

- You can tell them about it in person
- You can send them something about it
- You can make posters and post them around the neighborhood.
- You can put a magnet on your parent's car about your service.

Any kind of advertising is great, but remember there is a cost to all of these kinds of marketing, so you need to spend wisely and do the thing that will kick start your business the fastest.

The fastest way is to make a flyer and go around your neighborhood telling people about your business. Another

let your parents

great way these days is by building a web site, but you still have to get the word out so people know you are there.

My mom has had her own business doing marketing for a long time. She specializes in these things, so I was lucky. She was able to help me get started. The first thing we did was to come up with a name and make a flyer so I had something to give to my neighbors. Here is my first flyer:

We put a page up on our website so you can see the flyer better. This page also gives you some tips on how to

make a flyer yourself. Please be sure to ask for an adult to help you go to the webpage. howtoraiseamillionaire.com/flyer1

She really helped me, and your parents can help you, too. You don't have to be a marketing genius to do this; you just have to get started.

If you don't know where to start, my mom put all the stuff she did for me in a *Fast Start Action Guide*. You can buy it at our website:

howtoraiseamillionaire.com

It will make the whole thing super easy.

Now that you know what you are going to do, the next step is to come up with a name for your business. It should be something fun and something that tells your neighbors what

let your parents

you do. *Jack's Garbage Valet* does both those things. It tells my neighbors what I do and it is fun. For kids, it is a good idea to have your name in your business name. It makes it easier for your neighbors to remember. It makes it personal. It makes it yours.

Let's say your name is Joe. You can name your company something like *Joe's Garbage Valet*, just like mine. Then they'll know what you do and who you are. If you are starting a business with a partner, like a sister or brother, put both your names in it!

It does not matter whose name is first, what matters is how it sounds, like *Joe and Jenny's Garbage Valet*. If you can't decide on whose name is first, use your last name, like *The Smith Brothers' Garbage Valet*.

The next step is to design a flyer and print it out. There are certain things your flyer needs to say. Think about this: if you get a birthday party invitation in the mail and they forget to put the date of the party on it, you don't really know if you can go or not because you don't know when it is.

The same thing is true about your flyer: it needs to have all the important information on it.

Your flyer should include:

- Your company name
- What you do
- Your rates
- Your contact information (e-mail address and a cell or home phone number)

If you forget any part of this, your neighbors won't really be able to tell if they want or need your service. One of the most important things is to make sure they have a way to get ahold of you. They might have questions. They might want to know more information than what you have said on your flyer, so whatever you decide to put on your flyer, make sure you provide them with two ways to reach you.

let your parents

You can tell them where you live, what your email is, or give them a phone number - it is up to you, just make sure you give them two ways. Why two ways? Because if you only give them one and they can't do that one way, they won't be able to get ahold of you. I'll use the customer I told you about as an example. Remember, I told you about the lady who hurt her back. She was basically stuck at home. She could not get out of her house. So if I had only given her my address and not my phone number, she could not have called me. She would not have had a way to order my service.

Your flyer should be fun, like writing a fun title or question. Here is my second flyer:

Again, we put a page up on our website so you can see the flyer better. This page also gives you some tips on how to make a flyer yourself. Don't forget to ask for an adult to help you go to the webpage. howtoraiseamillionaire.com/flyer2

You'll notice it is smaller than my first flyer. It is smaller because I had already given them one flyer, so I could make my second flyer smaller. The important thing to notice is what is on my flyer. It has a talking garbage can that says, "Getting tired of taking me out every week?" No matter what your business is, you can come up with something funny to put on your flyer. This is a great time to ask your parents or your brothers or sisters for help. They might be able to think of something funnier than you. Don't be afraid to ask for help. You might even need help typing it up. And hey, what if you don't have a computer? The library usually has one you can

use. If you can't go to the library, try drawing it. Make a cute kid drawing, just make sure you put all the information on the flyer and it can be read.

Another tip is to copy it on colored paper to get people's attention. I did my first flyer on blue paper and my second flyer on green paper. It is a great way to make sure they saw the paper, and it makes them want to read it. Plain white paper is boring.

Don't be boring—you are a kid, take advantage of it and be an original.

Pick a time to go around your neighborhood and put out your flyers. For my business, we picked garbage day, when people were taking their cans back in. If their cans were out, I taped the flyer to the can; if the cans were already in, I put the flyer on their door. I did this because my business is all about the garbage cans and how it would be nicer not to have to take them in and out. Putting out my flyers

on garbage day was the best time. If I had put them out on a regular day, they might think, "Oh gee, putting my cans out is not so bad...why would I need this service?" Instead, I got them when they were dragging them in and out. If you are going to start a lawn service, put the flyers out when your neighbor's lawn needs mowing. If you are going to start a poop valet service, put the flyers out when you can see a lot of you-know-what on their lawn. I can just see the catchy saying for a lawn mowing business: "Don't you have something better to do than mow the lawn? Hire me—I'll mow it for you." How about this one for a poop valet service: "Hire me and you'll never have to scrape you-know-what off your shoes again!"

One thing to remember about flyers is never put the flyer in the mailbox, because it is against the law and can result in a fine.

don't do it!

Only the postman can put something in your mailbox. If you put your flyer in the box and the postman sees it,

let your parents

they can come back and charge you for a stamp. They can also fine you, which is like having a debt of money to pay. It is not like you'll go to jail, but it will cost you extra money, so be smart and don't put your flyers in someone's mailbox.

This leads me into another important part of selling your business. If I was walking around and putting my flyers out, and I saw a person, I went up to them and gave them my sales pitch and my flyer. Before you go around your neighborhood, prepare what you are going to say. This is your sales pitch. No matter how nice your flyer is, nothing is better than a good sales pitch. This can sometimes seem like the hard part. When you see someone, you should be able to tell them, in a couple of sentences, about your services and the reason why they should hire you.

PITCH + FLYERS = *more work for you!*

Because this is your sales pitch and it is very important, you need to practice it. No matter whether it is a random person or someone in your neighborhood, you want to do a good job. This might be the first time they have ever talked to you. If you don't do a good job, if you seem like you don't know what you are doing, why should they hire you?

It is going to be scary the first time you say it. You'll probably be a little nervous but you will eventually come up with good results. The more you do it, the less nervous you'll get. Believe me—I speak from experience!

Here is my sales pitch:

"Hi! My name is Jack James. I am your neighbor around the corner. I live on XYZ Street. Are you tired of taking your garbage cans in and out? Hire me and I'll do it for $10 per month. Here is my flyer. I can start this week."

At the end of your pitch, *ask for the business*! That is what the "I can start this week." part of my sales pitch is. It is asking for the business. Don't be afraid to ask. I know this can be scary, but it is really worth it in the end. Just do it. Walk up to your neighbor, give them your sales pitch, shake their hand, look them in the eye when you are talking to them, and close the deal ... *no guts, no glory!*

One of the things I have done that worked really good was if someone seemed on the fence, I offered to do their cans for one month.

This has happened to me twice. When I talked to them, I could tell they were not sure. So right away I offered to do their cans *for free* for a month. That made it easy for them to say "Yes." After four weeks of having me taking their cans in and out, they liked the service and wanted more. They didn't want me to stop. In a way, it was a gamble but it worked out great. Any time you can make it easy for your customers to say "Yes," it is a good thing.

It might take you a while to get some customers. Don't get discouraged.

You have to be patient and keep putting your flyers out there. My mom taught me you will probably hear "No" twenty

times before you get one "Yes." When people say "No," it's OK. You didn't lose anything. You didn't have the customer before you asked them and, if they say "No," you still don't have the customer. *It's no big deal!* Don't take it personally. They are not saying they don't like you, they are just saying they don't want your service that day. It does not mean to stop asking them. Just ask them again another day, and maybe it will be the right time and they will say "Yes." In our family, "No" doesn't mean "No," we say it means, "Next." It means you are just one "No" closer to the next "Yes."

Once you start your business and start going out and asking for customers, it's time to have fun and it's time to meet your neighbors!

Remember, if you were an adult, you probably hear "No" forty times before you get one "Yes." We have some advantages being kids because we are still *cute*. Trust me—it helps a lot. Don't give up! *You can do it!*

Now you're ready for Chapter 6.

Chapter 6

Doing the Job

When I was little, I really liked Thomas the Tank Engine. Mr. Conductor would always say, "You have to be responsible, reliable, and really useful." I thought of that when I was writing this chapter because it is what you need to do.

Once you have customers, they are depending on you to
get the job done right. You have to be friendly and reliable
to your customers. The truth is: if you don't do the job right,
they will figure it is not worth *your* time and *their* money—
mostly their money. They won't want your service anymore,
and they will *fire* you. You don't want that, so let's talk about
what you can do to make sure you don't ever hear the words
"You're fired!"

When I say, "Get the job done right," I mean get it done in
a responsible way. What do I mean?

- Think about what you would want if you were your
 customer.
- How would you want the job done?
- What would you want done if you were paying you?

In my case, I have a couple of things to consider. First
is the garbage man, and then is the postman. I make sure the
cans are not too close together, because if they are too close
together, the garbage man will get mad and won't take the
garbage. You can't really blame them: if they are too close
together, it makes it hard for them to pick the cans up with
their big claw thing. The cans have to be far enough apart. In
my city, they also have to be away from the curb a little bit.
It is not hard to do and really, I am making it easier for the
garbage man.

The other person I have to think about is the postman. Our
mailboxes are in front of our houses at the street.

Our postman drives a truck by and stops the truck at the mailbox. They don't get out of their trucks. If the garbage can is in the way and they can't drive up to the mailbox, they don't deliver the mail. My customers would not be very happy with me if every garbage day their mail didn't arrive.

The other thing to take into consideration is kind of obvious, but it is worth mentioning. I also make sure the garbage cans are not in the driveway or in the way of any cars.

let your parents

Be friendly and nice to your customers. Remember, they are paying you for your service. Talk to them; say "Hello", and ask them how their day is going.

After all, you know them now, they are your customer but they are also your friends. Be nice, get to know them, ask if there are other things you can do for them. For example, if I am talking to one of my customers and she tells me she is going on a business trip, I can ask if she would like me to bring her mail in for her while she is gone. That lets her know it is another service I offer. One spring, my neighbor's yard had a lot of weeds in it, so I offered to "weed eat" for them. They were happy to have me do the work for them: I got another job, and they got their weeds cut. It worked out great for everyone. The more you tell your customers what you do, the more they will think of you when they need something done.

Remember, they also talk to each other. One of my customers, Lucia, was talking to another one of my customers,

Charles. He told her about a trip they were going on and how they were worried about their garden. Lucia told Charles to have me water their yard while they were gone. It was a great way for me to get extra business. It was really nice of Lucia to tell Charles about me. If I had not done extra work for Lucia in the past, like watering her yard while she was away, she might not have thought to suggest me to Charles.

"Being reliable" means you need to do the job when you are supposed to do it. Sometimes, my mom and I go away for the weekend, so I make sure to ask my dad to do my cans. One time, when I first started my business, I forgot to put the cans back in. I had to apologize to my customers. I felt really bad; I felt like I had let them down. I didn't want to do that again, so I made sure to put notes up to remind myself to do the job. When I go away, I call and remind my dad about the cans because, really, no matter what, it is my responsibility to make sure the cans get done. I am lucky to have my dad, but it is my business so I make sure to call him; after all, if you don't do it every week it is easy to forget. I know this so I am sure to call, remind him and thank him for helping me.

The other thing you want to remember is to "under-promise and over-deliver." If your customers expect one thing from you and you do an even better job, they will really like it. I'll give you an example. Remember when Lucia told Charles to have me water their yard while they were on vacation? Well, I did water the yard, but I also cleared off their deck, dead headed their roses, put fertilizer on their plants, picked up their tools, and generally made sure their yard really looked great when they got home.

They were very pleased and surprised. I know it made them happy. I didn't tell them I was going to do it, I just did it. That made the surprise much better. When you do the job right, people will like you and recommend you to other customers. I will talk more about referrals in Chapter 7.

A happy customer will ask you to do other jobs for them because they know you will do a good job with other things. They trust you.

Don't do anything to lose that trust. It is very hard to get back.

Try hard and make sure you don't let your customers down. At first, it is hard to remember to do your job, but you need to do whatever it takes to remember. Be sure to put the most effort you can into doing your best. If you need help, ask for help.

See you in Chapter 7!

Chapter 7

Being Paid and Getting Referrals

*B*eing paid is one of best things about having your own business! Let's face it: collecting the money is fun.

My mom wanted me to learn all the different parts of running a business, so she helped me learn how to use a software program. It helps do thing like prepare invoices and keep track of when you are paid. The software is great, but it is not personal, so remember when your clients pay you, say "Thank you!" It is very important you are polite and thankful to your customers. They need to know you appreciate them.

Think about how you feel as a customer. Isn't it nice when you go to a restaurant for dinner and the person who is serving you is polite? It makes your dinner much nicer, and makes you want to come back. The same is true about your business. Just think of how you would like to be treated.

I have to be honest with you: I am not very good with the invoicing part of the business. Here is an example of one of my invoices:

For a closer look at my invoice, go to howtoraisea millionaire.com/invoice. This page will give you some tips on

how to make an invoice yourself. Don't forget to ask for an adult to help you go to the webpage.

It was hard for me to keep up with the monthly billing. My mom and I were dealing with a lot of personal stuff, and we knew my customers would understand. After a while, we decided it was too hard to do a bill each month, so we changed how I did the billing.

Instead of monthly billings, I gave each customer a year's worth of envelopes with stickers on them that showed how much they owed each month, and a letter apologizing and explaining why we were so bad at invoicing. Sometimes, you just have to admit when you do something wrong. Be smart and don't do what I did. Learn from my mistakes and do the envelope thing right off the bat. It might take you some time, but it will be worth it in the end.

One of the cool things is when my customers pay me, I get to spend time talking to them. I really like getting to know them. They are really nice people and I would never have gotten to know them if it were not for my business.

That is one of the cool things I never expected to happen. One customer even brings me stuff from their vacations. Once they went to Alaska and brought me back some real gold! Another customer gives me oranges from the tree in her yard. They are so sweet and yummy.

Another of my customers grew up in the same town as my mom. They started talking about it and asking each other about old places they used to go. There is a deli in Oakland where they both grew up and they both love their raviolis. When we go to the deli, we always bring back some raviolis for her.

The last time, she gave me peanut brittle back. What a yummy surprise. It was really nice of her. I have the best customers ever!

Our neighborhood has a Christmas party each year. The first year I had my business and went to the party, some of my customers were there. They started telling the other people at the party about me and that's what I mean by a "referral."

At the party, one of my customers, Lucia, started telling the other neighbors about my business, how much she liked my service, and before you know it, she was telling them they should hire me. It was a great way to get new clients. That party was a great success. I got two new customers from it—that was $20 more a month!

Being paid is important, but being courteous is just as important. It will make your business and your friendships grow.

let your parents

It is a good idea when you start your business to think ahead. One of the great things about reading this book is learning from what I did. Think about starting your own referral program before anyone refers you. That way, you will already know how you are going to *thank* your customer for the referral. When my customers refer me to someone else, I give them a $5 Starbucks gift card. This is my way of saying I appreciate the fact they referred me to someone else. It is not a lot, but it is the thought that really counts, not what I give them. I could make them cookies, make them something else they might like—it does not really matter. What matters is that I say *thank you*.

You can come up with your own ideas about a referral gift. I guarantee you will like their reaction.

On to Chapter 8!

Chapter 8

Getting New Customers

W hen you are trying to get new customers, there are a bunch of ways to do it. There are two ways that work for me:

1. Sometimes it is hard for people to say "No" to a kid, so just keep asking your neighbors if they want your service. Don't worry about the fact you have already asked them; just keep asking. Remember what I told you about expecting to hear "No" twenty times before you hear "Yes?"

This is what I mean. You might have to ask someone multiple times before they say "Yes." One time they might say "No" because they are too busy to talk to you. Another time they might say "No" because still they don't know you very well. The next time they might say "No" because they have dinner on the stove and they need to get back to fixing it. It might take five times before it is the right time to ask and they say "Yes." Don't get discouraged by them saying "No," just keep asking. Do it in a friendly and fun way. Make them laugh and smile when you ask. You can turn that "No" into a "Yes" if you are persistent.

2. Ask your customers if they know someone else who might be interested in your services.

As we discussed in Chapter 5, you should make a flyer. Don't have just one flyer. Make more than one and put them out every so often to get new customers.

If you use the same flyer every time, they will see it and know what it is about. They will probably just throw it away. But if you make it new and fun each time, they will read it and smile. Sooner or later, they will need your service.

You have to look at every neighbor as a potential customer. You can put your flyer out when you are doing your route. Making your flyers funny and a little crazy makes you memorable. I always include my picture so people will know who I am when they see some random kid taking garbage cans in and out. When they drive by and they see me, they might think of the flyer they saw. They might think to themselves, "Gee, I should hire him." If I did not have my picture on my flyer, they might think I just live at that house.

I know this works because one day I was putting one of my customer's cans back and their neighbor said, "Hey, you are the kid who put the flyers out, I have your picture on my

refrigerator." It was nice to be known. Maybe someday he will call me to do his cans.

If I see a person doing their cans while I am out on my route, I give them my sales pitch, hand them a flyer, and offer to do the first month free! "Free" is the word everybody likes to hear.

We talked about this in Chapter 5. If I do my service for them for a whole month, they are happy and *hooked*.

The other thing I have is a brochure. It has a lot more detail than my flyer does, and it tells my neighbors more about all the services I can do for them.

The brochure lists things like vacation mail, watering, dog sitting, and yard clean up. I don't give these out to everyone; just people I think would like to read it. I give them to people who need more information. I never thought it would come in handy, but in the fifth grade, we had to do a brochure for homework. We were studying the states and each of us

picked a state to learn more about. I picked Missouri. One of the things we had to do was make a tourist brochure. I used my *Jack's Garbage Valet* brochure to help make my Missouri brochure. It made the homework go a lot faster, and it looked pretty cool. My mom teases me all the time that I should send it to the governor of Missouri. One of these days, maybe I will send it to him. He can hire me to do his state brochure, and that will be another stream of income for my business.

Jack 's Garbage Valet

Service Order Sheet

Customer Name: _____

Address: _____

Phone: _____

Email: _____

I prefer for you to contact me by:

 ❑ Phone

 ❑ Email

 ❑ Both

I am ordering:

 ❑ Garbage Valet

 ❑ Garbage Valet with Tidy Curb

Start Date: _____

let your parents

This is my service order sheet. I have these handy when I am in the neighborhood delivering my flyers or doing my route. Here is another mistake we made that you can avoid. When my mom and I first went around the neighborhood, we only took our flyers. Not even a piece of paper and pencil to write on. When I got my first customer, I didn't have any way to write her name down, so my mom helped me make up a Customer Order Sheet. Use an order sheet like mine and you'll save yourself some trouble.

One last thing about new customers: don't forget they mean more work. If you are having a hard time getting your job done and your school homework, then don't go looking for new customers. I only go after new customers when I know I can handle it. I don't want too many because I want to have fun and do a great job, so I make sure I don't have too much or too little. You should do the same.

To get a better look at my Service Order Form and see some more ideas about how to do one, go to howtoraiseamillionaire.com/order. Like before, don't forget to ask for an adult to help you go to the webpage.

Let's move on to Chapter 9.

Chapter 9

Doing Something for Others

*H*aving my own business changed the way I think about money. I know I can do something or sell something to make money. Money is not scarce. It just takes thinking about it and work to make it happen. I can make my own money, which means I can buy my own toys, something I am sure most kids will think is cool. But there is something more important: I can give to others. As much as making the money might make me feel good, giving to others makes me feel better. It is hard to describe how it makes me feel, so I'll tell you a story about my first birthday after I started my business.

When my mom and I were planning my 11th birthday party, she suggested, instead of getting presents from my friends, I should ask for donations to a charity. I jumped at the idea and picked my charity: Operation Gratitude. I wanted to donate the money to somehow help the soldiers overseas in Iraq and Afghanistan. Operation Gratitude puts care packages together and sends them to the soldiers.

I am really glad my mom thought of the idea. I would not have thought of it on my own, but it was my decision to do

it. I planned my party and, in my invitation, I asked people to bring donations instead of presents. I know that might sound crazy for a kid, but remember how I said we hear a lot of stuff and we know more than adults think we do? Well, I knew there were kids out there whose parents were out fighting a war. They didn't get to kiss them good night, they worried about them being safe, and I was home with my mom. It was not hard for me to think about giving up my birthday presents when you think about it that way. It just seemed like the right thing to do. I don't know if I would have been able to get past the present thing if I didn't have my business. I am not saying I would not have, but it made it easier to jump at the idea.

We had my party at a baseball game. My mom and I are season ticket holders for our local baseball team. We had extra tickets so it made it easy to invite my friends to the game. Our season ticket holder friends were there too. It made it great! We had a tailgate party with my friends, family and baseball family. Then we went to the ballgame. We had squirt gun wars, played catch before the game, and we even set up a table for the party guests to write letters to a soldier.

That was one of the coolest parts, because not only were the soldiers going to get a care package, but they were going to get a letter from one of my friends.

Something else cool happened. A lady, who was at another tailgate party saw what we were doing and asked if she could donate too. *My friends and I raised $595.00 for Operation Gratitude!* We sent off the checks and letters with a list of who donated, and the people at Operation Gratitude sent me a thank you letter that is on my bedroom wall. You know, I am sure I would have gotten some really cool presents from my friends, but I have to tell you, that letter is better than anything someone could give me. It is something my friends and I did together to make someone far away feel a little closer to home.

Another thing I was able to do because I have my own business is donate money back to Little League. I used to play Little League. I don't play anymore because it is just too much work with all the homework and tutoring I have to do for school. I still love the game. I love going to the major league games with my mom. My dad has been a Little League umpire for a long time. My Little League has a junior umpire program and they like to have kids learn to umpire. My dad has helped me become an umpire too. The adult umpires don't get paid, they are volunteers, but the kids do get paid. The first time my dad and I umpired for Little League after I started my business, I decided I wanted to volunteer too. I decided I wanted to donate the money they gave me back to Berryessa Little League. The first time I gave the money back was the best. You should have seen the lady's face. She didn't believe me at first. I guess I was the first kid to donate my money back to the league.

Giving does not always have to be about money. It can be about the service your business gives to people. Lorraine, one of my customers, is a very nice older lady. She is the one I told you about who hurt her back a while ago and can't walk properly yet. I was very happy when she asked me to do her cans because I knew it was hard for her and I could help her. There might be people in your neighborhood who are like Lorraine and your service could really help them. They are not people who want stuff for free; they want to pay for the service you give them. It makes them feel good to pay for what you are doing and it makes you feel good to know what you are doing is really helping them too. It's not all about the money; it's about the friends you make.

See you in Chapter 10—my favorite chapter.

Chapter 10

The Big Warnings

I n this chapter, I will talk about the big warnings. If your parents are reading my mom's book, *How to Raise a Millionaire*, I have some advice for you. If your parents are not reading my mom's book, you can skip this chapter at your own risk!

Remember, I told you in Chapter 1 my mom had to nag me a little to agree to start my own business. I want you to learn from me. It was worth it to start the business, so if your parents ask you about it, just do it right away. Save yourself and your parents the heartache of the argument. Just say "Yes." Just start that business.

In her book, my mom has given your parents advice on parenting—not just how to raise a millionaire. Because of what she is telling your parents in her book, you could end up with some toy expendable results (a "toy fine"). She is going to tell your parents to hold you responsible and not let you get away with stuff anymore. *Watch it!* If you talk back or say bad words, it could result in a "toy fine." Maybe before they were wishy-washy...but after my mom

gets ahold of them they won't be wishy-washy anymore. What is a "toy fine?" My guess is you have already figured it out.

A "toy fine" is where your parents take something you care about away from you. Maybe it is a game, a video game, a DS, time on the computer, it does not matter. They are going to go after something you like.

If they do what my mom says, they will probably end up hanging these toys—probably action figures if you're a boy, or dolls if you're a girl—by their feet in your dining room window. I wouldn't want to be in their shoes!

Here's what happens to me when I am mean, rude, or obnoxious to my mom:

It usually starts with me saying something I really should not say. Then the chances are she starts the next sentence with, "Jack, you have a choice ...," and I know I am not going to like either one, because the two choices are usually either punishment or doing something I don't want to do.

You might want to try the "something you don't want to do" option because it may not last as long as the punishment. *The punishment stinks!*

In our house, if I talk back one too many times, my mom will take away one of my *Star Wars* action figures— usually one of my favorites: that would be Captain Rex. She takes him and hangs him upside down in our dining room window so I can see him and remember what I did, and not do it again. Sometimes I wonder what Captain Rex must be thinking.

He is thinking, "You crazy kid, how many times do I have to hang upside down in this window? Pick something nice to say for a change. I am getting *queasy*."

If your parents ask you to watch "SuperNanny" on TV, say "No" as quickly as you can! Why? Well, you might be in

the middle of the show and see a really bratty kid. Then your parents may say, "Does that *remind* you of anybody?" They are trying to make you feel guilty. They are trying to make you realize that, at times, when you pitch a fit, you look and sound just like that bratty kid on TV. I don't know about you, but I don't like feeling guilty! I don't know about you, but there have been times when I did act just like that bratty kid on TV. It only took a few times of watching SuperNanny for me to realize I don't really want my mom or anyone to think of me *that* way. I have to admit that one works pretty good, and it is pretty funny too.

If you are like me and every once in a while pitch a fit—maybe while you are doing your homework or just in general—watch out for the video camera! In her blog and on her website, my mom is telling your parents to tape you

during your fits and then show it to you so you can see how bad you are.

She might even threaten to show it to your date when you are older. You don't want that happening, so stop pitchin' fits! My mom is giving your parents ideas, so watch out.

The party is over

Chapter 11

Been there,
know how it feels

*H*aving Dyslexia, or any sort of reading or physical disability, can be extremely hard. It can be the main reason you get bullied in the first place. Which really sucks. I mean, I didn't ask to have Dyslexia. I don't like having it at all. Having Dyslexia makes school even more difficult for me, and then on top of it to be the target of a bully—talk about not fair.

Dyslexia is not what many people explain it as, because usually the people who explain it are people who don't have it, so they don't know what is happening—they are just guessing or think they know. They usually have OK intentions, they are not trying to make you more Dyslexic, but they don't exactly know. Dyslexia is not your mind jumbling the words around. I have heard a lot of people try to say that, and it is not true. It is not that your mind does not understand the meaning of the word, either. Here is what it is: there are trigger words, mainly prepositions or small sight words like the word "it" that cause your mind to be confused. Let me explain what I mean by trigger words.

let your parents

What does your mind see when you see the word "it"? Here is what I think you see—just the word "it" (i-t). What you don't see in your mind's eye is a picture of the word "it". In order for a Dyslexic to be able to read a word, the word has to have a picture that goes with it in your mind's eye. Like, let's say the word "train". If I see the letters t-r-a-i-n, in that order, my mind sees a steam engine. It sees that picture every time, so my mind has learned when letters are in that order, it means the word "train".

If my mind sees the letters i-t, my mind goes crazy. Not really, but it feels that way. My mind knows it should know the word. So my mind is basically at temporary war with itself. My mind is saying, "What is that word? I know what that word is. WHAT IS THAT WORD?" Seeing the word confuses me—it *triggers* the confusion. This happened especially when I was younger. Now I know what i-t means because I have memorized it. The problem is, I can't sound out these little

words like normal people can, so it is harder for me to read. Memorizing words is also hard for a person with Dyslexia. We have great memories for things we hear or movies we see, but memorizing "sight words" is almost impossible. This all makes school extremely hard. Luckily, I have gotten over it quite a bit. I have a little bit more to go, but as I get older, it gets easier.

I am telling you this because I know there are other kids out there who have felt the same way. They feel bad. It is really hard not to let your disability be the only thing that you are about. You are about so much more. My Dyslexia is just a small part about me. My Dyslexia actually lets me be creative and do things like write this book. I can think in ways other kids, who don't have Dyslexia, can't. Not because I am better than them: it is because my brain works differently.

If you are like me, there have been people who thought you were not a smart person, there have been people who thought you were weird, or thought you would make an easy target to tease. Well, they are not correct. I know you are a great person inside, no matter what it is that makes you different.

- Maybe you are in a wheelchair
- Maybe you only have one arm
- Maybe you can't focus at school
- Maybe you can't see
- Maybe you can't hear

It does not matter what you makes you different.

let your parents

It doesn't matter what people think you *can't do*. What matters it is what you *can do*. And what you *can do* are your strong points! What you *can do* is what makes you special.

We are fighters. We will never give up. Whether we have disabilities or whether we don't, kids can do anything.

We are the power of the future.

Conclusion

I hope you've enjoyed this book, will take my advice, and go on to become an entrepreneur. Together, we can bring this economy up and make the world a better place.

Whether you become a lawyer, a small business owner, or an employee for someone else, I know you will be very successful.

I know you'll be a great person in the future!

My Personal Mission

My mom has always told me to dream and to think big. She took me to a Brian Tracy seminar called, *The Power of Personal Achievement*. It was three days with Mr. Tracy, and he taught me how to write my mission statement and how to set goals to achieve my mission. I wanted to share my mission with you.

My mission is to become a scientist and cure cancer. I want to make the cure less horrible and painful than the cures they have today. I also want to help people prevent getting cancer.

let your parents

I will achieve my mission by finishing school, going to college, taking science, and becoming a doctor. I'll start my own company and get other expert scientists, and we'll work together to find a way to cure cancer. I will fund my company with the money I get from selling my book and my business.

I will know I have achieved my mission when the company I start works on a cure for cancer, we find one, and we are successful getting the cure out into the world.

The first step I will take to achieve my mission is to sell my book to start funding my cancer research company, overcome my Dyslexia, learn to read, and become an A student.

My next disease will be diabetes. I want to help kids like my friend Scott!

Thank you, Mr. Tracy, for helping me put my mission in life into words.

Thank you for teaching me how to set goals so I can achieve my mission.

Photo Gallery

Here I am with one of my customers, Charles. Charles and his wife are the customers who brought me gold from Alaska!

Here I am taking one of my customers cans out. The driveway is a big hill and I just take it slow.

*Here I am with one of my customers, Miss Maxine.
Miss Maxine is my fellow Genova's Lover!*

*One of my customers needed some help in
his yard, so I was able to make some extra
money and help him at the same time.*

let your parents

Here I am taking out the cans at another customer's house.

Recycle can too!!! I make sure the cans are far enough part that the two trucks can pick them up with ease.

Here I am at another customer's house, taking out their cans.

This is a picture of me and my dog Kealani at an Oakland A's game. It was Bring your Dog to the Ballpark Day.

CPSIA information can be obtained at www.ICGtesting.com
Printed in the USA
BVOW011929260412

288814BV00005B/1/P

THE BLESSING IS IN THE DOING

The Blessing Is in the Doing

DANDI KNORR

BROADMAN PRESS
Nashville, Tennessee

© Copyright 1983 • Broadman Press
All rights reserved
4260-01
ISBN: 0-8054-6001-2
Dewey Decimal Classification: 248.4
Subject Heading: CHRISTIAN LIFE
Library of Congress Catalog Card Number: 83-70643
Printed in the United States of America

I dedicate this book to Mom and Dad,
through whose doing I've been blessed

CONTENTS

Introduction 9

1. Doers 13

2. Laziness 19

3. Spiritual Deafness 34

4. Fear 45

5. Our Secret Formula 56

6. The Beginning and the End 71

7. Do It Excellently 86

8. On Time 96

9. Don't Do It! 112

10. The Blessing and the Curse 121

Introduction

Chris Chen stuffed his office papers into his black briefcase. The day had gotten away from him. *Tomorrow,* he thought, *tomorrow I'll make a point to talk to that new guy, Bob. Think I'll invite him to church. Maybe I could talk to him about Christ sometime.*

It wasn't until Chris was in his car and nearly home that he remembered his promise to return a call from the company's insurance man. The phone number still lay on his desk where he had posted it three days ago. Well, one more day couldn't hurt.

As Chris continued listening to the radio, the idea occurred to him, *One of these days. . . .* (This particular expression was quite a favorite with Chris. He referred to it often, sometimes in a deep, pensive, solemn tone, at other times almost wistfully.) *Yes, one of these days I'm going to figure out a good way to use my commuting hours. Why, I could memorize Scripture. Or record a tape to my parents.* And his mind slowly drifted back to the radio and the pick hit of the week.

Kris, Chris's charming wife, was busy in the kitchen when her husband drove up the driveway. "Sorry, Chris," she announced from her post at the oven. "Dinner isn't ready. I don't know where the day's gone!"

Chris was used to this delay. He understood. In fact, he himself didn't know where the day had gone. There simply were not enough hours in the day. For example, there would probably never be enough time to trim the hedges or water the lawn, not to

mention taking up tennis with Kris or helping out with Vacation Bible School.

Chris and Kris enjoyed their dinner, though Kris regretted not having time to put the candles on the table. "Let's have the Petersons over for dinner," she suggested. "I'd really like to get to know them better. They seem like such a nice family."

Chris agreed wholeheartedly. As to when, "someday" was agreed upon. Specifically, "someday soon."

Dinner over, Chris, newspaper in one hand, moved to his reserved spot in front of the TV, pulling the knob with his free hand. Standing over the sink, his wife began to chide herself for eating a generous piece of pie for dessert. "Tomorrow," Kris determined, "I'm starting my diet. No more desserts for me after tonight."

Admitting to herself it was too late in the evening to ask her husband about that leaky faucet and the bathroom shelf that needed repair, Kris sighed and joined Chris in the living room.

"New needlepoint project?" Chris asked his wife as she sat down on the couch and took out her latest hobby.

Kris nodded to the affirmative.

"Whatever became of that sweater you were knitting for me last Christmas?"

"Someday I'll finish it," Kris answered. "Someday" was an important time to Mrs. Chris Chen. Scheduled to be finished at that special time were projects ranging from sewing and macramé to piano and guitar lessons. These various hobbies lay scattered about in different degrees of completion, or shall we say incompletion. Kris enjoyed beginning most anything. But after all, there really wasn't time to finish everything.

As the happy couple sat watching one of their favorite programs, a rather shocking barrage of bad language surprised them. Chris, throwing down his paper, angrily shouted, "I'm going to write the television station and complain! Things like that shouldn't be allowed on TV! Somebody should do some-

thing about it. And that reminds me. I was going to write our senator and tell him we think his pro-abortion vote was an atrocity."

"Oops, that reminds me," Kris said as she rose from the couch and lay aside her needlepoint. "I don't think I ever finished that letter to your mother. I really did want to keep in touch better with them this year."

Sometime later Chris suggested they turn off TV and read in bed. "There are so many books I want to read. If I could even read one book a month, I'd know what people are talking about at the office. Then there are all the classics I've wanted to read."

"Actually, I've started at least a book a month, I'll bet," said Kris. "Trouble is, I don't know which one to finish."

But the night had raced by. The hour was late, too late for reading in bed, well past their bedtime. Agreed that tomorrow night they would have to see that they got to bed on time, Chris and Kris turned out the light and climbed into bed.

Lying in the dark, Chris thought it would be a great idea to begin to pray with his wife each night before they went to bed. Maybe they could read something from the Bible too. Yes, he'd do it, thought Chris as sleep closed around him, tomorrow.

The average American considers himself very busy; yet he rarely seems to achieve his goals and dreams. It's our plague that we can be consumed with activity, yet devoid of accomplishment. Too often we fail to do what we want to do, or what we know God wants us to do. I'm convinced that if we Christians did half of what we dream or think of doing, God would be glorified on earth, and his children would truly manifest the "sweet aroma of the knowledge of Him in every place" (2 Cor. 2:14).

So now, jump prayerfully into the following pages; and we'll set out on our attack against procrastination and laziness. Most of us can identify with some of the pitfalls mentioned in the story of Chris and Kris. But do we have to resign ourselves to bad habits

and lack of discipline? Or can we allow God's Spirit to change us into doers, doers of the Word? For Jesus taught, *"If you know these things, you are blessed if you do them"* (John 13:17, italics mine).

DANDI DALEY KNORR

1

Doers

God has designed us to reflect the glory and image of the perfect Christ. Maturity in the Christian life is a process of becoming more like Jesus (he must increase; I must decrease). Christ's time on earth showed us a poured-out life, free from selfishness and procrastination. Please don't let yourself sink into discouragement as you think of Jesus' and Paul's lives, and then reflect on your own. The same power demonstrated by Jesus on earth is available to us!

Jesus

Even a cursory glance at the Gospels, the history of Jesus' life on earth, confirms that he didn't procrastinate. When he said he would travel to Jerusalem, he did so—on foot, even when he knew the cross awaited him there. Christ kept his promises. He merited the trust and confidence his disciples placed in him.

Jesus had a definite plan and refused to be drawn off course. One morning when he had gone away by himself to pray, Simon Peter came to him. The crowds were gathering and looking for him. But Jesus replied, "Let us go somewhere else to the towns nearby, in order that I may preach there also; for that is what I came out for" (Mark 1:38). Christ continued to press on and proclaim the gospel of God's kingdom.

At the height of Jesus' popularity, the multitudes were rallying behind him. Once they rushed upon him to make him king. But

Jesus eluded the crowds. Nothing distracted him from his purpose.

Christ was a doer, an initiator, a leader. He spent his earthly life walking from town to town, proclaiming the message of salvation. He healed the sick, preached the gospel, trained his disciples, performed miracles, raised the dead. People constantly surrounded him, making demands. Religious leaders of his day opposed him. He became tired and hungry and thirsty. The Son of man had nowhere to lay his head. Yet early in the mornings, Jesus often made time to meet with his Father alone. He spent whole nights in prayer.

Frequently Jesus explained the secret of his life by pointing out his dependence on the Father. "Truly, truly, I say to you, the Son can do nothing of Himself, unless it is something He sees the Father doing; for whatever the Father does, these things the Son also does in like manner" (John 5:19). "I can do nothing on My own initiative. As I hear, I judge; and My judgment is just, because I do not seek My own will, but the will of Him who sent Me" (John 5:30). "I do nothing on My own initiative, but I speak these things as the Father taught Me" (John 8:28). "For I did not speak on My own initiative, but the Father Himself who sent Me has given Me commandment, what to say, and what to speak!" (John 12:49). "Do you not believe that I am in the Father, and the Father is in Me? The words that I say to you I do not speak on My own initiative, but the Father abiding in Me does His works" (John 14:10).

Jesus knew the will of his Father. He had come to seek and save the lost. And he had come to die. As Jesus wandered through the country and passed through a village of the Samaritans, Luke recorded that Christ was journeying "with His face toward Jerusalem" (Luke 9:53).

Time wasn't an enemy to Jesus. Aware of his objective, he always lived in full control of time. As early as the event of his first recorded miracle, Jesus asserted, "My hour has not yet come" (John 2:4). In the beginning of his ministry, Jesus often kept himself from public acclaim. During the Feast of Tabernacles, his

brothers urged him to make himself known to the public, to declare himself openly. But he tried to make them understand, "My time is not yet at hand" (John 7:6). He mastered his time on earth. Jesus knew how to work within time limitations, even though he, the only begotten Son, had existed in timeless eternity.

Finally, the night Christ was betrayed, he prayed to his Father: "Father, the hour has come" (John 17:1). When his time on earth was nearly over, Jesus knew he had accomplished the work that the Father had given him to do.

Paul

The apostle Paul gives us another example from the Scriptures of a life poured out to God. Few would dare accuse Paul of laziness or procrastination. In a letter to the Corinthians, Paul listed several events he endured in the Lord's service: Beaten times without number; whipped thirty-nine lashes five times; beaten with rods three times; three times shipwrecked; many journeys; dangers from rivers, robbers, from his countrymen, Gentiles, false brethren; dangers in the wilderness, in cities, on seas (2 Cor. 11:22-33). "I have been in labor and hardship, through many sleepless nights, in hunger and thirst, often without food, in cold and exposure" (2 Cor. 11:27).

Paul the apostle was also Paul the tentmaker. At crucial times during his missionary ministry, Paul was forced to practice his trade as well as preach the gospel. Scripture doesn't detail Paul's vocation; but I'll bet he was a great tentmaker! He wrote to his friends in Colossae: "Whatever you do, do your work heartily, as for the Lord rather than for men" (Col. 3:23). And he sent word to the Thessalonians, who had decided it would be a good idea to quit working and just wait for the Lord's return, "If anyone will not work, neither let him eat" (2 Thess. 3:10).

In addition to traveling, preaching, tentmaking, and daily concern for the churches, Paul managed to write the letters that comprise much of our New Testament. Paul knew his objective,

his calling. At the end of his life he could assert that he had been poured out as a drink offering upon the sacrifice and service of others' faith (Phil. 2:17). His advice for his son in the faith, Timothy, was: "But you, be sober in all things, endure hardship, do the work of an evangelist, fulfill your ministry" (2 Tim. 4:5). Paul wrote in his last letter to Timothy, "I have fought the good fight, I have finished the course, I have kept the faith" (2 Tim. 4:7).

Scriptural Exhortations

The Bible contains commands, warnings, and appeals for God's people to be obedient, to accomplish the will of the Lord, to *do it*. The Old Testament records Israel's failure to obey God and the results of such disobedience.

In the Law, God exhorts his people by commandments given to them through his servant Moses. With every mention of the commands, God insists on Israel's obedience and adherence:

"O Israel, you should listen and be careful to *do it*, that it may be well with you and that you may multiply greatly, just as the Lord, the God of your fathers, has promised you, in a land flowing with milk and honey" (Deut. 6:3).

"For if you are careful to keep all this commandment which I am commanding you, to *do it*, to love the Lord your God, to walk in all His ways, and hold fast to Him; then the Lord will drive out all these nations from before you" (Deut. 11:22-23).

Israel's major disobedience came in her failure to enter the Promised Land. God, who miraculously brought them out of Egypt and slavery, through the Red Sea, gave them the promise of the land. Israel had the Lord's guarantee that he would fight for them to dispossess the Canaanites. Yet the Israelites under Moses failed to obey and enter the land. Consequently, though God forgave them, that generation of Israel (except for Joshua and Caleb, the two spies who had believed God) died in the wilderness without entering the Promised Land.

God carefully outlined for Israel the consequences of obedience to the Lord's commands and the consequences of

disobedience. If Israel would listen and do the commands given by God, she would be blessed. God would establish them as a holy nation and defeat all their enemies. "The Lord your God will set you high above all the nations of the earth. And all these blessings shall come upon you and overtake you, if you will obey the Lord your God" (Deut. 28:1-2).

Just as sharply outlined are the consequences of disobedience. For if Israel would not obey, if she refused to observe all of God's commandments, then, says the Lord, they would be cursed. "The Lord will send upon you curses, confusion, and rebuke, in all you undertake to do" (Deut. 28:20).

As Old Testament teachings focus on our need for obedience, so the New Testament writers repeat the importance of obeying, accomplishing, doing. Listen to a few of these New Testament teachings, with italics added:

"But He [Jesus] answered and said to them, "My mother and My brothers are these who hear the word of God and *do it*" (Luke 8:21).

"Therefore every one who hears these words of Mine, and *acts* upon them, may be compared to a wise man, who built his house upon the rock" (Matt. 7:24).

"Whatever He says to you, *do it*" (John 2:5).

"For I gave you an example that you also should *do* as I did to you" (John 13:15).

There can be no doubt that everything the Bible teaches fights against laziness and disobedience and for *doing*. Yet many of us live ineffectual lives plagued by procrastination, lack of discipline, and habits of unfaithfulness. Daily disobedience in the small tasks of life have grown habitual—so habitual, in fact, that we may no longer recognize our failures to act as disobedience. We're in danger of settling for a life-style that's far inferior to God's will for us. In the next chapters we'll examine some possible reasons why we fail to act on God's will and on our own plans or desires. And we'll look in the Bible at some practical biblical cures God has given us for laziness and procrastination.

Study Questions

Study Passage: John 17:1-4

1. In what ways was Jesus a "doer"?

2. What evidence does Scripture give that Christ was in full control of his time while on earth?

3. Begin to identify any specific areas in your life where you're not accomplishing God's will for you.

4. Can you think of other examples from the Bible of people who were hard workers?

2

Laziness

Read this quotation from a Puritan mother, Elizabeth Joceline, in *The Mother's Legacie to her unborne child,* 1632: "Be ashamed of idleness as thou art a man, but tremble at it as thou art a Christian. . . . What more wretched estate can there be in the world? First to be hated of God as an idle drone, not fit for His service; then through extreme poverty to be condemned of all the world."

King Solomon in Proverbs 6:6-11:
"Go to the ant, O sluggard,
Observe her ways and be wise,
Which, having no chief,
Officer or ruler,
Prepares her food in the summer,
And gathers her provision in the harvest.
How long will you lie down, O sluggard?
When will you arise from your sleep?
'A little sleep, a little slumber,
A little folding of the hands to rest'—
And your poverty will come in like a vagabond,
And your need like an armed man."

Jesus in Luke 6:49: "But the one who has heard, and has not acted accordingly, is like a man who built a house upon the ground without any foundation; and the river burst against it and immediately it collapsed, and the ruin of that house was great."

The apostle Paul in 2 Thessalonians 3:10: "If anyone will not work, neither let him eat."

Joseph Vissarionovich Stalin, in his "Constitution of the Union of Soviet Socialist Republics" of 1936, Article 12: "In the USSR, work is the duty of every able-bodied citizen, according to the principle: 'He who does not work, neither shall he eat.'" (Wonder where he stole that principle?)

The Bible takes a firm stand against any form of laziness, idleness, or unfaithfulness. Most people today have grown to accept a degree of laziness in themselves and in others as normal. But God's plan of action and abundant living leaves no room for laziness.

The Book of Proverbs overflows with admonitions to the slothful man, "the sluggard." According to these proverbs, the sluggard's fate is to crave and get nothing (13:4), to beg and get nothing (20:4), with his own desires finally putting him to death (21:25). The man who gives in to laziness ends up despising himself (15:32). He is brother with him who destroys (18:9), actively sinning in his own passivity.

In contrast to the sluggard, the virtuous hard-working woman receives honor in Proverbs 31, partially due to her hard work. She looks for flax and wool, joyfully works with her hands, cares for her family's clothing and food needs, rises while it's still night, sees to her household, helps the poor, "and does not eat the bread of idleness" (Prov. 31:27).

Procrastination

An early warning symptom of laziness is procrastination, putting things off for tomorrow which should be done today. From my survey research, over 90 percent of the Christians I interviewed admitted procrastinating often or always!

But putting work off isn't unique to the twentieth century. God's people have procrastinated since the beginning of time. When Joshua assumed leadership of the Israelites, the nation had been

wandering for forty years in the wilderness as a result of their disobedience and failure to enter the land. Joshua knew that part of his job would be to overcome the inertia of inaction. "So Joshua said to the sons of Israel, 'How long will you put off entering to take possession of the land which the Lord, the God of your fathers, has given you?'" (Josh. 18:3).

Through Haggai the prophet, God chided Israel for procrastinating in building God a temple. "This people says, 'The time has not come, even the time for the house of the Lord to be rebuilt.'" Yet they had found time to build their own houses (Hag. 1:2).

Likewise, Jesus warned his disciples that they must work the works of God now, as long as it is still day. For night is coming, he exhorted, when no man can work.

Habits of Unfaithfulness

Laziness manifests itself in our habits of unfaithfulness. Our expectations of accomplishment diminish when we continually fail to do what we say we will do. The more days we sleep in, the easier it becomes to stay in bed that extra fifteen minutes. "Laziness casts into a deep sleep" (Prov. 19:15).

You probably know certain people you always expect to be late. They probably expect tardiness of themselves. Why do you feel you can count on Jerry, but not George? Both are great guys; but George has shown himself habitually unfaithful. He seems to forget that he promised to call and inform the others, or that he said he would pick up what you needed. But then, you never really thought he would do it.

Jeremiah gives us insight into how habits of unfaithfulness begin. Through Jeremiah, God spoke to Israel: "I spoke to you in your prosperity;/But you said, 'I will not listen!'/This has been your practice from your youth,/That you have not obeyed My voice" (Jer. 22:21).

For some, unfaithfulness begins at home. One of the kindest things parents can do for their children is to make them follow

through on commitments, building habits of faithfulness. When my sister and I were kids and received a gift or card from a relative, Mom would sit us down at the kitchen table and make us immediately write the sender. Before we knew how to write, she had us color a picture to send to them. To this day, I tend to answer a letter the moment it arrives.

On the other hand, no one prevented me from telling little "white lies" in order to break dates, back out on appointments, etc., without hurting anyone's feelings. Conveniently, I could be in the middle of washing my hair, coming down with something, or forced to go out of town suddenly. My easy exits from unwanted commitments allowed me to be unfaithful when it was convenient for me. Even now I'm tempted to pull out the old bag of excuses and give them a try.

It's hard to break these habits of unfaithfulness and patterns of laziness. Part of the solution is confession of sin; I'll talk more about this later. A second aid is to sanctify the little things. God says to take every thought captive to Christ. Check out your actions with him too. We sanctify everything by means of the Word of God and prayer (1 Tim. 4:5). If you have trouble getting to work on time, pray that God will help. Then set your alarm and get out of bed when it rings. If you fail and arrive late as usual, confess your unfaithfulness to God, and try it again.

God concerns himself with all the details of our lives. "In all your ways acknowledge Him" (Prov. 3:6). His perfect will permeates each minute action. We can't afford to fall into bad habits, deceiving ourselves into thinking that small things don't matter. God, when he directed Moses in the building of the tabernacle, detailed dimensions, materials, and all the construction plans. Much of Exodus sounds like a blueprint, describing boards and bars, sacred garments, and tabernacle objects. Even the curtains merit full instructions! God required faithfulness at every job.

Jesus said, "He who is faithful in a very little thing is faithful also in much; and he who is unrighteous in a very little thing is

unrighteous also in much" (Luke 16:10). And Paul reminded the Corinthians, "It is required of stewards that one be found trustworthy" (1 Cor. 4:2). Begin now to break any cycles of laziness so God can say to you, "Well done, good and faithful slave; you were faithful with a few things, I will put you in charge of many things, enter into the joy of your master" (Matt. 25:21).

The Comfort Syndrome

Laziness may stem from something I label the comfort syndrome. We like our comfort! Think how many daily, yearly, and lifetime decisions are made on the basis of comfort alone, rather than following God's leading. One of the biggest industries, entertainment, thrives even in times of economic recession because we feel we must be entertained, amused. We may arrange our schedules around "Dallas" and "Love Boat" and even eat and sleep by the tube. Our vocations and choices of location may rest on the calculated ease and comfort that job will provide. How available are we to change if God calls us to leave our homes and try something new and "uncomfortable," less secure?

Christ had no place to lay his head. Yet for many Americans owning a home is an overriding concern and a major life goal. For years I was afraid for us to own our own home because I thought that my home might weigh too heavily in future decisions, making it harder for us to obey God if he should call us elsewhere.

That wasn't a response of faith. There's nothing wrong in owning a home. The error would come if we valued the comfort and security of a home more than obeying God's voice. In fact, Dave and I did own a home . . . for about six months, before God called us to be missionaries overseas. I hated to leave our little two-bedroom house. But God's call was so clear that home-ownership didn't enter into our decision making.

Men in positions of power have always found it necessary to

contend with the comfort syndrome and a life of ease. In a speech before the Hamilton Club in Chicago in 1899, Theodore Roosevelt said:

> In speaking to you, men of the greatest city of the West, men of the State which gave to the country Lincoln and Grant, men who pre-eminently and distinctly embody all that is most American in the American character, I wish to preach, not the doctrine of ignoble ease, but the doctrine of the strenuous life, the life of toil and effort, of labor and strife; to preach that highest form of success which comes, not to the man who desires mere easy peace, but to the man who does not shrink from danger, from hardship, or from bitter toil, and who out of these wins the splendid ultimate triumph.[1]

The comfort syndrome appeared in Israel during the days of the prophets. Amos warned: "Woe to those who are at ease in Zion,/And to those who feel secure in the mountain of Samaria" (Amos 6:1). The Lord spoke through Zephaniah against men who were "stagnant in spirit" (Zeph. 1:12). A life oriented around comfort soon stagnates. We don't act unless we *feel* like acting.

How can we combat the comfort syndrome? First, live a life of faith, not feelings. The "If it feels good, do it!" philosophy leaves us victims of our ever-changing feelings. One of my friends asserts he can't share his faith unless he feels like it. He doesn't share his faith much. He's allowed his moods to dictate in a spiritual area where God has given specific commands.

In eight years of missionary work, I can remember two instances where I *felt* like sharing my faith before I actually did it. Most of the time I was scared or tired, but went ahead anyway out of obedience to Christ's command. But not once did I regret going ahead and talking about Christ. The regrets came when I listened to my feelings, rather than responding in faith and obedience to God.

About six years ago, Dave succeeded in transforming me into a runner. However, to be honest, "jogger" more accurately describes my slow pace. If anyone asks me how I like jogging, my enthusiastic response is, "Great! I love it!" True, I love the benefits of jogging, the accompanying weight loss and fitness

gain. But over nine times running out of every ten, I feel like skipping that day. I almost never *feel* like jogging. But I do it, responding to a desire to be fit and feel fit. And this desire is deeper than the momentary urge to take off my running shoes and go back to bed.

A life based on feelings is a roller-coaster existence. Circumstances generally determine our feelings. If circumstances are good, we're high. If they come down, so do we. But our life doesn't have to follow suit. Paul wrote, "And the life which I now live in the flesh I live *by faith* in the Son of God, who loved me, and delivered Himself up for me" (Gal. 2:20, italics mine). Therefore, he found he could be content in every circumstance, both in abundant times and in times of need.

We're servants of the Most High God. Servants cannot afford the luxury of working only when they feel so inclined. They can't make decisions based on their own personal comfort. Servants belong to their Master and must obey him. And our Master is rich in loving-kindness and mercy, rewarding our obedience and faith, oftentimes allowing our feelings to catch up with our obedience, helping us both to will and to do work for his good pleasure.

Confess

One of the major hurdles in overcoming laziness is to see laziness as sin. We grow hardened by the deceitfulness of sin, especially when that sin has become commonplace and accepted. In England in Puritan times, *Homily Against Idleness* was widely preached. It taught that "by corruption of nature through sin" man "taketh idleness to be no evil at all, but rather a commendable thing, seemly for those that be wealthy."[2]

Alexander Whyte (1836-1921), one of Scotland's most important ministers, once said, "I would have all lazy students drummed out of the college, and all lazy ministers out of the Assembly. I would have laziness held to be the one unpardonable sin in all our students and in all our ministries." He continually

exhorted pastors to concentrate on humility, prayer, and work.[3]

Knowing what God wants us to do, yet failing to do it because we're too lazy, isn't just too bad. It's sin. Ezekiel delivered God's message to Israel and warned her of the sin of Sodom: "Behold, this was the guilt of your sister Sodom: she and her daughters had arrogance, abundant food, and *careless ease,* but she did not help the poor and needy" (Ezek. 16:49, italics mine). Israel in her complacency was guilty of not acting to help the poor.

James wrote the same message: "Therefore, to one who knows the right thing to do, and does not do it, to him it is sin" (Jas. 4:17). Those planned projects, the ideas that never materialized, the commitments neglected, promises broken—if God gave you those plans but you defaulted through laziness or procrastination, those are sins of omission. You omitted God's will (as contrasted with "committing" an act contrary to his will).

Solutions

No matter how many years you may have spent giving in to lazy feelings, or developing habits of procrastination, you don't have to continue those patterns. Because Christ lives in you, you can change. Begin to conquer laziness by taking the positive step of confessing sin. Confess means "to say the same thing as," or to agree. First John 1:8 says, "If we say that we have no sin, we are deceiving ourselves, and the truth is not in us." Agree with God that your laziness, time-wasting, neglect, or procrastination is sin. At the source of most sins of omission lurks selfishness. It is always easier and more convenient not to act than to obey God. Obedience requires change. Proverbs 28:13 advises confession of sins: "He who conceals his transgressions will not prosper,/But he who confesses and forsakes them will find compassion."

Confess, or agree with God, not only that sin is sin: Agree with God that when you confess sin, God has forgiven you completely. We have God's promise that "If we confess our sins, He is faithful and righteous to forgive us our sins and to cleanse us from all unrighteousness" (1 John 1:9).

To break the sin cycle of laziness, we have to understand forgiveness. God has removed our transgressions from us "as far as the east is from the west" (Ps. 103:12). He promises to remember our sins and lawless deeds no more (Heb. 10:17). He has canceled out the certificate of debt consisting of decrees against us and taken it out of the way, not using a list of our sins to condemn us (Col. 2:14).

Why can we agree with God that we are forgiven? Do we gain forgiveness when we confess, say we're sorry, and promise not to do it again? Or do we earn forgiveness by behaving better the second chance? What is the basis for our forgiveness? The answer: Christ. "And He Himself is the propitiation [satisfaction] for our sins; and not for ours only, but also for those of the whole world" (1 John 2:2).

We can never earn forgiveness. Any attempt at self-improvement or good works to make up for past disobedience will only result in frustration. The writer of Hebrews presents a logical argument to those who would try to earn God's forgiveness through sacrifices. These sacrifices offered year after year, he reasons, can never make the worshiper perfect. Otherwise they would have ceased to offer them. But sacrifices merely served to remind them of their sins. Only the perfect Christ could satisfy the cost of sin. And Christ, having offered one sacrifice for sins for all time, sat down at the right hand of God (Heb. 10:12).

The cost of payment for our personal sin is too high to be met by anything we could do. Without the shedding of blood, there is no remission of sins (Heb. 9:22). Nothing short of Christ's suffering and death on the cross could have paid for our sins. Keeping this high cost in mind helps prevent flippant attitudes toward sin. A fellow student once confided to me that each time she recognizes her sin and confesses it, she tries to picture Jesus being nailed to the cross to die for that sin. Remember what Christ has done to earn forgiveness for us. Peter wrote that forgetting our purification from sins contributes to a lack in Christian character (2 Pet. 1:9).

We've confessed our sin and accepted God's forgiveness on the basis of Christ's death. Next, God tells us to repent. Now there's an unpopular word. "Repent" conjures in the mind pictures of severe preachers dressed in black. Yet the Bible clearly teaches the need for true repentance. Repent means to change our attitudes and actions, to turn from sin to God.

A Christian who has been mired in laziness or who has disobeyed God in the same area day after day grows to expect disobedience from himself. Joan wants to get to church on time or to work early. But she has run late nearly every morning for seven years and has stopped expecting any change in her habits. She may confess her tardiness as sin and thank God for his forgiveness. But she won't do anything differently the next day. She may sincerely feel sorry for herself and her sins; but she hasn't repented.

The Bible gives us examples of people who, like Joan, were sorry but not repentant. God spoke through Hosea the prophet and rebuked Ephraim for her lies and rebellion and deceit. Of Ephraim's insincere repentance, her sorrow for sin without a change in attitude and action, God said: "And they do not cry to Me from their heart/When they wail on their beds;/ . . . /They turn, but not upward" (Hos. 7:14,16). They were upset, but failed to turn to God. Sin made them uncomfortable, but not repentant.

Paul faced a similar situation when he wrote a letter to the Corinthians criticizing their actions. But the people of Corinth responded properly and turned to God in repentance. Paul clarified the two types of sorrows in 2 Corinthians 7:9-11: (1) There is a sorrow that is according to the will of God and produces a repentance without regret, leading to salvation. (2) There is also a sorrow of the world that produces death. If we have confessed, accepted God's forgiveness, and repented, our sorrow will be the godly sorrow. We will begin to break the laziness sin cycle. John the Baptist's message of repentance required persons to bring forth fruit in keeping with their repentance.

Diligence

When the laziness cycle begins to break, we can initiate positive steps to develop improved habit patterns. Two character qualities essential to every Christian are diligence and discipline. Proverbs 12:27 advises that "the precious possession of a man is diligence." The author of Proverbs contrasts the diligent man with the sluggard.

The New Testament uses several Greek words to convey the concept of diligence. One of these words is related to the word for work and carries the meaning "making an effort, taking pains, endeavoring." A second word contains the idea of earnestness and zeal. Paul instructed the Romans that the one who leads must lead with diligence and that they should give preference to one another in honor, not lagging behind in diligence (Rom. 12:8,10-11).

The same word translates as "earnestness" in 2 Corinthians 8:7. There Paul encouraged the Corinthians to abound in all earnestness and in love. Elsewhere we're urged to be diligent to enter the sabbath rest (Heb. 4:11), to apply all diligence in our faith (2 Pet. 1:5), to present ourselves approved to God as workmen (2 Tim. 2:15), and to "be diligent to be found by Him in peace, spotless and blameless" (2 Pet. 3:14).

God often builds diligence in his children through trials. Paul once sent a Christian brother to the Corinthians and commended him to them as one whom Paul had often tested and found diligent in many things (2 Cor. 8:22). When we remove ourselves from the laziness cycle and enter the battlefield, God can work in us, forming diligence and providing ways of escape when we are tempted.

Memorize Peter's encouragement in 2 Peter 1:5-8, and let God begin to form diligence in your daily living:

"Now for this very reason also, applying all diligence, in your faith supply moral excellence, and in your moral excellence, knowledge; and in your knowledge, self-control, and in your self-

control, perseverance, and in your perseverance, godliness; and in your godliness, brotherly kindness, and in your brotherly kindness, Christian love."

Discipline

No cure for laziness is complete without a strong application of discipline. Such a small number of us possess real discipline that we doubt if it's within everyone's grasp. Who hasn't said to himself, "I wish I were more disciplined"?

J. Oswald Sanders in his book *Spiritual Leadership* outlines the character qualities of a leader. In a section on discipline he writes: "It has been well said that the future is with the disciplined, and that quality has been placed first in our list, for without it the other gifts, however great, will never realize their maximum potential. Only the disciplined person will rise to his highest powers. He is able to lead because he has conquered himself."[4]

Conquering self, bringing self under control of the spirit and experiencing victory over our natural inclinations: This is the essence of discipline. The Proverbs refer to this process as controlling or ruling our own spirit. "Like a city that is broken into and without walls/Is a man who has no control over his spirit." (Prov. 25:28). "He who rules his spirit [is better],/than he who captures a city" (Prov. 16:32).

We can equate ruling our spirit to good ol' self-control. Paul compared Christian discipline to the self-control required of an athlete who competes in the games. An athlete must exercise discipline in all things. Athletic training isn't rallying strength for one big physical exertion. Daily training and regular, consistent exercise make the athlete successful.

When Dave finally convinced me to start jogging, I gritted my teeth and determined I would run. My first outing turned into a fiasco. No amount of teeth gritting could prevent side aches and shortness of breath before I'd gone a quarter mile! Training must occur regularly and faithfully to produce its desired effect.

Lack of discipline can spur all kinds of sin. Anger, lust, gluttony,

laziness, procrastination—all reveal a dearth of self-control. Our consistent failures to establish morning devotions or proper study habits or to keep commitments may relate to poor discipline.

The New Testament word for "discipline" literally means "saving the mind, primarily, an admonishing or calling to soundness of mind, or to self-control." Second Timothy 1:7 translates that God has given us a spirit of "sound mind" in the King James Version, or a spirit of "self-control" in the Revised Standard Version. Our logic tells us we should live disciplined lives. We want discipline and self-control. Yet many Christians find themselves bound in slavery to undisciplined living.

True freedom lies in obedience and discipline, being able to do what we want, and capable of not doing things we don't want to do. Chapter 5 on the Holy Spirit looks in detail at God's emancipation proclamation for those in bondage. But some principles regarding discipline and obedience may help here.

Discipline, like obedience, can be learned. The Book of Hebrews tells us that even Jesus learned obedience through the things he suffered. In order for us to learn obedience, or discipline, we submit to God and say no to ourselves. Paul wrote several practical examples of disciplined men and encouraged us to imitate them. The soldier doesn't waste time doing his own thing, but concentrates on the one who enlisted him. As disciplined soldiers, we should learn to do what God commands, not what we feel like doing. Next, an athlete competes for the prize according to the rules. Finally, we can follow the example of the hard-working farmer (2 Tim. 2:3-6).

Paul wrote to Timothy, "Discipline yourself for the purpose of godliness; for bodily discipline is only of little profit, but godliness is profitable for all things, since it holds promise for the present life and also for the life to come" (1 Tim. 4:7-8). Our discipline isn't an end in itself, that we should become proud of our own self-discipline. The purpose of discipline lies in an increased potential for godliness and service for God.

Oswald Sanders writes:

The young man of leadership caliber will work while others waste time, study while others sleep, pray while others play. There will be no place for loose or slovenly habits in word or thought, deed or dress. He will observe a soldierly discipline in diet and deportment, so that he might wage a good warfare. He will without reluctance undertake the unpleasant task that others avoid or the hidden duty that others evade because it evokes no applause or wins no appreciation.[5]

So now let's begin to look at some explanations for our procrastination, laziness, and disobedience. Then we'll turn to our most potent weapon against laziness—God's Holy Spirit.

Notes

1. From *Magill's Quotations in Context,* ed. Frank H. Magill (New York: Harper and Row, 1969), p. 192.

2. Christopher Hill, "Sermons on Homilies," *Society and Puritanism in Pre-Revolutionary England* (New York: Schocken Books, 1964), pp. 438-440.

3. From *Walking with the Giants* by Warren W. Wiersbe. Copyright 1976 by Baker Book House and used by permission. Page 91.

4. From *Spiritual Leadership* by J. Oswald Sanders. Copyright 1967, 1980. Moody Press. Moody Bible Institute of Chicago. Used by permission. Pages 71-72.

5. Ibid., p. 73.

Study Questions

Study Passage: Romans 12:9-13

1. In what one task do you most often tend to procrastinate?

2. Can you identify any habits of unfaithfulness or laziness in your life?

3. Any commitments you've failed to keep lately?

4. Ask God to show you any areas of sin in unfaithfulness which you need to confess. Include sins of omission.

5. List your sins in these areas as God's Spirit brings them to mind. (Don't be needlessly introspective.) Write 1 John 1:9 over your list and throw it away. Thank God for his forgiveness.

6. What will repentance in the above areas involve?

3

Spiritual Deafness

One basic reason why we don't obey God and accomplish his will on earth may be our failure to hear God's voice. The CB radio expression "Do you have your ears on?" isn't so different from a question Jesus often asked. All through the Gospels Jesus talked about hearing: "He who has ears to hear, let him hear."

What could Jesus have meant? Most of his listeners probably had ears. In fact, he had created ears! But Jesus knew that the heart of man can impair his hearing. Even God's children can be guilty of spiritual deafness.

In Isaiah 42:18-20 God scolds his children: "Hear, you deaf!/ And look, you blind, that you may see./Who is blind but My servant,/Or so deaf as My messenger whom I send?/ . . . /You have seen many things, but you do not observe them;/Your ears are open, but none hears."

Jesus put it this way: "You will keep on hearing,/But will not understand;/ . . . /For the heart of this people has become dull,/ And with their ears they scarcely hear" (Matt. 13:14-15). There's a lot more to hearing than meets the ear!

Pay Attention

Occasionally, when Dave says something to me, I don't hear him because I'm not paying attention. Then follows the common excuse that the message went in one ear and out the other. I might have been engrossed in a TV movie (Cary Grant and Katherine Hepburn). Maybe I was solving the economic crisis or

worrying about my poor bread that refused to rise. But for some reason I didn't value what Dave had to say enough to make me pay attention to him.

In Mark 4 Jesus set down several profound principles about hearing. "And He was saying to them, 'Take care what you listen to. By your standard of measure it shall be measured to you; and more shall be given you besides. For whoever has, to him shall more be given; and whoever does not have, even what he has shall be taken away from him'" (Mark 4:24-25).

The "standard of measure" may be understood as the value you place on what you hear or what you expect to hear. The evening weather report is considered of more value to the would-be picnicker or camper than to the Saturday night bowler. So, several hours after the news, the outdoorsman will be more likely to recall the weather report than would the bowler.

Our predetermined attitudes or values will affect how well we pay attention and hear. Can you identify with any of these responses as you sit down to listen to a speaker or a sermon or to read an article or a biblical passage?

1. "I've heard all this before; this isn't for me."
 Result: Boredom.
2. "This should be a nice talk; he's a good speaker."
 Result: You are entertained; you experience little or nothing of life-changing value.
3. "I expect to have God change my life every time I listen to His Word."
 Result: Your life is changed.

What is your standard of measure for God's Word? Judging by your actions (time, interest, attention), how valuable do you consider the Bible? Your answer to this question just might indicate how well your ears are hearing and how well your mind is paying attention when you hear God's Word.

Jeremiah scolded and warned Israel, "To whom shall I speak and give warning,/That they may hear?/Behold, their ears are closed,/And they cannot listen. Behold, the word of the Lord has

become a reproach to them;/They have no delight in it" (Jer. 6:10). Jesus reminded us "that many prophets and righteous men desired to . . . hear what you hear, and did not hear it" (Matt. 13:17).

A time may come when we will understand how valuable the Word is and regret our neglect. Dave and I lived for one year in Communist Eastern Europe. I remember the near panic I felt in anticipation of that year when I considered the possibility of being imprisoned. I tried to imagine what it would feel like to be without a Bible for months or years. It was the same urgency I caught from seeing the movie of Corrie ten Boom's book *The Hiding Place.* I was so moved by the thought of those women confined to a concentration camp and the high value they set on the Bible to sustain them in prison that I went home and memorized John 14, my favorite chapter of the Bible. If I'm ever imprisoned without my Bible, it's nice to know I'll always have John 14! "'Behold, days are coming,' declares the Lord God,/'When I will send a famine on the land,/Not a famine for bread or a thirst for water,/But rather for hearing the words of the Lord'" (Amos 8:11-12).

Hearing God and paying full attention aren't merely options for Christian living; they're essential. "Incline your ear and come to Me. Listen, that you may live" (Isa. 55:3). Hearing problems may indicate a low value, or standard of measure, placed on the Bible. Take care what you listen to, and value it highly.

Proximity Problem

On days when Dave is upstairs at his desk studying, and I'm downstairs or in the garage, I can easily fail to hear him. We're too far apart. A second explanation for spiritual deafness is the distance separating us from God.

Ephesians 2:11-12 explains that before becoming Christians, we were separated from Christ, excluded from the common-wealth, and strangers to the covenants of promise. We were hostile to God. By accepting Jesus Christ into our hearts, we

become friends and children of God. Now a relationship with the Almighty God is possible—possible, but not automatic. We need to develop a close relationship with God, a friendship where we abide closely enough to hear God's voice.

We get to know God better by spending time with him. We can't expect to know God's will for us if we don't know him. Most of us have what we call "passing acquaintances," people we know well enough to say "Hi" if we pass them in the street. But we haven't spent time with them or taken the time to learn about them. We don't really *know* them. Don't settle for a passing acquaintance with God.

How can we know God? If all we had to go on was that he is a supreme being in the heavens, we couldn't expect to develop a living friendship with him. But God has communicated himself to us through the Bible and through his Son, Jesus.

The Scriptures tell us how we can grow closer to God. We're assured that no prophecy of Scripture is a matter of one's own interpretation, but that men moved by the Holy Spirit spoke from God (2 Pet. 1:20-21). And all Scripture is profitable for reproof, for correction, for training in righteousness (2 Tim. 3:16). First Corinthians explains that we should consider the things that happened to our biblical ancestors as examples of how to and how not to live.

As a new Christian at the University of Missouri, I wanted to please God and learn more about him. But how could I? Offhand, I could name about five of the Ten Commandments; but I didn't know many details about this new life of faith. What I needed was a manual, an instruction book. I found what I needed in the Bible.

Jesus' encounter with the two men on the road to Emmaus in Luke 24 teaches us several important lessons about the Scriptures. Jesus met Cleopas and a friend on the road, but they didn't recognize him. After the men have attempted to tell him what had happened concerning the crucifixion, Jesus opened the Scriptures to them. And beginning with Moses and all the

prophets, he explained to them the things about himself in the Bible (Luke 24:26-27).

Later when Jesus broke bread with them, the two men recognized him as the Lord. They said to each other, "Were not our hearts burning within us while He was speaking to us on the road, while He was explaining the Scriptures to us?" (Luke 24:32).

How long has it been since you've had a good case of spiritual heartburn, when Christ has opened the Scriptures to you and you found yourself near to him—no proximity problem? We should nurture a burning desire to know our Lord better, to know his Word and instructions for us. We don't study the Bible just to know the Bible. When Cleopas and his friend listened to Jesus, they recognized him. When we study the Bible, we should see Jesus.

Studying the Bible helps remedy the second hearing defect, being too distant from God to hear him. Placing a higher value on the Bible should help us pay attention to what God says to us. Now we can turn to the third possible explanation for spiritual deafness, interference.

Interference

I've been making cookies in the kitchen and missed what Dave said to me because my mixer was too loud. Or I didn't answer the doorbell because I couldn't hear it over the roar of the vacuum cleaner. Two people sitting together may not hear each other because they happen to be seated on an airplane over the wing during takeoff.

We may fail to hear God's voice because something else in our life comes across louder than what God says. Interference comes in all shapes and sizes. Hosea prophesied to rebellious Israelites who refused to listen to God. Their interference showed itself in the form of productivity and success. As Israel increased in numbers and prosperity, the people grew deaf toward the Lord.

God said Israel was playing the harlot, loving prosperity and ignoring God.

If you govern your life by anything other than Christ, then that interference may impair your spiritual hearing. What considerations most influence your decisions? Is it more important that your children or friends want a certain plan for you, or that God calls you to a plan? Is everything you do done in light of your job? your pleasure? your security or comfort? Are you open to God's still small voice, or is interference drowning God's leading?

Another sure interference to godly hearing is sin. The solution to unconfessed sin, and to all interference, is to recognize the sin and confess it to God. Agree with God that you have been wrong by allowing anything to interfere with his voice. Be on guard against anything that's so loud you can't hear God's voice.

We Don't Want to Hear

The last explanation for spiritual deafness ranks simplest. We don't hear because we don't want to hear. I must admit that sometimes I find deafness convenient: "Dandi, would you get the phone?" or "Is anyone driving my way?" or "Do we have a volunteer?"

The prophets rebuked Israel for her stubborn refusal to listen to God. Isaiah described the Israelite nation (30:9-10):

"For this is a rebellious people, false sons,
Sons who refuse to listen
To the instruction of the Lord;
Who say to the seers, 'You must not see visions';
And to the prophets, 'You must not prophesy to us what
 is right,
Speak to us pleasant words,
Prophesy illusions.'"

Israel kept refusing to hear the Word of the Lord. The people wanted pleasant words instead.

Jeremiah found the same difficulty with Israel. Again and

again God warned through Jeremiah: "You are each one walking according to the stubbornness of his own evil heart, without listening to Me" (Jer. 16:12). Over and over in Jeremiah recurs the phrase, "But you have not inclined your ear or listened to me" (Jer. 25:3-9; 35:12-17). Why? Because Israel didn't want to listen.

Why should God make his voice clear to us if we're not willing to obey him? Why should he take the trouble to reveal his will if we have no serious intention of following his will? Most Christians want to know God's will. We stand in varying degrees of curiosity on the subject and varying degrees of obedience. The most neglected step in trying to discern God's will for our lives is likely the first, necessary, step—a willingness to obey God, whatever his plan may involve.

Before my husband and I moved overseas as missionaries, God withheld absolute knowledge of his will for us until we were both willing to go or to stay. When our time overseas was completed, I wanted to know for certain whether God's will for us meant staying another year or returning home at the end of the current year. I was ready to fly back to the good ol' U.S.A. anytime! But God brought me to a point of willingness, willingness to stay overseas if that were his will for us, before he definitely called us to return.

We'd prefer to hear the details of God's will and then decide if we'll conform to that plan. God, however, usually requires our commitment prior to revealing his will. Paul wrote the believers in Rome: "I urge you therefore, brethren, by the mercies of God, to present your bodies a living and holy sacrifice, acceptable to God, which is your spiritual service of worship. And do not be conformed to this world, but be transformed by the renewing of your mind, *that you may prove what the will of God is,* that which is good and acceptable and perfect" (Rom. 12:1-2, italics mine). Paul entreated the Romans to dedicate themselves to God, to put themselves as an offering before God for him to use as he wanted. In this way they could discover God's will for them.

To hear God's voice and know his will, be available and willing

to obey God's plan. In essence this is what Jesus explained to the Jews: "If any man is willing to do His will, he shall know of the teaching, whether it is of God, or whether I speak from Myself" (John 7:17). Conversely, we could say that if any man is *not* willing to do God's will, he will *not* know the teaching and will *not* hear God. Jesus told the Jews, "Why do you not understand what I am saying? It is because you cannot hear My word" (John 8:43).

The writer of Hebrews struggled to communicate with his audience. He told them that they had become dull of hearing. They should have been teachers; instead, they still had need for someone to teach them the elementary principles of God (Heb. 5:11-12).

In Deuteronomy Moses used a great phrase. He told the Israelites to *listen obediently* to the voice of the Lord (Deut. 15:5, italics mine). Listen obediently? The best solution to spiritual deafness: Listen obediently! Isaiah 50:4-5 says:

"He awakens Me morning by morning,
He awakens My ear to listen as a disciple.
The Lord God has opened My ear;
And I was not disobedient,
Nor did I turn back."

Clara H. Scott wrote the hymn "Open My Eyes that I May See" in the late nineteenth century. Listen to verse 2:

Open my ears that I may hear
Voices of truth Thou sendest clear;
And while the wavenotes fall on my ear,
Ev'rything false will disappear:

Silently now I wait for Thee,
Ready, my God, thy will to see;
Open my ears, illumine me,
Spirit divine!

We can become people who have ears to hear, men and women who are, as James wrote, "quick to hear" (Jas. 1:19). Later in his letter James promised: "But one who looks intently at the perfect law, the law of liberty, and abides by it, not having become a forgetful hearer but an effectual doer, this man shall be blessed

in what he does" (Jas. 1:25). Paul wrote in Romans 2:13, "For not the hearers of the Law are just before God, but the doers of the Law will be justified." In the next chapter we'll see how to bring ourselves to action once we're certain we've heard God and know what he wants us to do.

Study Questions

Study Passage: James 1:19-25

1. How much time do you average per day in personal Bible study?

2. Do you often feel too busy for Bible study? Make a thorough list of your daily activities for today.

 Circle any nonessential activities.

3. Are you aware of any interferences that might be preventing you from hearing God's will? Confess these to the Lord.

4. The Pharisees are said to have prayed seven times a day. See if you can remember to pause and acknowledge God's presence seven different times throughout your day tomorrow. Ask for guidance and give praise.

5. Are there any specific areas where you want to know God's will? Reread Romans 12:1-2. Are you willing to obey?

6. Write a paragraph detailing specifically what God has called you to do.

4
Fear

Work has been defined as something which never killed anybody; but it does scare some people half to death. There may be many reasons why we don't go ahead and act once we've heard God and know what we should do. One reason is fear. In this chapter we'll look at three common fears that produce inaction and see how we can begin to conquer those fears: (1) fear we've heard wrong; (2) fear of inadequacy; and (3) fear concerning God, or unbelief.

Fear We've Heard Wrong

Fear that we haven't heard God correctly, that maybe we really don't understand his will for us, can produce a paralysis of indecision. This paralysis is related to what is commonly known as the procrastination plague. The victim grows fearful and unsure, unable to make decisions. Actions suffer delay or may halt altogether. Psychologists analyzing this dreaded paralysis have recently discovered a noteworthy phenomenon in the animal kingdom. While charting the behavior of frogs, psychologists found that if the critters were placed in a kettle of boiling water, they would immediately jump out, saving themselves. But if placed in a kettle of cool water which was then heated by slow degrees, the frogs, unable to determine when the water temperature had become unbearable, never made the decision to jump and consequently allowed themselves to be boiled to death. The procrastination plague can be deadly.

Solution

What solution exists for the indecisive Christian who fears he hasn't heard God, fears he may not actually know God's will or plan? God, who hasn't given us a spirit of timidity, but of power and love and discipline (2 Tim. 1:7), has also given us the mind of Christ (1 Cor. 2:16). When we're walking with Christ, we can confidently use our sound mind to draw logical conclusions and plans of action. Proverbs 16:9 says: "The mind of man plans his way,/But the Lord directs his steps." When we harbor no unconfessed sin and sincerely seek to follow the Lord, we don't need to be afraid to make plans. As the prophet Samuel once directed Saul, "Do for yourself what the occasion requires; for God is with you" (1 Sam. 10:7).

Have you ever made a decision when you knew you were close to the Lord and confident of his will for you, and then found yourself doubting the next day or even the next hour? When Dave and I were on Campus Crusade staff in Toledo, Ohio, I began to see the need for a united prayer effort for our ministry there. One day I hatched the idea of beginning a Women's Auxiliary for the purpose of prayer. As I prayed about it, I grew more and more confident that this was the Lord's plan.

Several days later, after failing to enlist a single member and finding no enthusiasm for such an auxiliary, I began to question the value of my plan. Our lives were already busy and filled with activities. What did I need with another responsibility? Who would want to join another group? Besides, I was exhausted and had a headache.

Then I remembered a slogan a friend in Texas always used: "Don't forget in the dark what God has shown you in the light." God had made his will clear for me when I was peacefully engaged in Bible study and prayer. Only now, in the midst of rejections and problems, did I begin to doubt his leading. Speaking of himself Jesus said, "Walk while you have the light, that darkness may not overtake you; he who walks in the darkness does not know where he goes" (John 12:35). Eventually

the auxiliary prayer group materialized, and God used it to undergird our campus ministry with prayer.

The Christian life should be an active life, not plagued with indecision and procrastination from fear we may not know God's will. "Thy Word is a lamp to my feet,/And a light to my path" (Ps. 119:105). At times God's revelations more closely resemble a flashlight to our feet when we would prefer a bolt of lightning to the head. When the Lord called Abram to leave his home, his relatives, his native country, all he had to go on was God's promise to bring him to a land God would show him. If Abram had waited for more information, undecided whether to leave until he knew exactly where God wanted him to go, he might have stayed in Haran.

The apostle Paul was a man of action who couldn't afford the luxury of indecision. He traveled from city to city declaring the message of Christ. He kept moving, but was open to changing his plans if God revealed a different route. In the middle of Paul's journeys, the Holy Spirit forbade him to speak the word in Asia, the west coast province of Asia Minor. Paul continued in another direction to Myria and attempted to go to Bithynia. But the Spirit of Jesus didn't permit him to go there either. Paul could have thrown up his hands and given up on trying to discern God's perfect plan. Or he might have stopped his journeys, undecided what he should do next. But God gave Paul a vision of a certain man of Macedonia appealing to him to come to Macedonia and help them. Immediately Paul headed for Macedonia, concluding God had called him to preach there.

God could point Paul in the right direction more easily because Paul was moving. A moving target is easier to direct than a stationary one. Remember when King David, reasoning that he lived in a fine cedar house but that the ark of God remained in a tent, decided to build God a temple? It seemed like a good idea. Nathan the prophet first advised David to do it, to do all that was in his heart. Then God spoke to Nathan and told him that David was not the one to build God's house. The job would go to

Solomon. God was faithful to correct Nathan's counsel and change David's direction. So David didn't have to fear stepping out and making a decision, as long as he stayed open to God's further revelation. If indecision paralyzes us, God has to overcome our inertia before he can continue to reveal his plan and alter our course if necessary.

Fear of not knowing God's will is unfounded. God yearns for us to know his will. He won't withhold his plan from us if we really want to follow him. A Christian has to struggle to get out of God's will. Jonah willfully disobeyed God's plan for him to prophesy and warn the men of Nineveh. The Book of Jonah records his struggle to keep out of God's will, while God does all possible to draw him back. The center of God's will is a place of rest, free from the fear of indecision.

Fear of Inadequacy

A second fear that prevents us from acting on God's will is a fear of our own inadequacy. We're afraid we're not capable. We might fail. Christians turn down opportunities to teach Sunday School, join an evangelistic outreach, volunteer for civic organizations, or run for office. Why should I write my congressman, or try to change anything as big as city politics, when there are thousands of people more qualified?

We sense our inadequacies in different areas. We're too old, or we're too young. We're not brilliant enough, not well educated. But Paul wrote, "For consider your calling, brethren, that there were not many wise according to the flesh, not many mighty, not many noble; but God has chosen the foolish things of the world to shame the wise, and God has chosen the weak things of the world to shame the things which are strong ... that no man should boast before God" (1 Cor. 1:26-28,29). God knows exactly how much education and intelligence you have. In fact, your lack of abilities may enhance your fulfillment of God's will as people realize what God can do through you. The first-century crowd marveled at Peter and John because they were uneducated and

untrained. The people recognized that the apostles got their confidence from being with Jesus (Acts 4:13).

Even the great Bible prophets suffered from fears of inadequacy. Isaiah, when he saw the Lord, proclaimed, "Woe is me, for I am ruined!/Because I am a man of unclean lips" (Isa. 6:5). Jeremiah tried to excuse himself from service: "Alas, Lord God!/ Behold, I do not know how to speak,/Because I am a youth" (Jer. 1:6).

Moses began his ministry questioning God: "Who am I, that I should go to Pharaoh, and that I should bring the sons of Israel out of Egypt?" (Ex. 3:11). Then Moses felt it necessary to inform the Almighty, "I have never been eloquent, neither recently nor in time past, nor since Thou hast spoken to Thy servant; for I am slow of speech and slow of tongue" (Ex. 4:10).

Solution

Good thing for us that God's plans aren't thwarted just because we're inadequate! It may not come as a surprise to you, but the truth is, we are inadequate! The Bible compares man to the grass that withers and the flower that fades away. "Stop regarding man," Isaiah prophesied, "whose breath of life is in his nostrils;/ For why should he be esteemed?" (Isa. 2:22).

Paul wrote the Philippians that the true believers "put no confidence in the flesh" (Phil. 3:3). He warned the Corinthians against thinking too highly of themselves: "If any one supposes that he knows anything, he has not yet known as he ought to know" (1 Cor. 8:2). Proverbs 26:16 explains that overestimating one's capabilities is one of the marks of a lazy person: "The sluggard is wiser in his own eyes/Than seven men who can give a discreet answer."

Humility has been defined as holding a right evaluation of ourselves. We shouldn't think too highly of ourselves or our capabilities. The humble person, not the proud and boastful, will be exalted by Christ.

But to have a godly humility and a proper evaluation of

ourselves, we need to realize that God made us exactly as we are. We should see ourselves through his eyes. David declares man's worth in Psalm 8:5-6: "Yet Thou hast made him a little lower than God,/And dost crown him with glory and majesty!/Thou dost make him to rule over the works of Thy hands;/Thou hast put all things under his feet."

In Psalm 139:13-15 David wrote: "For Thou didst form my inward parts;/Thou didst weave me in my mother's womb,/I will give thanks to Thee, for I am fearfully and wonderfully made;/Wonderful are Thy works,/And my soul knows it very well./My frame was not hidden from Thee,/When I was made in secret,/And skillfully wrought in the depths of the earth."

What was God's answer to Moses' excuse of being slow of speech? The Lord said to Moses, "Who do you think made man's mouth, Moses?" In Numbers Moses is said to be the most humble man on the face of the earth (12:3). Admitting God's sovereignty in our makeup helps us view ourselves accurately.

To overcome fear of inadequacy, we need to admit that we are inadequate, realize that God has made us exactly as we are, and, finally, understand that our adequacy is in God. This principle carries the most significance for our becoming people of action. Paul clearly stated in 2 Corinthians 3:5-6: "Not that we are adequate in ourselves to consider anything as coming from ourselves, but *our adequacy is from God,* who also made us adequate as servants of a new covenant" (italics mine).

The key to successful Christian living is knowing that our adequacy is from God. On our own we can do nothing worthwhile. Nothing! Not one good deed! As I once heard a speaker elaborate, "Nothing is a big zero with the rim kicked off."

But we can do all things through Christ who strengthens us (Phil. 4:13). It's God who is at work in us, helping us to accomplish his will (Phil. 2:13). *In him* we have been made complete (Col. 2:10). *In him* we have been blessed with every spiritual blessing in the heavenly places (Eph. 1). All things are possible with God.

Apart from Christ, we can do nothing. But his presence guarantees success. To Moses' protests of inadequacies, the Lord answered—not that Moses was indeed capable—but that the Lord would be with him. Moses might have appreciated a good, rousing pep talk: "Come on, Moses! You've got a lot going for you, Son. You're big and strong. You know the language of the Jews and the Egyptians. You're well educated, virtually a queen's son, the perfect man for the job. You've got more knowledge than any of those Hebrew slaves. Why wouldn't they follow you?" But God simply assured Moses: "I will be with you."

In Joshua's farewell address, he told the Israelites, "One of your men puts to flight a thousand." Why? Because they had such superior weapons or unique fighting skills? No. "For the Lord your God is He who fights for you, just as He promised you" (Josh. 23:10).

I wish all Israel had that perspective today. Perhaps many Israelites do. But I remember a comment made by a general in the Israelite army. He was lecturing when I was a student at the University of Missouri. When it came time for the audience to ask questions, I rallied all my courage and asked, "Don't you think it's amazing what God did to help Israel win the seven-day war in fulfillment of Bible prophesy?"

He laughed a bit and answered, "Madame, God isn't responsible for that victory. We have an excellently prepared army."

The apostle Paul didn't qualify as the world's strongest man. He suffered health problems and physical disabilities. But he not only accepted his infirmity, or his thorn in the flesh; he claimed that he was well content with weaknesses. God's power, he learned, is perfected in our weakness. Therefore, he chose to boast about his weaknesses, that the power of Christ might dwell in him. "And God is able to make all grace abound to you, that always having all sufficiency in everything, you may have an abundance for every good deed" (2 Cor. 9:8). Paul never gave up or used his inadequacies for an excuse to stay home. Instead, Paul allowed Christ to use his inadequacies to bring glory to God!

J. Hudson Taylor, the great missionary and founder of the China Inland Mission, wrote: "All God's giants have been weak men, who did great things for God because they reckoned on His being with them."[1]

Unbelief

Fears about God and his powers, or just unbelief, have plagued God's people in every century. The classic example of unbelief comes from the Israelites after their Exodus from Egypt. The nation stood on the verge of entering the Promised Land. Twelve spies sent out to scout the land return. Ten of the men reported back, fearful of giants in the land. They informed Moses that when they saw the Canaanites, "We became like grasshoppers in our own sight, and so we were in their sight" (Num. 13:33).

The whole nation, fearful, guilty of unbelief, grumbled against Moses, "Would that we had died in this wilderness!" (Num. 14:2). Joshua and Caleb tried to dissuade Israel from her rebellion: "The Lord is with us; do not fear them" (Num. 14:9). But Israel capitulated to unbelief and failed to enter the Promised Land. Their lack of trust cost them forty years wandering in the desert until all that generation died, except Joshua and Caleb.

Solution

In order to conquer fear or unbelief, look at our great God. Joshua and Caleb were looking at the Lord, and not at the tall inhabitants of Canaan, when they urged Israel to believe God and conquer the land. Unlike the ten spies, these two remained bold and fearless as they trusted their God.

David, squaring off against giant Goliath, looked at his mighty God, not at his enemy. He wrote in Psalm 25:15: "My eyes are continually toward the Lord,/For He will pluck my feet out of the net." And in Psalm 16:8: "I have set the Lord continually before me;/Because He is at my right hand, I will not be shaken."

Similarly, as long as Peter focused on Jesus, he was sustained to walk on the waters. But the moment he took his eyes off Christ

and looked at the raging storm, he began to sink. His unbelief came when he stopped looking at Jesus.

Looking at God increases our belief because the better we know God, the more we trust him. Unfortunately, this maxim fails to apply in most of our earthly relationships. Too often, the better we get to know someone, the more reason we see to distrust his actions and motives. But because God is perfectly just and righteous, loving and trustworthy, to know him intimately is to trust him fully.

We conquer unbelief by trusting God. David wrote the fifty-sixth Psalm when the Philistines seized him in Gath. Read verse 4: "In God, whose work I praise,/In God I have put my trust;/I shall not be afraid./What can mere man do to me?"

Our job is to commit our works to the Lord. We can trust him to accomplish everything he calls us to do. Over and over God reiterates, "I am the Lord. Nothing is too difficult for Me." Nothing merits our fears. "Faithful is He who calls you, and He also will bring it to pass" (1 Thess. 5:24). Paul knew that God could do more than Paul wanted him to do. God could perform far above and beyond his highest thoughts or dreams or desires.

It's one thing to say that we trust the Lord and believe he can perform great tasks. It's another matter to trust God to the extent that our actions change.

In 1859 a Frenchman named Blondin dazzled spectators by walking a tightrope across Niagara Falls, 160 feet above the water. The first time he crossed, Blondin received thunderous applause. He straightway blindfolded himself, turned around, and proceeded to cross the falls the second time. Again, wild applause and cheers. Next, he made the same trip while standing in a sack. The amazed crowd drew deep breaths of admiration as the Frenchman alternately crossed on stilts, walked halfway across on foot, sat down, cooked an omelette, ate it, and returned.

On one such trip, Blondin walked across the falls handily, pushing a wheelbarrow in front of him. As he stepped off the

rope, he asked the cheering crowd, "Who believes that I can make that same trip again, pushing my wheelbarrow?" To a man, the crowd answered with encouragement and trust. They trusted this man's ability to do the feat required. Then Blondin replied, "Then who will step in the wheelbarrow and come with me?" Not a man accepted the challenge. If we believe God can do what he's promised, we should step in and act with him!

In this chapter we've examined three common fears that lead to our inaction: fear we've heard God wrong, fear of inadequacy, and unbelief. Yet sometimes I hear and understand God's will in a matter; I'm not afraid; I believe God can do it; but I still don't act. I may want to lose five pounds, know that I should answer a letter promptly, intend to follow through on a church or civic commitment, feel led to talk to a neighbor about Christ, etc. But I fail to act. Fear isn't the explanation.

The next chapter deals with the most important solution to problems in our Christian walk. Self-control is a fruit of the Spirit. Andrew Murray wrote, "The secret of true obedience . . . is the dear personal relationship to God. All our attempts after full obedience will be failures until we get access to His abiding fellowship. It is God's holy presence, consciously abiding with us, that keeps us from disobeying Him."[2]

Notes

1. From *Walking with the Giants* by Warren W. Wiersbe. Copyright 1976 by Baker Book House and used by permission. Page 61.

2. Andrew Murray, *The School of Obedience* (Chicago: Moody Press), p. 39.

Study Questions

Study Passages: 1 Corinthians 1:26-29
2 Corinthians 9:8-15

1. Consider the three common fears reviewed in this chapter. Do you acknowledge any of these fears?

A. Fear you've heard God wrong and don't know his will

B. Fear you're inadequate

C. Unbelief

2. Write out the solutions to your fears. Apply the study passages.

3. To help focus on the greatness and adequacy of God, do a word study on one or more of his attributes. Look up "sovereign," "power," "might," "love," "holiness," etc., in a concordance. Chart each verse that refers to God.

4. How should a focus on God's nature help you overcome fear and inaction?

5

Our Secret Formula

Without knowledge and experience of the Spirit-filled life, no Christian can hope to please God. Bad habits that have thrived unhindered for years need something strong to dissolve them. The secret formula for victory in Christian living is Christ's power in us.

According to 1 Corinthians 2:14 to 3:3, every person falls into one of three categories: (1) Natural—someone who hasn't accepted Christ as personal Savior; (2) Spiritual—a Christian who appraises all things spiritually with his mind of Christ; or (3) Carnal—fleshly, a Christian who acts like a natural man. His life is characterized by the same sins of a natural man: jealousy and unChristlike behavior.

For a Christian, someone who definitely has accepted Christ's death as payment for his personal sins and has been born of the Spirit, the natural man category is no longer possible. But two options remain open for Christians: spiritual or carnal.

When we hear the word *carnal,* visions of gross, overt sins may flash before us. But living in the flesh also applies to a good life filled with success, but lived in one's own power. If everything I do can be explained logically as a result of self-effort, then I'm subtly choosing the carnal life. If I'm doing my best, but not allowing Christ to live his life in and through me, I'm settling for a carnal existence.

A carnal Christian, no matter how good his deeds, can't please God. Isaiah told Israel the Word of the Lord: "'What are your

multiplied sacrifices to Me?' says the Lord" (Isa. 1:11). And later, "All our righteous deeds are like a filthy garment" (Isa. 64:6).

Near the end of his life the author of Ecclesiastes concluded, "Thus I considered all my activities which my hands had done and the labor which I had exerted, and behold all was vanity and striving after wind and there was no profit under the sun" (Eccl. 2:11). Even diligent activity counts for nothing if the work was done in the flesh, apart from God's power.

Solomon reveals the same insight in Psalm 127:1: "Unless the Lord builds the house,/They labor in vain who build it;/Unless the Lord guards the city,/The watchman keeps awake in vain." Labor in man's power yields nothing of value. The righteous must live by faith, not by fleshly effort.

Discovery of the power of God's Spirit in us should ignite more change in us than any other revelation. Apart from Christ, we can do nothing! God calls us—not just to labor for him—but to abide in him and allow him to work through us, producing fruit, as though we are branches receiving strength from the vine. A carnal existence makes as much sense as a branch walling itself off, separated from the tree, in an effort to produce its own fruit, without benefit of the tree's sap and nourishment.

Carnality yields frustration. What Christian hasn't agonized with the same question Paul wrote in Romans 7:24? "Who will set me free from the body of this death?" For that which I am doing, I don't understand. I'm not doing what I'd like to do; instead, I'm doing the very thing I hate. My inner man concurs with God's law, but I see a different law in my fleshly body waging war with the law of my mind.

We may want to get up early, discipline ourselves to morning devotions, jog before or after work, read instead of watch TV at night. But we keep sleeping in, rushing off to work, arriving late, watching another day slip away wasted and unfulfilled. Dieting, Bible study, and special family times rank high with us in our minds. But our daily actions negate earnest desires. The wishing of the good is present, but the doing of the good is not.

It's a paradox: When Christ comes to live in our hearts, we become new creations with new spiritual natures. We can communicate with God. For the first time, we possess the potential to overcome sin. But unfortunately, we don't lose our old nature. The sin nature that previously controlled all actions and motives stays in our fleshly body until we die and receive our heavenly body. We're left with two options: (1) dominance by the new nature, controlled by God's Spirit; or (2) continued dominance of the old sin nature. On this choice pends Christian success or failure, happiness or defeat.

My mother used to tell my sister and me, when we were kids, that there were two invisible people on our shoulders. A good angel perched on my right shoulder. And (you guessed it!) a little devil sat on my left. My instructions were to only pay attention to my right shoulder. True, Mom's theology may sound a bit unorthodox. But she made us aware of the two-sided struggle we could expect.

Paul referred to the dichotomy, or choice we have, in different ways. The contrast of Romans 7 *vs.* Romans 8 focuses on the differences between those who live according to the flesh and those who live according to the Spirit. The former set their minds on the things of the flesh, the latter on things of the Spirit. Those living in accordance with the fleshly desires can't please God, and the mind set on the flesh is death. But the mind set on the Spirit is life and peace. So we can choose to be led by the Spirit of God or to be controlled by the flesh.

Paul wrote to the Galatians and warned them about the flesh-spirit battle. "Walk by the Spirit, and you will not carry out the desire of the flesh" (Gal. 5:16). The Spirit wars against the flesh. They oppose one another so that we can't do what we please. The deeds of the flesh are described as immorality, impurity, sensuality, idolatry, sorcery, enmities, strife, jealousy, outbursts of anger, disputes, dissensions, factions, envyings, drunkenness, carousings.

Contrast these deeds with the fruit of the Spirit—love, joy,

peace, patience, kindness, goodness, faithfulness, gentleness, self-control. We can't sit on the fence, straddled between such opposites as immorality and self-control, enmity and kindness. We can try to harmonize both sides of the fence—goodness and faithfulness on Sunday; jealousy and strife the rest of the week. But we can't last in the middle ground. Why? Because the one who sows to his own flesh will reap corruption. But the one who chooses to sow to the Spirit will reap eternal life.

In a letter to the Corinthians, Paul set forth this dichotomy in still another way. He had depicted the carnal-spiritual struggle as a war between flesh and Spirit in his letter to the Galatians. He wrote to the Romans about the same struggle, but used the illustration of slavery. Second Corinthians 4 draws a verbal picture of our outer man and our inner man. Our outer man, the flesh, is continually decaying. But our inner man, the spirit, must be renewed day by day. We can strengthen the inner man by allowing God's Spirit to control us and conform us to the image of Christ.

As for the outer man of flesh, he just gets worse and worse. Man's not getting better and better. The longer he's exposed to the world, the more decadent he grows. The more time we spend in the outer man, living in the flesh of our own efforts, the worse our old sin nature decays.

In Ephesians the two choices take the form of the "old self" and the "new self." The old self is being corrupted by lust and deceit and sin. The new self reflects the likeness of Christ and has been created in righteousness and holiness of truth. Paul encouraged us to lay aside the old and put on the new (Eph. 4:22-24).

Be Filled with the Spirit

How can we choose the new nature, the inner man? How can we make sure Christ is controlling our lives? Before he ascended to the Father, Jesus warned his disciples not to leave Jerusalem, but to wait for what the Father had promised, the coming of the Holy Spirit. Only then would they find power to be his witnesses

for the whole world. Earlier, Christ had referred to the Spirit as living water not to be given until he had been glorified. Then, belief in Christ promised flowing rivers of living water to spring from the believer's innermost being.

The Bible clearly instructs us on how we can bring ourselves under the Holy Spirit's control. Prerequisite to a filling of the Spirit comes an emptying of self. Lay aside the old self, and put on the new self. Die to sin, in order to live to Christ. Reckon our fleshly bodies dead, so we can be renewed in our spirit of Christ.

This emptying of self, or laying aside the old man, begins with confession to God. In chapter 2, I said that to confess means to agree with God concerning sin, that we have sinned, and that God forgives our sins on the basis of Christ's death for us. Without confession and dethroning self from the control center of our lives, we can't expect God to fill us with his Spirit. The Spirit waits for us to hand over the reins. Christ taught that if a seed is to grow, it must first fall to the ground and die to itself. Then new life can sprout from the seed. Confess to God any self-effort, any attempt at controlling your own life. Then, emptied of self, you are ready to be filled with the Holy Spirit.

Too many Christians are frustrated and defeated because they stop here, after the step of confession. Repeatedly they find themselves confessing the same sins, hoping to do better next time, but feeling they probably will fail again. They may sincerely repent, determine to change their ways or attitudes, and yet lack the power to change.

What's missing? When we confess, we're emptied. We need to fill up—to be filled with the Holy Spirit. God's Holy Spirit—not our self-effort—provides power for the Christian to change. Christ living in us through the power of his Holy Spirit works his will in us when we allow him to take control. Ephesians 5:18 says, "And do not get drunk with wine, for that is dissipation, but be filled with the Spirit." The analogy of getting drunk with wine infers the total control desired by the Spirit. When someone is intoxicated with wine, the wine affects his actions, even his

speech and thoughts. When we obey and are filled with God's Spirit, God influences our actions, thoughts, and desires.

We are filled with the Holy Spirit by faith, just as we became Christians by faith. "As you therefore have received Christ Jesus the Lord, so walk in Him" (Col. 2:6). We receive Christ by faith, trusting him to come into our lives and forgive our sins. We take him at his Word that he will come in if we ask him. Once Christ comes to live in our hearts, we are born spiritually and possess all of God. The Bible declares that we are then sealed by the Holy Spirit. Paul wrote the Romans, "But if anyone does not have the Spirit of Christ, he does not belong to Him" (Rom. 8:9).

Even though God's Holy Spirit lives in each believer, the Spirit doesn't automatically exercise control over every Christian. God didn't create and doesn't sustain robots. This is where our choice emerges. We can choose to run our own lives in self-effort; or we can choose to be filled and controlled by the Holy Spirit. God's will for us: "Be filled with the Spirit."

If we pray and ask God to fill us with his Spirit, to take control of our lives, how can we know if he complies? By faith we trust God to keep his word. First John 5:14-15 promises that if we ask anything according to God's will, he will grant our request. We know that to be filled with the Spirit is God's will, since he's commanded us to be filled. Pray and ask God to fill you with his Holy Spirit. Then trust him to control you.

Jesus described the process of allowing God to control our lives when he urged his followers to come to him with their heavy burdens. He instructed them to give him their burdens and take his yoke upon them. The yoke of an oxcart controls the beasts. Christ promised that submission to his control would lead to rest for the soul (Matt. 11:28-30).

The letter kills, but the Spirit gives life (2 Cor. 3:6). Jobs we've wanted to accomplish, attitudes we've unsuccessfully attempted to force upon ourselves, become possible under the Spirit's control. We learn that nothing is impossible with God.

Love, joy, peace, patience, kindness, goodness, faithfulness,

gentleness, and self-control attest to the working of God's Spirit within us. And we can't manufacture these characteristics by our own efforts. I remember a Sunday afternoon, standing in the hallway of my sorority house, directly outside "enemy territory," a roomful of girls I couldn't get along with. I wanted to go in and love them, or even like them. But I couldn't. Nothing about them or their behavior evoked affection in me. I was trying to change my attitude, repeating over again and again, "I will like them. I will like them." But it didn't work. I imagined kind deeds I could perform for them. Yet even then, I didn't feel kind; I still disliked them.

Later in the year I discovered how to be filled with the Holy Spirit. One morning I was in the middle of my prayers and realized that I was earnestly praying for those same girls. And I was filled with compassion and love for them. They hadn't changed; I had. God's Spirit was loving them through me.

Being filled with the Spirit affects our attitudes, but also results in changed actions. God's power in our inner man eventually penetrates to the outer man. Now we can really start to put an end to procrastination and laziness. God cares about every area of our lives. When the Lord instructed Moses in the details concerning tabernacle construction, God didn't leave anything to self-effort. A man from the tribe of Judah, named Bezalel, was filled with the Spirit by the Lord God, in order that he might be a fine craftsman and make artistic designs for the tabernacle. The power of God's Spirit would make Bezalel a better and more skillful worker (Ex. 31:3).

When Samson rescued Israel, God filled him with the Spirit to furnish him power for the job. Prior to Samson's amazing feats we read, "The Spirit of the Lord came upon him mightily" (Judg. 14:6,19). God's Spirit gave Samson power to accomplish deeds he never could have done in his own power.

Likewise, God's Spirit in us makes it possible for us to experience victory in areas where we've continually failed. A friend of ours had been an alcoholic for years. He had repeatedly

made his vows and sworn "off the wagon." But each time, he would break his self-promises and give in to his drinking problem. At age 59, Jim found Christ and learned what it means to have God's Spirit control him. Several weeks after receiving Christ, Jim prayed for strength to quit drinking. God took away his desire for alcohol and has given Jim the power to overcome this temptation for the past five years.

Jan had quit smoking at least twice a year for the last ten years. But in her heart, she knew it wouldn't last; she was hooked. The week Jan invited Christ into her life and asked Christ to take control, she lost her desire to smoke.

Those are dramatic examples of how God's Spirit can work in us to break bad habits. Sometimes the Spirit works less dramatically, slower than we want him to work; but still he works within us. Another friend came to Christ from a background of gangs and drugs. His conversion was just as real and his love as great as Jim's. But this friend still struggles with his desire for drugs. Sometimes he fails; but he's learned to confess to God and let God's Spirit fill him again. His recovery hasn't come instantaneously. But he has seen progress and change as he has trusted God day to day.

The Holy Spirit will help us see success in areas where we've always failed. But he will also give us the power to do more effectively tasks we're used to doing in the flesh. For example, even in the flesh I'm fairly efficient and hard-working by nature. If I've sinned and retaken control of my life from the Spirit, I still may achieve my daily work goals and complete kitchen duties and errands. But without relying on the Holy Spirit's power, all those efforts count for nothing in God's eyes. He isn't impressed. God seeks loving obedience, not forced sacrifice from self-effort. Filled with the Spirit, I can accomplish the same chores with joy and a relaxed thanksgiving.

God spoke through Jeremiah and chided Israel for forsaking God, the fountain of living waters, in order to hew for themselves broken cisterns that couldn't hold water (Jer. 2:13). By choosing

to rely on themselves, the Israelites were settling for second best, or worse. We can continue to live second class and miss capitalizing on the power of God that dwells inside us.

Praying to be filled with the Holy Spirit isn't a once-for-all-time decision. Unfortunately, we can retake control from the Spirit by sinning. That's why being filled with the Spirit is an ongoing process of confessing to God and asking to be filled with the Spirit. Sometimes I have to confess and be filled a dozen times a day.

When I get up each morning I like to ask God to take control of my life for that day and live his life through me. Then during the day, if I'm sensitive to God, his Spirit will convict me of sin.

For example, I've told God I want to lose ten pounds and not snitch between meals. But I snitch. Instead of giving up altogether, I need to confess, then ask Christ to take control again. Later in the day I consciously ignore a girlfriend's request to phone her after lunch. When I realize my broken commitment because I was too selfish or lazy to phone, I should confess to God, thank him for his forgiveness, and ask him to fill me with his Holy Spirit. (Then make the call!) Each time I retake control, I need to give it back to God—and the sooner, the better.

If you don't get anything else from this book, I hope you'll realize the impossibility and futility of overcoming laziness, procrastination, and habits of unfaithfulness apart from the power of the Holy Spirit. This is God's secret weapon for his children.

Set Your Mind

One of the greatest battle frontiers in the war against laziness and inefficiency is the mind. Skirmishes are often won or lost in our minds, before we lift a finger to act. In our new nature, filled and controlled by God's Spirit, we possess the mind of Christ. And Christ calls in all our thoughts, urging us to bring them captive to him.

I can't overemphasize the importance of a godly mindset. In

the struggle of flesh against spirit, our mind plays the vital role. Romans teaches that those who are according to the flesh set their *minds* on the things of the flesh, but those who are according to the Spirit set their *minds* on the things of the Spirit. The *mind* set on the flesh is death; but the *mind* set on the Spirit is life and peace. The *mind* set on the flesh is hostile to God and cannot even subject itself to the law of God (Rom. 8:5-7).

How can we reach the mindset that will give us life and peace? Philippians 4:8 reads, "Finally, brethren, whatever is true, whatever is honorable, whatever is right, whatever is pure, whatever is lovely, whatever is of good repute, if there is any excellence and if anything worthy of praise, let your *mind* dwell on these things" (italics added).

By an act of my will I can turn my mind toward worthy subjects. By consciously remembering Christian truths, Christ's life and ministry on earth, any Scripture passages I've memorized, or blessings and gifts God has given to me, I can begin to train myself for a more godly mindset. I need to discern whatever is good, lovely, and positive in other people, instead of analyzing their faults. Sometimes I think that 90 percent of us Christians feel we have the gift of exhortation; and I'm one of this majority. We can see so clearly the bad attitudes and irritating or unspiritual habits of our brothers and sisters in Christ. Our sharp discernment causes us to criticize openly or inwardly. But we forget that exhortation involves encouragement. Barnabas, the son of encouragement (or exhortation), spent his thoughts and energies building up his brothers in Christ, not criticizing them.

Colossians 3:2 says, "Set your mind on the things above, not on the things that are on earth." The paths of our thoughts, whether they lead chiefly through heavenly spheres or bog down in earthly mire, reveal our mindset. When Peter attempted to prevent the Lord from suffering, Jesus reprimanded him, "Get behind Me, Satan! You are a stumbling block to Me; for you are not setting your mind on God's interests, but man's" (Matt. 16:23).

Setting the mind goes a step beyond knowing. First, we

discern God's will. Then we apply our minds to knowledge, determining, setting our minds on the action. Peter wrote, "Therefore, gird your minds for action, keep sober in spirit, fix your hope completely" (1 Pet. 1:13). Proverbs 22:17 advises, "Apply your mind to my knowledge."

In our present Christian generation, a mind set on the kingdom of God requires us to live in expectation of Christ's return and to set our minds on God's interests. We all admit that if we knew Christ would return tomorrow, we'd behave differently today. The evil servant in Matthew 24 made the mistake of not really expecting his master's return. His mindset was wrong.

In becoming an effectual doer, we have to set our minds on what we know is God's will. But a godly mindset differs from raw determination. And it's not positive thinking. All of us have tried to grit our teeth and decide we *will* be on time, *will* work harder, *will* read the Bible more. And generally, we *will* get frustrated. The main difference between sheer determination and a godly mindset is our dependence on God's Spirit.

Set the Heart

An added dimension to a Spirit-filled mindset is setting our hearts. Proverbs 3:1 says, "My son, do not forget my teaching,/ But let your heart keep my commandments."

"His heart wasn't in it." "He has his heart set on it." "Do it with all your heart." Such comments reflect how important our heart is in effective doing. We say that we have the heart for a task when we deeply desire to see that job done.

The Hebrew word for *heart* ranges in meaning to include "inner man," "mind," "will," "heart." Decision battles are fought, won, and lost in this seat of emotions and will, as in our minds. For example, in Genesis 6:5 the Bible records that in the days before the flood, every imagination or intent of the thoughts of man's heart was only evil continually. Another wording might read that every thought framed in man's mind, or purposed in man's heart, was only evil continually. We can set our mind on

evil or good, and we can purpose our heart for evil or good.

Part of setting our heart comes from earnestly desiring to accomplish God's will. Jesus lauded those who hunger and thirst after righteousness and promised that they would be satisfied. Unless we yearn to obey God and do the things that lie in his will for us, our natural apathy will defeat us before we begin. Projects will die in our minds from lack of loving care.

God's people have been those who set their hearts on God and on his plans. My life verse and motto is Ezra 7:10: "For Ezra had set his heart to study the law of the Lord, and to practice it, and to teach his statutes and ordinances in Israel." Ezra set his heart for the things God had called him to do, both in personal obedience and in teaching others.

King Hezekiah ruled Judah righteously, although his father and previous kings corrupted Israel and led the nation to idols. For that reason, Hezekiah stands out in a dismal history of disobedience as a man whose heart and mind followed the Lord. Second Chronicles 31:21 reports, "And every work which he began in the service of the house of God in law and in commandment, seeking his God, he did with all his heart and prospered."

In the same way as the author of Proverbs advised, "Apply your mind," he also admonished, "Apply your *heart* to discipline" (Prov. 23:12, italics added). To succeed in discipline, apply your heart! God's Holy Spirit within us has freed us from the dominance of sin, freed us so that we can overcome laziness. But we still have to choose to apply our minds and apply our hearts to do what God calls us to do. Ephesians 1:18 refers to "the eyes of your heart," a good metaphor that conveys the need to focus our hearts on the things of God.

Set your mind; set your heart. "Let each one do just as he has purposed in his heart" (2 Cor. 9:7). King Josiah reigned thirty-one years in Jerusalem and ruled righteously, attempting to turn Judah back to the Lord. He ordered reparations of the Temple which had been left to ruin and decay by Judah's evil kings. In the

restoration process, the books of the Law were uncovered and brought to the king. When Josiah heard the words of the Law, he tore his clothes and humbled himself before the Almighty God. Then he gathered all the elders of Judah and Jerusalem and all the people, from the greatest to the least, and went up to the house of the Lord, where he read in their hearing all the words of the book of the covenant.

Then Josiah "made a covenant before the Lord to walk after the Lord, and to keep His commandments and His testimonies and His statutes with all his heart and with all his soul, to perform the words of the covenant written in this book" (2 Chron. 34:31). Josiah made all who were present stand with him in a covenant with God, to do God's statutes with all their heart.

And Josiah's covenant would be a good step for all of us who are serious about doing God's will. Make a covenant with the Lord to walk in the Spirit, to set your mind and heart on him, and to discipline yourself for the purpose of godliness.

Study Questions

Study Passages: 1 Corinthians 2:14 to 3:3; Ephesians 5:15-21

1. Describe the three categories of people given in 1 Corinthians 2:14 to 3:3. In which category are you? How do you know?

2. In several different ways, describe the two choices open to believers.

3. In your own words, how can you make sure you're filled with the Holy Spirit right now?

4. What specific changes can you expect to see in your life as a result of living under the control of the Holy Spirit?

5. Make a note throughout this week of every time you're convicted of sin. Confess the sin on the spot, and ask God to fill you with his Spirit.

6. Explain what it means to "set your mind on things above."

7. List three actions you plan to "set your heart" on this week.

8. Write out a covenant you can make with God to let his Spirit make you a more effective doer.

6

The Beginning and the End

Some people have no trouble beginning projects. A college girlfriend of mine probably began more books than any one person I know. You could always identify her room by the myriads of partially read books placed in strategic corners and on shelves and desk tops, standing backside up, teepee style, to mark her place.

Other people show forte in finishing projects. They may hesitate for weeks or months and turn down countless ideas as implausible or beyond their abilities. But once they make the move, they can't rest until the job is ended.

Because of the differences in these two divisions of doing—trouble beginning a job, and trouble completing it—let's consider separately beginning and finishing.

Begin It

Putting off the first steps of any project or plan we want to do adds up to procrastination. A scrawl on the subway wall reads: "Tomorrow is today's greatest labor-saving device." How many people have conceived great ideas that never materialized because no one began to act on the idea?

The late Thomas Edison chatted one day with the governor of North Carolina. The governor complimented Edison on being a great inventor.

"I am not a great inventor," said Mr. Edison.

"But you have over a thousand patents to your credit, haven't you?"

"Well," explained Mr. Edison, "The ideas I use are mostly the ideas of people who don't develop them themselves."[1]

Jesus said, "We must work the works of Him who sent Me, as long as it is day; night is coming, when no man can work" (John 9:4).

What stops you before you start? Fear of opposition, fear of failure, or lack of faith can keep us from stepping out and beginning.

At a dramatic moment in Israel's history, as that nation stood on the verge of one of God's greatest miracles, God delivered some surprising advice. There Moses waited with the Red Sea before him, Pharaoh and his raging army closing in behind him, and the grumbling Israelites beside him. But before God instructed Moses to raise his staff for the waters to part, God had this to say to his servant: "Why are you crying out to me? Tell the sons of Israel to go forward" (Ex. 14:15).

Joshua succeeded Moses as leader in Israel. God gave him the charge of leading the Israelites across the Jordan and into the Promised Land. That may not sound like an awesome task until you realize that they didn't have bridges and ferries in those days. The Jordan River, raging at flood stage, greeted poor Joshua as he stepped into the position of leadership. And the Israelites hadn't exactly proven themselves wholeheartedly loyal to their previous leader.

Joshua followed God's instructions and commanded the priests carrying the ark of the covenant of the Lord to begin. "And it shall come about when the soles of the feet of the priests who carry the ark of the Lord, the Lord of all the earth, shall rest in the waters of the Jordan, the waters of the Jordan shall be cut off, and the waters which are flowing down from above shall stand in one heap" (Josh. 3:13). It wasn't until the priests put their feet into the overflowing Jordan that God made the water

passable. They had to get their feet wet! To begin God's will is an act, a step of faith.

Laziness obstructs beginnings. If we live in dependence on our feelings, we'll be reticent to start anything. To begin something new means changing our habits or normal mode of action. That means overcoming inertia, moving out on the fact that God wants us to begin, regardless of our feelings pro or con.

When Dave and I were working with a campus ministry in Toledo, Ohio, we had to set up many of our appointments via the phone. Sometimes we'd hold a large open meeting where a Christian speaker covered a topic of interest to students—love, marriage, prophecy, dating, etc. At that meeting we'd collect cards from students interested in learning more about a personal relationship with Christ, cards with names, addresses . . . and phone numbers.

Now, I have always hated phone calls. It's so easy to be misunderstood when people can't see your facial expressions. And there's some force that repels me from sitting down and dialing that number. The hardest part of my job description was telephoning. And the most difficult point came in beginning my calls. Once I'd made the first connection, I could zip through a long list of numbers. But that first step! If I had waited for a time when I felt like phoning, those students would never have heard from me. We can't let our feelings stop us from beginning what God intends for us to do.

There may be many other reasons which contribute to our failure to begin—a wrong mindset, wrong heartset, misplaced values. But no matter what form our failure to begin God's work may take, that inaction is disobedience.

Instant Obedience

Have you ever noticed the way the Gospel writer Mark used the word "immediately"? As soon as Jesus was baptized by John the Baptist, *immediately* the Spirit impelled Jesus to go out into the

wilderness. And *immediately* he went (Mark 1:12).

Jesus expected the same kind of instant obedience from his disciples: "'Follow Me, and I will make you become fishers of men.' And they immediately left the nets and followed Him" (Mark 1:17-18).

Continually in Mark the past tense completed action follows the present-tense command. Jesus said, "'I say to you, rise, take up your pallet and go home.' And he rose and immediately took up the pallet and went out" (Mark 2:11-12). To the man with a withered hand, Jesus commanded, "'Stretch out your hand.' And he stretched it out, and his hand was restored" (Mark 3:5). When Jesus raised Jairus' daughter from the dead, he told her: "'Little girl, I say to you, arise!' And immediately the girl got up and began to walk" (Mark 5:41-42).

Instant obedience doesn't come naturally to me—far from it! I'm afraid my pathway on the road to God's will for my life is marred with scuffmarks from my dragging feet. But I want to see God change me and make me spontaneously obedient to his still small voice within me.

I've always been deliberate, too deliberate. I remember the times Dave and I stood socializing after a meeting or party and someone said, "Could anybody give me a ride home?" Almost instantly Dave would volunteer, or at least ask if home was in our direction. Not me. I'd still be calculating every angle of convenience *vs.* inconvenience, whether or not I could spare the time.

Even when someone in authority tells me to do something, I rarely respond in instant obedience. Seldom could my actions be described as immediate. I question and try to read my feelings to determine if I really want to do what I'm told.

To immediately respond yes to God often means saying no to something or someone else. And that change requires an effort and a decision. Some of our deepest regrets stem from failure to respond instantly in obedience. Then it's too late; we've missed our opportunity.

All of us know someone who seems plagued by indecision,

someone who can never make up his or her mind. I have a frien[d] who gave up breakfast while living in her college dorm because she could never decide so early in the morning which cereal to choose. On a larger scale, continual failure to obey God instantly may result in acute indecision. Saying no to God's leading is disobedient. But disobedience is also saying nothing to God, not yes, not no.

Often Christians find it relatively easy to make one significant decision to obey God. We say yes to God's call overseas, yes when God leads us to marry. But our subtle daily refusals to obey God deaden us; and we gradually grow ineffective in God's service. Only routine faithfulness can bring us out of the mire of indecision.

When my sister and I were in grade school, Dad gave Mom a special plaque to hang above her kitchen sink. The slogan was only a joke; I don't think my Mom ever needed prompting to work hard. Industry came with her German heritage. Just for fun, because the words were too big for us to understand, Dad had my sister and me memorize the words. I still remember some of them:

> "Lose this day loitering, 'twill be the same story tomor-
> row, and the next more dilatory. This indecision brings
> its own delay; and days are lost lamenting over days.
> Are we in earnest? Seize this very moment. What you
> can do or dream, you can begin it. . . ."

The ancient philosopher Plato had the same idea: "The beginning is the most important part of the work."[2]

Finish It

Now that we have begun, how can we consistently finish whatever God calls us to do? I wonder if there exists a person who has never started an exercise program or a diet. But how many of us actually achieve our desired weight and stay there, or reach good physical condition and keep up training?

On a higher level, many Christians who began to fulfill the

inistry God called them to never finished it. Often brand-new Christians are excited about their new faith and share Christ's message with everything that moves. But when they become older, more "mature" Christians, they rarely talk about Christ to others. Quiet times or daily devotions begun in earnest fade in neglect. Most of us could list abandoned resolutions left over from New Year's Eve—or maybe we can't even remember them.

Again, Jesus shows us the perfect example through his persevering life on earth. Jesus fixed his eyes on Jerusalem in order to fulfill his mission—to be crucified and die for our sins. He overcame opposition from Satan, men, and physical circumstances to finish the job. He taught his disciples, "No one, after putting his hand to the plow and looking back, is fit for the kingdom of God" (Luke 9:62). At the end of his earthly life, Jesus could pray to the Father, "I glorified Thee on the earth, having accomplished the work which Thou hast given Me to do" (John 17:4). And on the cross: "It is finished" (John 19:30).

A similar attitude emerges from the life and letters of the apostle Paul. "But now finish doing it also," Paul wrote the Corinthians, "that just as there was the readiness to desire it, so there may be also the completion of it by your ability" (2 Cor. 8:11). And to Archippus, one of the believers at Colossae, he wrote, "Take heed to the ministry which you have received in the Lord, that you may fulfill it" (Col. 4:17). Paul gave the same advice to Timothy: "But you, be sober in all things, endure hardship, do the work of an evangelist, fulfill your ministry" (2 Tim. 4:5).

Near the end of his life, Paul wrote to Timothy: "I have fought the good fight, I have finished the course, I have kept the faith" (2 Tim. 4:7). And at his tearful final parting with the Ephesian elders, Paul confided, "But I do not consider my life of any account as dear to myself, in order that I may finish my course, and the ministry which I received from the Lord Jesus, to testify solemnly of the gospel of the grace of God" (Acts 20:24).

Most Christians have trouble finishing some aspect of God's will or completing projects and plans. Incomplete obedience

from God's people isn't a new phenomenon. Perhaps the best case history concerns Israel at the critical moment when the Israelites stood on the threshold of the Promised Land.

We know the events. Moses agrees to send out twelve spies into Canaan to check out the land. The spies return with conflicting reports and a ten-to-two decision that Israel is just too weak to conquer the giants in the land. Nobody questions God's will. God had commanded them to inhabit the land of Canaan and subdue the people. But Israel's unbelief kept them from acting.

Israel paid dearly for her incomplete obedience. Even when the Israelites finally entered the land under Joshua, the tribes failed to finish the job. They disobeyed God's command to annihilate the Canaanites and possess the land wholly. They didn't finish the job! Joshua records what happened:

"Now as for the Jebusites, the inhabitants of Jerusalem, the sons of Judah could not drive them out; so the Jebusites live with the sons of Judah at Jerusalem until this day" (Josh. 15:63).

Likewise, Manasseh and Ephraim: "But they did not drive out the Canaanites who lived in Gezer, so the Canaanites live in the midst of Ephraim to this day, and they became forced laborers" (Josh. 16:10).

Again and again Joshua used the phrase "But they did not drive them out completely." He rebuked Israel, "How long will you put off entering to take possession of the land which the Lord, the God of your fathers, has given you?" (Josh. 18:3).

The Book of Judges records each tribe's disobedience. Judah failed to drive out the inhabitants of the valley. The sons of Benjamin didn't drive out the Jebusites from Jerusalem. Manasseh didn't take possession of Beth-Shean or its villages; neither did Ephraim, Zebulun, Asher, Naphtali, or Dan. But the Canaanites persisted in living in the land (Judg. 1:19-34).

The remainder of the historical books record the price Israel had to pay for her incomplete obedience, for leaving the job undone. The same people the Israelites failed to oust from the

Promised Land returned again and again to plague Israel from generation to generation. When God chastised them for their disobedience, he predicted their ensuing penalty: "But you have not obeyed Me; what is this you have done? Therefore I also said, 'I will not drive them out before you; but they shall become as thorns in your sides, and their gods shall be a snare to you'" (Judg. 2:2-3).

In the Numbers account of Israel's failure to enter the land, Joshua and Caleb emerge as sharp contrasts to the other ten spies. Their complete obedience and total faith in God stand against Israel's incomplete obedience and lack of trust. Caleb urged the people, "We should by all means go up and take possession of it, for we shall surely overcome it" (Num. 13:30).

Joshua and Caleb received their reward. All the other adult Israelites present on that day died in the wilderness. Only Joshua and Caleb got to enter the land God promised to his people.

God knows our weaknesses and our circumstances; yet he calls us to complete obedience, to finish whatever he shows us to do. Unlike blind faith or blind obedience, the trust God expects from us comes when we keep our eyes open and fixed on him. When Jesus demanded complete obedience from his disciples, he didn't hide the persecution and hardship in store for them. "They will make you outcasts from the synagogue," he warned them, "but an hour is coming for everyone who kills you to think that he is offering service to God" (John 16:2).

Earlier Jesus had alerted his men to the exacting requirements of discipleship and urged them to count the cost. Anyone who wants to build a tower must first sit down and calculate the cost, to see if he has enough to complete it. When a king sets out to meet an opposing king in battle, he must first sit down and take counsel whether he is strong enough with ten thousand men to encounter the one coming against him with twenty thousand. In the same way, we need to calculate the cost of fulfilling God's will (Luke 14). But we look beyond ourselves to the God of infinite resources and power in all such calculations.

Part of the battle to finish is won in the beginning. From the outset, make a commitment to finish what you start. Evidence abounds in the broken homes across our country, evidence of commitments not made in the beginning. Marriage studies evaluate the modern trend of rampant divorce and conclude that couples enter marriage with one hand on the back door. Their commitment, at best partial, dissolves when hard times come. The marriage partners hold an option to quit.

You've probably experienced the difference a firm commitment can make in the duration of relationships. Most of us realized we were stuck with our brothers or sisters for life. Even though you may have had some of your worst fights with your sister, you eventually reconciled because she was still your sister. The same might have been true with a best friend. Somehow, you always got back together. But quarrels with acquaintances might have been enough to dissolve any existing friendship.

I admit that I was a joiner when I entered the University of Missouri. My freshman year saw the addition of my name to eight organizations. I began in these groups with varying degrees of commitment. I loved the Speaker's Committee and never missed a meeting. We decided what celebrities we'd invite to speak at MU. But I signed up for half a dozen groups just to check them out. After a few weeks I dropped most of them. I joined a sorority and resolved not to quit, but to keep an arm's length from full involvement. Four years later, that fairly accurately described my sorority days.

The following year, after personally accepting Christ, I began to attend Campus Crusade for Christ meetings, determined to become a part of their work and learn all I could. That commitment made the difference and kept me actively involved when homework and other activities vied for my time.

If you're a lifetime dieter, like me, you know deep inside when you begin a diet whether or not you're serious and committed to keeping it. I suppose I've lost an entire person (and gained most of him back) over the years of weight watching. But there have been

...sons of seriousness when I've achieved my dieting goals.

Make a commitment in the beginning and avoid some of the temptation to quit later. Commit yourself, verbally or in writing: "I will write my parents once a week." Or go a step further and make a commitment verbally or in writing to another person: "Mom and Dad, I will write you once a week."

In fact, it often helps to make yourself accountable to someone else. This sums up the major success of Weight Watchers. People are accountable to someone else who weighs them in and keeps a record of gains and losses. Many would-be physical fitness seekers find it helpful to make a pact with a partner to run together each morning. It helps my momentum in writing to simply tell Dave that my goal is to finish this chapter by the end of next week.

Perseverance

We can't talk about finishing the job without mentioning perseverance. Perseverance is persisting in an undertaking in spite of opposition or discouragement. It forms an integral part of maturing as a Christian. Peter wrote, "applying all diligence, in your faith supply moral excellence, and in your moral excellence, knowledge; and in your knowledge, self-control, and in your self-control, perseverance, and in your perseverance, godliness; and in your godliness, brotherly kindness, and in your brotherly kindness, Christian love" (2 Pet. 1:5-7). Perseverance isn't just a character trait that some people are blessed with and others of us don't have. It's a quality that God builds in us as we obey him in every area of our lives.

Paul told Timothy to pursue perseverance and to flee harmful desires (1 Tim. 6:11). He told him to throw himself wholly into the work God had given him. "Take pains with these things; be absorbed in them, so that your progress may be evident to all. Pay close attention to yourself and to your teaching; persevere in these things" (1 Tim. 4:15-16).

We live in an instant society—instant milk, instant coffee, TV

dinners, instant communications, instant answers. We like instant results. When we don't get immediate results, our tendency is to jump to the next activity. But God doesn't mold us in the image of Christ instantly. We're under construction while we struggle on earth.

It's rare these days to hear of someone who's devoted his entire life to one cause or one goal. We float in and out of causes with the rising tides. I respect men and women who persevered in order to complete one job. It took Daniel Webster thirty-six years of solitary work to complete his dictionary. A man named Cruden spent his entire life in the woods cross-referencing Scripture and developed the classic Cruden's Concordance of the Bible.

God will allow some Christians victory instantly and take away their desire for alcohol or cigarettes. For others, God in his divine sovereignty doesn't take away that desire, doesn't automatically make it easy for his child to overcome a bad habit. For these believers, the struggle may continue for years, even for all their years on earth.

God has called us to persevere, not to give up. Press on, fight the good fight, run in such a way as to win. "Be steadfast, immovable, always abounding in the work of the Lord, knowing that your toil is not in vain in the Lord" (1 Cor. 15:58).

God hasn't exempted us from failure. Someone has said that defeat isn't bitter if it isn't swallowed. Our failures can turn into God's most effective teaching tools. We're more receptive to God's instructions when we've just seen our own methods fail. Realize that you're free to fail. God won't give up on you.

God knows our human nature and in Scripture continually encourages us not to lose heart. Jesus told the parable of the nagging widow who pleaded before the unrighteous judge, "to show that at all times they ought to pray and not to lose heart" (Luke 18:1).

Paul reminded the Corinthians that though their outer man was decaying, though they might fail and sin, they shouldn't lose heart because their inner man was being renewed day by day

2 Cor. 4:16). And to the Galatians he wrote: "And let us not lose heart in doing good, for in due time we shall reap if we do not grow weary" (Gal. 6:9).

Ironically, tribulation can build perseverance. "We also exult in our tribulations, knowing that tribulation brings about perseverance; and perseverance, proven character; and proven character, hope" (Rom. 5:3-5).

God prefers daily loyalty and routine faithfulness over big-splash Christianity. The Lord reprimanded the Israelites through the prophet Hosea: "For your loyalty is like a morning cloud,/And like the dew which goes away early./. . ./For I delight in loyalty rather than sacrifice,/And in the knowledge of God rather than burnt offerings" (Hos. 6:4,6).

God could have caused Israel to possess the Promised Land in one fell swoop, one giant miracle. But his plan called for their routine faithfulness. Back in Exodus 23:30, God had revealed his plan: "I will drive them [the Canaanites] out before you little by little, until you become fruitful and take possession of the land."

Daily, routine faithfulness requires constant consultation and communion with God throughout the day. I cherish my "constant communion" days, when I take the time to bring every thought captive to Christ during my daily routine, to pray without ceasing while I'm doing dishes, feeding the baby, washing my hair, walking. If only I would live this way each day! But I get wrapped up in my activities and plans and problems.

It used to puzzle me that Paul, the man of action, would write the Thessalonians, "Make it your ambition to lead a quiet life and attend to your own business and work with your hands, just as we commanded you" (1 Thess. 4:11). But any labor can be godly and can draw us closer to the Lord, when we're routinely faithful.

The dedicated missionary Hudson Taylor said: "We have too many 'celebrities' and not enough servants—'nine day wonders' that may flash across the scene for a time and then disappear. Before God works *through* a man, He must work *in* a man,

because the work that we do is the outgrowth of the life that we live."[3]

We can't keep getting ourselves pumped up for each big event, for one big sacrifice or one final surrender. We have to die daily to sin and yield daily to God, to continually make choices of obedience. Begin God's work, finish it, and persevere.

An anonymous poem reads:

> The church is made of just two kinds of folk,
> No matter how closely you view it;
> The ones who will talk about what should be done,
> And those who get busy and do it.

God's work excels any other work men may undertake. Do Christians excel proportionately? Are we excelling in all we do as representatives of Christ on earth? The next chapter will deal with the quality of our labor.

Notes

1. From *Speaker's Encyclopedia of Humor,* ed. Jacob M. Braude (Englewood Cliffs: Prentice-Hall, Inc., 1961), p. 121.

2. From *The Republic,* book 2, line 377*b*.

3. From *Walking with the Giants* by Warren W. Wiersbe. Copyright 1976 by Baker Book House and used by permission. Page 64.

dy Passage: 2 Peter 1:5-8

Name three projects you've thought about doing but haven't started.

Why didn't you begin them?

Do you really want to begin? If so, set a time and do it!

2. Name three projects you've started, but never finished.

What kept you from completing them?

Make yourself accountable to someone. Plan how you will complete the job. Calculate the cost of its completion (time, energy, money).

3. How have past tribulations increased your perseverance?

4. To live a life of routine faithfulness, what changes will you need to make in your daily habits?

7

Do It Excellently

We make a tragic mistake when we don't do our best because we're Christians and know that God and our Christian friends will forgive us. I think Paul may have been cautioning Timothy against this tendency to do less than his best around Christians when he wrote: "And let those who have believers as their masters not be disrespectful to them because they are brethren, but let them serve them all the more, because those who partake of the benefit are believers and beloved" (1 Tim. 6:2). Since we feel less pressure to teach brilliantly before a Sunday School class than if we were teaching at a public school or speaking publicly, we may conclude that the Sunday School class merits less preparation.

How excellent is your private Christian life, the part only God sees? Few people will ever know how faithfully or intensely you study your Bible or pray. I finally admitted to myself in college that my treatment of class assignments and course study differed drastically from my personal Bible study. Conscientiously I fulfilled each class assignment, knowing I'd receive a grade for projects completed, a higher mark for work well done. My Bible study usually squeezed its way into my other activities when I had a spare moment. And when I did study the Bible, my methods were haphazard and loose, not at all like my homework studies.

What a critical error in our thinking! Christians should be renowned as the best workers in the world, the most efficient,

honest, skillful at their jobs. Every boss, Christian or not, s̶
yearn to hire Christians. People should count on us to be
best, most dependable friends possible. God has made us
representatives, Christ's ambassadors on earth. Did you ever sto
to think that all someone may ever see of the Lord Jesus on earth
is your life?

Up to this point we've talked about doing God's will in God's
power. Now we need to emphasize doing it God's way. What is
God's way of doing things? I knew a Christian girl several years
ago who loved the Lord and knew him intimately. Rosemary
never seemed surprised at God's miracles or at answered
prayers. Time after time when we saw God do something only he
could do, Rosemary would grin and say, "Honey, that's his style."
Our little Christian group prayed we could get a room to hold a
large evangelistic meeting. We ended up with an auditorium, and
God filled it. "That's his style." A friend struggling to make his
grades asked for prayer to help him study and pass biology. Our
friend scored an A. "Honey, that's his style!"

God does have a style, the highest standard of excellence. His
style is evidenced everywhere in his creation. Each autumn I'm
overcome with the beauty of the colors God has given to his
world. At least a hundred shades of green intermingle with reds
and yellows, browns and oranges, to create scenes man could
never recreate. God could have created our earth in black and
white. We never would have known the difference. Colors rarely
affect the functioning of the world. But God made the beauty of
colors to reflect his beauty. He made his wonders for us to richly
enjoy. For he "richly supplies us with all things to enjoy" (1 Tim.
6:17).

God has filled his creation with infinite variety. He might have
made only one kind of bird, or one species of tree or leaf; but
that's not his style. Each living creature contains such an intricate
network of cells, vital organs, and complex reactions that science
can only attempt to describe what God has done.

The God of the Scriptures asserts his excellency in his

...onship to creation. In his instructions to man on how man ...st worship the Almighty, God commanded Moses to build a ...bernacle. But this was not to be an ordinary tent of meeting. ...od's specific orders called for skillful workmen, minute specifications, the most excellent materials, bronze and gold and silver, fine linen and acacia. You may find chapters 35—40 of Exodus a little dull reading. But God, who wouldn't permit a sloppy job on his tabernacle, felt it important to guarantee that the work would be excellent. So he described in detail what Israel must do. When the work ended, they knew it was what God wanted: "And Moses examined all the work and behold, they had done it; just as the Lord had commanded, this they had done. So Moses blessed them" (Ex. 39:43).

We can see the same standard of excellence in Jesus' earthly life. When Jesus turned the water to wine at the wedding feast, the headwaiter wondered why this most excellent wine had been saved until last. He healed the lame, and they didn't limp away— they leaped! The sick picked up their pallets and walked home, or rose to wait on Christ. He didn't settle for improved vision for blind men. Jesus gave them back their complete sight. He captured audiences as he spoke with authority. I have a feeling that his sermons were smooth and well prepared. Look at his Sermon on the Mount, for example. He did everything well.

Is it unreasonable for God to expect us to do our best? Peter wrote, "Keep your behavior excellent among the Gentiles" (1 Pet. 2:12). Part of the sanctified life God calls us to involves his setting us apart for his purposes. We separate from the world's mold in every area of our lives in order to glorify him.

God entrusted his statutes and commandments to his people, Israel. In keeping them, Israel was to show itself a nation set apart to God in the midst of heathen nations. Jesus instructed his followers, "You are the light of the world. . . . Let your light shine before men in such a way that they may see your good works, and glorify your Father who is in heaven" (Matt. 5:14,16).

Far too often, the difference between Christian and non Christian organizations or meetings does not glorify the Father. Christian meetings are the ones you can count on to begin late and end late. How many Christian organizations, projects, or programs excel secular equivalents? Many do excel; but many do not.

If God touches every area of our lives, and the Holy Spirit controls us, then even our secular works, jobs, and commitments should reflect our relationship with God. Paul wrote Titus and criticized certain men whose lives didn't coincide with what they claimed to believe. "They profess to know God, but by their deeds they deny Him, being detestable and disobedient, and worthless for any good deed" (Titus 1:16).

God expects us to manifest a difference. We are "letter[s] of Christ . . . written not with ink, but with the Spirit of the living God, not on tablets of stone, but on tablets of human hearts" (2 Cor. 3:3). And as his letters, we need to adopt his standards of excellence in everything we do. Read 1 Timothy 3—5 and see the exacting requirements for becoming an overseer, a deacon, an elder, or simply part of the body of believers.

Motivation

Performing our work excellently means striving for the best possible quality of work in whatever we do. But God doesn't just want excellent work; he wants excellent work done from right motives. We should work wholeheartedly because God has called us to be good workers.

I love to see people who throw themselves into something they love doing. Full of enthusiasm, they don't try to "just get by." A remarkable woman in my hometown has worked virtually her entire life at the only factory in town, the shoe factory. Mrs. H. is still the hardest worker at the factory. She takes the most active job, stacking boxes, and turns out the greatest quantity of work. Mrs. H. likes her work and likes doing a good job. And it disturbs

er to see some of the young kids start work at the factory with one goal: to get by with as little work as possible.

Charles Dickens, author of *David Copperfield, Tale of Two Cities, Pickwick Papers, Oliver Twist,* and classic after classic, wrote this late in his life: "Whatever I have tried to do in my life . . ., I have tried with all my heart to do well. What I have devoted myself to, I have devoted myself to completely. Never to put one hand to anything on which I could not throw my whole self, and never to affect depreciation of my work, whatever it was, I find now to have been my golden rule."[1] It remains a mystery how one man could write so much, none of it dictated. Dickens has written more pages than many people will read in an entire lifetime.

How do you approach the Christian life? Have you thrown yourself into it, immersed yourself in the Scriptures and in prayer? Or do you just get by? Is it the same in your secular job? Do you "do your work heartily, as for the Lord rather than for men; knowing that from the Lord you will receive the reward of the inheritance. It is the Lord Christ whom you serve" (Col. 3:23-24)? Do you resent extra work, or "with good will render service, as to the Lord, and not to men, knowing that whatever good thing each one does, this he will receive back from the Lord" (Eph. 6:7-8)?

In *God's Best Secrets* Andrew Murray writes:

> When we want to make anything a success in worldly affairs, we put our whole heart into it. And is this not much more necessary in the service of an holy God? Is He not worthy? Does not His great holiness, and the natural aversion of our hearts demand it? The whole heart is needed in the service of God when we worship Him in secret.
>
> And yet how little most Christians think of this. They do not remember how necessary it is—in prayer, in reading God's Word, in striving to do His will—to say continually: "With my whole heart have I sought Thee." Yes, when we pray, and when we try to understand God's word, and to obey His commands let us say: I desire to seek God, to serve Him and to please Him with my whole heart.[2]

God deserves our best—at least. The prophet Samuel urged

Israel to serve the Lord wholeheartedly, on the basis of all Go had done for them. "Only fear the Lord and serve Him in truth with all your heart; for consider what great things He has done for you" (1 Sam. 12:24).

What great things has God done for us, that we should give him our best efforts? First, he's given us *his* best, his only begotten Son. He has given us eternal life, our salvation. Beyond this we could all name hundreds of "bests" God has blessed us with, if we will only "consider."

Colossians 1:10 urges us to "walk in a manner worthy of the Lord, to please Him in all respects." Ephesians 4:1 entreats us to "walk in a manner worthy of the.calling with which you have been called."

These are calls to excellence. Paul wrote the Corinthians, "Run in such a way that you may win" (1 Cor. 9:24). Now, when I do my jogging, quite honestly, my goal is to get through the experience, and to gain a little exercise in the process. That's fine—for jogging. But for Christian living, we're to run in such a way that we can win.

Dave, presently a casual marathoner (if you can be casual about twenty-six miles), ran cross country in high school. He explains that running to win requires a strategy. Running your hardest doesn't necessarily promise you a victory; you might run out of steam. Doing your best in a race entails being in top condition, having a plan, and running your best effort. The next chapter deals with devising a game plan and goals. But let's talk more about doing our best.

Doing work that's better than someone else's doesn't guarantee excellence in God's book. God doesn't compare us with other Christians; we shouldn't compare ourselves. "But let each one examine his own work, and then he will have reason for boasting in regard to himself alone, and not in regard to another" (Gal. 6:4). This attitude pleases God. And we profit from it too. You know how much more enjoyable a job is when you are satisfied

...n your own efforts, when you don't need to feel ashamed for
...k of industry.

Excel Still More

Paul wrote to the Thessalonians and encouraged them not
only to do their best but to continually try to do better, to excel
still more. The church at Thessalonica has been called the
model church. Paul commended the believers there for becom-
ing imitators of him and of the Lord. Word of their faith had
spread so widely that Paul heard good reports of the Thessalo-
nians wherever he went.

But Paul discouraged complacency. They had to continue to
grow and improve. In his first letter to the Thessalonians, twice
Paul urged them to "excel still more" (1 Thess. 4:1,10; "abound"
in 1 Thess. 3:12 may also be translated "excel"). He prayed that
the Lord might cause them to increase and abound in their love
for one another.

Apparently the Thessalonians followed Paul's advice. In his
second letter to them Paul began, "We ought always to give
thanks to God for you, brethren, as is only fitting, because your
faith is greatly enlarged, and the love of each one of you toward
one another grows ever greater" (2 Thess. 1:3).

Similar advice is found in Paul's letter to the Philippians: "And
this I pray, that your love may abound still more and more in real
knowledge and all discernment, so that you may approve the
things that are excellent" (Phil. 1:9-10). He called the Colossians
to be "increasing in the knowledge of God" (Col. 1:10).

Peter had the same idea of progressing in the Christian life,
continuing to improve and excel. When he listed Christian virtues
the believer should strive to apply daily, Peter added: "For if these
qualities are yours *and are increasing,* they render you neither
useless nor unfruitful in the true knowledge of our Lord Jesus
Christ" (2 Pet. 1:8, italics mine). Stagnation has no place in the
Christian life. We must continually grow and become more like
Christ.

Philemon must have been quite a man. That small, two-page book in your Bible bears his name. Paul greeted him as a beloved brother and fellow worker and praised him because the hearts of the saints had been refreshed through him. Paul asked Philemon for a favor, something Paul didn't seem to do very often. He asked Philemon to let his slave Onesimus return unpunished to Paul for his personal service. But I think we gain the deepest insight into Philemon's character in verse 21, where Paul wrote: "Having confidence in your obedience, I write to you, since I know that you will do even more than what I say."

Have you known anyone like Philemon, someone you can always count on to carry to completion anything he undertakes? If he says he'll do it, you know he will. When you've served on committees, or held a position of some responsibility, do you remember the relief you felt when you could entrust a task to someone you knew to be dependable?

In working with Campus Crusade for Christ on university campuses, Dave and I planned large meetings and retreats. Sometimes I felt that 50 percent of our work was best accomplished through delegating responsibilities, and the remaining 50 percent through delegating wisely. With some students, we knew we'd need to check up on them to make sure they made their phone calls, printed the invitations, or contacted proper authorities. In the end we might even have to do the work for them. But what an incomparable delight when we found a truly trustworthy and dependable guy or girl! I can understand the joy and comfort Paul claimed Philemon gave him.

I hesitate to throw in the time-worn expression, "Anything worth doing is worth doing well." But it's true. We Christians, more than any other people on earth, can know that if what we are doing is God's will, then it's worth doing, and worth doing excellently. Consequently, God urges us to do our best, to excel still more, and to be someone on whom others can depend.

We'll move on now from doing God's will in God's power, God's way, to another factor in effectual doing: the element of time.

Notes

1. John Forster, *The Life of Charles Dickens* (Philadelphia: J. B. Lippincott Company, 1903), p. 36.

2. Andrew Murray, *God's Best Secrets* (Grand Rapids: Zondervan, 1974), page containing January 28 entry.

Study Questions

Study Passage: Colossians 3:23-24 (Memorize)

1. Think of ten ways God has revealed his standard of excellence.

 Describe some of the excellencies in Jesus' earthly life.

2. List one chore where you consistently do a halfway job. Is it worth excelling still more? If yes, how will you improve?

3. Name two people you consider dependable. What qualities in their lives are worth imitating?

4. Right now, what things are you "throwing yourself into"?

5. List three areas you feel God may want you to "excel still more" in. What changes will each require?

8
On Time

Time—our number 1 excuse for not getting things done! But we falsely accuse our old enemy Time. For one of the few quantities 100 percent equally divided among all men and women is time. No matter how wealthy or famous you may be, you'll never have more (or less) time than I have in a day. So our problem may stem from lack of motive, lack of determination, lack of heart, or lack of method; but it's not lack of time.

If anyone ever had a valid excuse for failing to work within the limits of time, it would have been Jesus. Coming from an eternal existence with the Father where time wasn't structured, Jesus entered our world of time and space. But he lived on earth in perfect control of time. Throughout his earthly ministry, Jesus explained some of his actions with this phrase: "My hour has not yet come" (John 7:6,8,30).

Conscious of the time and hour, Jesus rebuked his mother at the wedding feast in Cana when she encouraged him to show his power (John 2:4). He rebuked his brothers when they urged him to declare himself publicly. No one seized him before his time of crucifixion because "His hour had not yet come." But on the night of his betrayal, as he prayed to the Father, Jesus declared: "Father, the hour has come; glorify Thy Son, that the Son may glorify Thee" (John 17:1).

In Ephesians 5:16 Paul exhorted us to make the most of our time or to redeem the time. Each minute has incomparable value and can never be recaptured. If we squander one minute

foolishly, we lose that minute for all eternity. Paul conveyed urgency of each passing day: "And this do, knowing the tim that it is already the hour for you to awaken from sleep; for nov salvation is nearer to us than when we believed. The night is almost gone, and the day is at hand. Let us therefore lay aside the deeds of darkness and put on the armor of light" (Rom. 13:11-12).

God assures us that he is the Creator and Controller of time. "There is an appointed time for everything. And there is a time for every event under heaven" (Eccl. 3:1).

The classic psalm on time, Psalm 90, entitled "A Prayer of Moses," contains a prayer for an awareness of and a godly perspective on time:

> ⁴For a thousand years in Thy sight
> Are like yesterday when it passes by,
> Or as a watch in the night.
>
> .
>
> ⁹For all our days have declined in Thy fury;
> We have finished our years like a sigh.
> ¹⁰As for the days of our life, they contain seventy years,
> Or if due to strength, eighty years,
>
> .
>
> ¹²So teach us to number our days,
> That we may present to Thee a heart of wisdom.

The psalmist deemed time so important that he wanted to number not just his years, but his days!

Time Thieves

Americans are infamously busy people. Abroad, many imagine the caricature of the average American as a highly active person rushing through each day in a flurry of activity. Yet most of us readily admit we aren't accomplishing all we intend to do. What's our problem? Look out for time thieves!

The Wrong Things

Sometimes when we think we're too busy, we're really just doing the wrong things. We've taken on activities that lie outside

God's will for us. God could have given us twenty-six or twenty-seven hours in a day if he thought we needed them. But twenty-four suffice to accomplish his will for one day.

Proverbs 12:11 says, "He who pursues vain things lacks sense." Obviously we can't hope to act on every item that crosses us during a day. So how do we choose what things to do? On the basis of God's will for your life, establish and clearly define your own personal priorities. You need to have a sense of the relative importance of all your activities.

Without well-defined priorities we'll fall prey to the tyranny of the urgent. Circumstances will govern us rather than careful volition. We've all suffered through days when we seemed to tread water with one hope: Stay alive! We wake up and dash to the phone to make those urgent calls that had to be in by 9:00. If we don't write that letter or pay that bill, it won't arrive on time; so we sit down and get it off and run to the post office. Barely time left to get to work on time or drive the kids to school. The rest of the day rolls on in a series of emergencies—job or home duties. The house needs feverish straightening before the neighbors arrive. And the day rushes on.

The urgent will take over unless we determine our priorities and plan accordingly. At the end of this chapter I've suggested you list your own personal priorities. What facets and activities mean the most to you? When you formulate your list, make sure that your priorities match God's priorities for you. God has told us that the most important command is to love him with all our heart. Does your relationship with God head your priority list? Then activities that help you get to know him better (personal Bible study, prayer, meditation, church, etc.) should get precedence over other things on your list. My relationship with my husband follows God on my priority list. Dave comes before any house, ministry, or writing. Children come next; then any ministry God has given me.

If your priorities align with God's for you, and if you keep them

firmly in mind, you'll be better prepared to say no to activities that fall too low on your list. Unfortunately, we can't do everything (I know, I tried). We can't excel in everything. Each time we say yes to one task, we say no to hundreds of others. Get control of your priorities and say no on the basis of God's will, not on the basis of urgency.

Frequently, we waste time repeatedly without realizing it. La Bruyère in *Les Caractères* says, "Those who make the worst use of their time most complain of its shortness." If asked, we might sincerely respond that we didn't have a free minute all day. But if we had taken notes of everything we did during the day, we might give a different answer. My second action suggestion at the end of this chapter is to keep a fifteen-minute interval chart of everything you do throughout the day. This will help you find tiny (or not so tiny) time slots that you waste every day.

We can transform some of these wasted minutes or hours into useful, productive minutes by using a little foresight. Three items I carry along with me wherever I go prevent me from wasting time when I have to wait unexpectedly anywhere. I try to keep blank paper so I can write a letter while in a waiting room or if I arrive early for a meeting. I carry a pocket New Testament in my purse, or at least memory verse cards. And for the past three years I've toted a small book with blank pages, sold in most book stores as "Anything Books" or "Me Books." These I use to outline book chapters, chart ideas, or begin magazine articles.

Certain time wasters fall under the heading of "Interference." In a survey I took in Illinois and Missouri, I flushed out some common time wasters. Most people, when asked, "What do you feel is the biggest thief of your time?" responded, "TV." If your set has ever gone on the blink, you can attest to the added hours in a night without television. I'm not an anti-TV crusader. I believe it can entertain and relax if used wisely (besides, I love old movies). But it's so easy to let television govern us, instead of vice versa. We can lodge the same criticism against sports, music, and any

...er activity that threatens self-control in our use of time.

The Wrong Way

If your problem isn't that you're doing the wrong things, maybe you're doing things the wrong way. First Corinthians 14:40 reads, "But let all things be done properly and in an orderly manner."

John Wesley followed the admonition to orderliness. It was said of him that one never saw a misplaced book or scrap of paper lying about in Wesley's study. His exactness and punctuality made it possible for him to carry the tremendous burden of work that fell to him. He consistently weighed the value of time.

We owe God efficiency and prudent management of the hours he's given us to accomplish his will. A Persian proverb goes, "Luck is infatuated with the efficient." It may seem like luck; but there's nothing magical or unattainable about efficiency. Efficiency isn't a personality trait. Anyone can learn to operate efficiently. Be a learner and an observer of people you admire as efficient workers.

A big part of efficiency is planning. "What may be done at any time will be done at no time." The first week with our new baby, Jennifer, threw my normal, semi-efficient routine upside-down. A typical day now found me heading for the washing machine to begin a wash load. But on the way I'd pass the hall mirror, the dirty and smudged hall mirror. Then I'd head back to the kitchen for cleanser and a paper towel. But in the kitchen a pile of dirty breakfast dishes would draw me to the sink. Once at the sink I'd remember the hamburger in the freezer. Better get it out while I was thinking of it. The freezer sits in the garage. Once in the garage I'd notice the baby buggy waiting to be cleaned. And the day wore on. . . .

A life-style like the one I just related would discourage any potential doer. How can we grasp hold of our lives and control their direction? Two concrete steps can take you a long way on the road to recovery: (1) Set goals; (2) Schedule yourself.

I never would have begun either of these practices without

brutal insistence from my superiors while I was on the staff of Campus Crusade for Christ. To those callous enforcers, I'm eternally grateful! These principles are their ideas—not mine.

Setting Goals

"Therefore I run in such a way, as not without aim" (1 Cor. 9:26). I can affirm the axiom, "If you aim at nothing, you'll surely hit it." I've hurried through entire days at breakneck speed, seldom pausing for a breath, then been stymied by the question, "What did you do today?" To serve God in the most effective way possible, we need to set personal goals.

How do you set goals? First, ask yourself what your overall goal in life is, in light of scriptural teaching. To glorify God, to get to know God better, to know him and make him known, to bring God praise and honor, all of these are goals which the Bible suggests for us. Pick out a verse that sums up what you believe God would approve as your life goal. At different times I've used one of the following verses as my life goal:

"For Ezra had set his heart [Dandi had set her heart] to study the law of the Lord, and to practice it, and to teach His statutes and ordinances in Israel" (Ezra 7:10).

"To the end that we who were the first to hope in Christ should be to the praise of His glory" (Eph. 1:12).

"For you have been bought with a price; therefore glorify God in your body" (1 Cor. 6:20).

Each subsequent lifetime or yearly goal you formulate should relate back to this lifelong statement of purpose. The next step is to choose a succinct life goal in each area of your life. You can break down categories to suit you. Here are some ideas:

Spiritual	Financial
Marriage	Intellectual
Family (spouse/children)	Vocational
Family (parents/siblings)	Ministry
Physical	Roommates
Social	

I'll give you my life goals in ten areas. Yours will be different; but this might help give you an idea of how to write them out.

1. Spiritual Life Goal—to know God better, become more like Christ, and make him known.

2. Marriage Goal—Realize our oneness in Christ and be continually growing in our love.

3. Family (children)—To raise children who are Christians, who love and serve the Lord.

4. Family (parents, brothers, sisters)—To draw close to them and increase in love.

5. Physical—My body will be an asset, not a liability.

6. Social—I will be at ease in every situation, comfortable and able to share Christ anywhere.

7. Financial—Be free from the love of money.

8. Intellectual—Constantly curious and a learner; aware of current events and able to relate Christ to them.

9. Vocational—Be able to work wherever God calls me; to do my work heartily, for the Lord, not man.

10. Ministry—Continually share my faith and make disciples.

With life goals fixed, we can move on to more specific yearly goals and plans in each area. Here is where priorities will emerge that should influence your daily scheduling of activities. Make a yearly goal in each of the eight or ten areas. Then write down your plan to accomplish those goals.

Spiritually, do you want to read through the Bible in a year, do special studies in Ezra and John, memorize your favorite chapter, pray ten minutes every morning? Under "Family," plan to study the Bible with your husband, pray together as a family. A yearly physical goal might be to lose five pounds, exercise twenty minutes every day, sleep seven or eight hours a night.

Taking time to compose your personal goals will multiply your time later. But lots of goals never advance from the paper we print them on. Now, with goals set and priorities established, you can begin to implement your goals into a weekly schedule.

Scheduling

"The plans of the diligent lead surely to advantage" (Prov. 21:5). I'd never complete half my work if I didn't write down my plans into a weekly schedule. Granted, that doesn't guarantee their execution; but they will at least stand a fighting chance.

If you've never made a schedule, you may think your week is already tightly scheduled for you by your job and other daily routines and commitments. But figure it out mathematically, using generous estimates for the givens in your day, the hours you can't do anything about.

$$
\begin{array}{ll}
8 \text{ hrs. sleep} \times 7 \text{ days} = & 56 \text{ hours} \\
8 \text{ hrs. work} \times 5 \text{ days} = & 40 \text{ hours} \\
3 \text{ hrs. meals} \times 7 \text{ days} = & 21 \text{ hours} \\
4 \text{ hrs. wkly. meetings} = & \underline{4 \text{ hours}} \\
& 128 \text{ hours}
\end{array}
$$

Subtract your weekly hours already committed from the 168 hours in a week, and find the number of hours available to you for personal planning.

$$
\begin{array}{l}
168 \text{ hours (in a week)} \\
\underline{-128 \text{ hours (already committed)}} \\
40 \text{ hours (unscheduled)}
\end{array}
$$

Our schedules differ; but we can all find hours we can't account for by the routines of the day. These are the hours we have to capitalize on to reach our goals. If your goals include leisure reading, writing letters, exercising, sewing, Bible study, and phone calls, schedule them in at different times during the week, using these unpledged hours.

J. Oswald Sanders in his book *Spiritual Leadership* writes the following in a chapter he calls "The Leader and His Time":

> Time has been defined as a stretch of duration in which things happen. The quality of a man's leadership is revealed in what happens during that stretch of duration. The character and career of a young

person are determined largely by how and with whom he spends his spare time. He cannot regulate school or office hours—those are determined for him—but he can say what he will do before and after. The manner in which he employs the surplus hours after provision has been made for work, meals, and sleep will make him either a mediocrity or a man to be reckoned with.[1]

Schedule! Schedule! Schedule! But, caution: Obviously, few weeks run exactly according to schedule. Be flexible! God may bring a friend to your door who needs to talk with you. You need to follow his leading and be available, even if your schedule has you jogging that hour. The purpose of a schedule is to serve you; you don't serve it.

Goals and schedules get better if you look them over and evaluate them. At the end of the year, and even at the end of a month, look over your goals and see what areas you're neglecting.

Be Prepared

To make the wisest use of time, we have to be prepared. When Dave and I were missionaries overseas, we found the pace of life slower than our own. But we soon learned we needed to be more and better prepared—not less.

We never knew when someone would ask us to take an hour and speak. Once a friend came over at 7 AM to ask Dave if he would please take two days and hold a conference, beginning at 9 AM! So we prepared all our messages well in advance and carried them with us wherever we went.

In most situations all we can do is be prepared and be available. "The horse is prepared for the day of battle,/But victory belongs to the Lord" (Prov. 21:31). Our scheduling and planning help us prepare for the day of battle.

Closely related to being prepared is the admonition to be on time. Have you noticed that some people always come late, and others usually arrive on time or early? It seems to matter little to the habitually late whether the appointed hour comes in early

morning, at midday, or at night. You can count on their tardiness.

I can't believe that people want to arrive late or like keeping others waiting. So I've developed a theory concerning tardiness, and a projected cure. I inherited promptness from parents whom I've never known to arrive late anywhere. But since that happy childhood, the Lord has blessed me with roommates and close friends who suffer from habitual tardiness. In trying to discern the difference between the tardy and the prompt, I quickly ruled out innate flaws in the tardy or special virtues of the prompt. I've concluded that the prompt, including myself, through practice have lowered our "hurry threshold."

Let me explain. Most people know what doctors mean by the term "pain threshold," that point at which pain is felt and reacted to. Individual thresholds vary. I may experience pain the second a pin touches my hand, while you may not feel pain until the pin penetrates $\frac{1}{8}$ of an inch. We'd say that my pain threshold is lower than yours.

Well, I believe my hurry threshold is lower than most of my friends. If I'm due at a meeting fifteen minutes from my house at 8 AM, I feel the need to hurry when the clock strikes 7:00. Consequently, I plan the necessary steps to be completed by 7:30 AM. (Better allow for something unexpected to delay you at least fifteen minutes.) Dave, on the other hand, with his higher hurry threshold, may not feel any sense of urgency until 7:40. Then it's too late.

What the tardy should do is lower their hurry thresholds. If you're due at 8 AM, pretend you're due at 7:30. Plan your schedule accordingly. Practice this remedy consistently for all appointments and learn the pleasure of being on time—or even early!

Do It Together

Sometimes we can lighten our workload and shorten the time needed if we plan on cooperating with others. Ecclesiastes 4:9-12 reads:

"Two are better than one because they have a good return for their labor. For if either of them falls, the one will lift up his companion. But woe to the one who falls when there is not another to lift him up. Furthermore, if two lie down together they keep warm, but how can one be warm alone? And if one can overpower him who is alone, two can resist him. A cord of three strands is not quickly torn apart."

Americans tend toward rugged individualism. Frankly, I enjoy being by myself and doing things alone. But God hasn't called us to aloneness. If you're discipling people in Christ, you should spend as much time as possible with them. Do your laundry and shopping together. Run and exercise together. "[Make] the most of your time" (Eph. 5:16).

Planning and scheduling together with your husband or wife or roommate may save both of you time and frustration. If I schedule our family hour in the morning, and Dave plans it for after dinner, one of us is going to be disappointed. If I've blocked out Thursday nights for reading, while Dave has planned Tuesday as a reading night, we miss some togetherness we could have had if we'd planned.

God instructs us to work together as a body of believers. "Therefore encourage one another, and build up one another, just as you also are doing" (1 Thess. 5:11). I've found one of the best ways to encourage some Christians is to ask for their help. Exchange a hobby. Teach her to macramé; and learn from her how to make a flaky pie crust. Hebrews 10:24 suggests, "And let us consider how to stimulate one another to love and good deeds." Take a minute and consider.

Two Birds with One Stone

Doing work together can help make us more efficient. Here's another suggestion, but one I cautiously suggest: Do two or more things at once. For some people, combining activities comes naturally. President James Garfield could write Latin with one hand and Greek with the other simultaneously! And Leo-

nardo da Vinci reputedly could draw with one hand and write with the other, also at the same time.

I can't enjoy television unless I'm writing letters, balancing our checkbook, or working on a crafts project. Letter writing seems a chore to me unless I'm riding in the car or doing some secondary activity.

I rarely bake one item at a time. The trouble and mess created in my kitchen when I bake one cake almost equals the disruption of concocting several dishes at once. I mix one while the other is in the oven.

Walking, running, biking, and driving all provide great spans of "mind time" that you can use to memorize verses, write a song, pray for each person in your church or family or class, and compose countless lists you may need for groceries, packing, shopping.

I write this suggestion with reservation for several reasons. Doing two things at once might mean that you'll do a poor job on your minor activity, or on both of them. Now, if your secondary is watching TV, no problem; but if it's preparing your Sunday School lesson or doing homework, you could get into trouble.

Another negative potential is that you'll become too hurried and busy to enjoy what you do. Sometimes at the end of one of my baking marathons, I feel I've been through a war.

And even if you enjoy all your activities when you combine them, you may unwittingly convey the image of an unapproachable person. All of us know people we'd be afraid to ask for any of their time because they always appear to be in such a hurry.

One of the women I've most respected and wanted to emulate is Ney Bailey, a Campus Crusade worker and counselor. Ney probably accomplishes more in one day than most people will do in a week. But whenever I see her or have wanted to talk with her, she calmly and convincingly acts as if she had nothing else to do and nowhere to go. Even if she only has three minutes, she can give me her full attention. Too often, when I'm busily rolling through the day's events, people feel they need to step aside.

Leisure

As our leisure hours increase and our work hours decrease, the question of how to use our free time becomes more serious. The average American work week has diminished to about thirty-five hours from fifty hours in 1920, sixty hours in 1900, and seventy hours in 1850. At the same time, life expectancy keeps lengthening. In Roman times life expectancy was set at thirty. In medieval days, you could expect to see forty. Today the average life span is in the seventies.

What should we do with all those extra hours? Experts say this is how we Americans amuse ourselves on an average summer weekend: 30 million go swimming; 18 million picnic; 8 million are on the seas and lakes; 34 million play tennis; 20 million play golf; 2½ million ride motor bikes (9 million on regular bikes); and 30 million men work in home workshops.[2] Surveys show that over 90 percent of our homes have TV sets. And the average American watches the tube between 6½ and 7 hours a day!

I think most of us tend to sharply divide our work and/or ministry from our leisure time. Those free hours are *ours,* and we have to guard them jealously! We fall into a five o'clock turn-off syndrome. The next morning, it's hard to account for last night's free hours. Somehow they faded into night.

What's the answer for our leisure time? We need to view all our time as belonging to God. That doesn't mean we shouldn't play. I'm a firm believer in and practitioner of fun and leisure. But planned free hours profit more than the unplanned. Schedule in for yourself times to play and rest. See all of your time as God's time. "In *all* your ways acknowledge Him,/And He will make your paths straight" (Prov. 3:6, italics mine).

Notes

1. From *Spiritual Leadership* by J. Oswald Sanders. Copyright 1967, 1980. Moody Press. Moody Bible Institute of Chicago. Used by permission. Page 135.
2. Bernie Smith, *The Joy of Trivia* (New York: Bell Publishing Company, 1976), p. 85.

Study Questions

Study Passage: Memorize Ephesians 5:15-18

1. List the first six priorities in your life. How accurately does your time management reflect these priorities?

2. Keep a fifteen-minute chart of your daily activities tomorrow.

5:30 AM	12:00 PM
5:45	12:15
6:00	12:30
6:15	12:45
6:30	1:00
6:45	1:15
7:00	1:30
7:15	1:45
7:30	2:00
7:45	2:15
8:00	2:30
8:15	2:45
8:30	3:00
8:45	3:15
9:00	3:30
9:15	3:45
9:30	4:00
9:45	4:15
10:00	4:30
10:15	4:45
10:30	5:00
10:45	5:15
11:00	5:30
11:15	5:45
11:30	6:00
11:45	6:15

6:30 PM	9:30
6:45	9:45
7:00	10:00
7:15	10:15
7:30	10:30
7:45	10:45
8:00	11:00
8:15	11:15
8:30	11:30
8:45	11:45
9:00	12:00 AM
9:15	

3. What did you learn from your time chart?

4. Select a verse or phrase that best summarizes your life's goal. Memorize it.

5. Draw up your yearly goals in the following areas:
 1. Spiritual
 2. Marriage
 3. Family (spouse and children)
 4. Family (parents, brothers and sisters)
 5. Physical
 6. Social
 7. Financial
 8. Intellectual
 9. Vocational
 10. Ministry
 11. Roommate(s)

6. Consider how to stimulate two friends to love and good deeds. Be specific! List your ideas.

7. Name three leisure activities you would like to plan for your free hours.

9

Don't Do It!

Balance keeps us on God's narrow path of righteousness, balance that his Spirit teaches and reveals to us. So we need a chapter on *not* doing, *not* working. All of us need to hear "Don't do it!" now and then. Some readers, those of you who already consider yourselves "doers," may find this chapter more helpful than all the other pages in this book.

Motive

Our best efforts and most brilliant actions mean nothing to God if we have wrong motives. Sometimes we forget that God doesn't really need us and all our good works. He has chosen to use us to accomplish his will. But he could get along nicely without us.

What God wants from us is a pure heart and right motives. The intent of our heart weighs more heavily with God than the result of our best efforts. "For God sees not as man sees, for man looks at the outward appearance, but the Lord looks at the heart" (1 Sam. 16:7). King David realized the importance of the heart attitude of his people toward God. In his final recorded prayer in 1 Chronicles 29:18-19, David prayed for Israel and, in particular, for his son Solomon:

"O Lord, the God of Abraham, Isaac, and Israel, our fathers, preserve this forever in the intentions of the heart of Thy people, and direct their heart to Thee; and give to my son Solomon a

perfect heart to keep Thy commandments, Thy testimonies, and Thy statutes, and to do them all."

But Israel strayed from God. Even when the Israelites continued going through the right actions, offering the sacrifices God had commanded, God grew angry at their motives. The prophets denounced Israel's hypocrisy. Isaiah wrote (1:11):

"What are your multiplied sacrifices to Me?"
Says the Lord.
"I have had enough of burnt offerings of rams,
And the fat of fed cattle."

It's alarmingly easy to study the Bible or read morning devotions without meeting the Lord. It's also quite possible to pray, privately or in a group, without true communication taking place between God and us. We can win years' worth of awards for perfect Sunday attendance and still displease God. Entire ministries or missionary efforts may count for nothing in God's eyes. God looks at the heart, not at the way things look outwardly. Only God really knows the quality of your spiritual life, whether or not your work and efforts bear fruit for his kingdom.

I think most of us will have a few surprises awaiting us in heaven. The pecking order of Christians and the value of their services on earth may contradict our previous evaluations. Some of us who picture ourselves piling and arranging a large volume of good works to present to Christ on the Day of Judgment may find ourselves scraping through the rubble of wood, hay, and straw ashes, looking for something done purely in the name of Christ.

Don't Do It . . . to Please People

One motive God detests is acting to please people rather than him. Caring what men may think has caused the downfall of many men and women, as recorded in the Scriptures for our instruction.

Saul lost his kingship because his heart didn't belong to God. At the crisis moment in Saul's life, the Philistines on the attack, his own men beginning to desert him, and Saul awaiting Samuel's arrival, Saul sinned against God. He offered a sacrifice only Samuel could legally offer. When Samuel arrived and confronted Saul with what he had done, Saul admitted that he had listened to the people instead of obeying God.

Again, after another act of disobedience, when Saul failed to annihilate the Amalekites and chose to spare King Agag and the choicest animals, Samuel asked him why he disobeyed God. "Then Saul said to Samuel, 'I have sinned; I have indeed transgressed the command of the Lord and your words, because I feared the people and listened to their voice'" (1 Sam. 15:24).

Jesus didn't tolerate the hypocrisy of the Pharisees. The sect of Pharisees was originally formed in order to bring Israel back to the Lord through stricter adherence to the law of the Lord. But somewhere along the way their motives degenerated into keeping laws rather than serving God. Jesus, our loving, forgiving, tolerant Savior, was stern in his denouncement of the Pharisees. He called them children of the devil, whitewashed tombs, an evil, adulterous generation, hypocrites, blind guides, fools, blind men, serpents, and a brood of vipers!

Jesus exposed the discrepancy between the Pharisees' actions and their heart motives: "But they do all their deeds to be noticed by men" (Matt. 23:5). "Even so you too outwardly appear righteous to men, but inwardly you are full of hypocrisy and lawlessness" (Matt. 23:28). He cautioned his own followers: "Beware of practicing your righteousness before men to be noticed by them; otherwise you have no reward with your Father who is in heaven" (Matt. 6:1).

It's likely that the apostle Paul might have been tempted to do his work for men in order to gain their acceptance and favor. Others constantly tried to discredit Paul to the believers. But in his letter to the Galatians Paul wrote: "For am I now seeking the favor of men, or of God? Or am I striving to please men? If I were

still trying to please men, I would not be a bond-servant of Christ" (Gal. 1:10). The result: People glorified God, not Paul.

Paul wrote to the believers encouraging them not to fall into the trap of striving to please men rather than God. "Slaves, be obedient to those who are your masters according to the flesh, with fear and trembling, in the sincerity of your heart, as to Christ, . . . doing the will of God from the heart. With good will render service, as to the Lord, and not to men" (Eph. 6:5-7). And to the Colossians he wrote, "Whatever you do, do your work heartily, as for the Lord rather than for men" (Col. 3:23).

We know better, but all of us enjoy the approval of other people. We love praise and recognition. There's nothing wrong with liking people's praise, until we begin to make their praise our objective. Then it becomes our motivation for acting.

Often praise from men accords with praise from God, as when David slew the Philistines for the Lord and all Israel cheered him. But what happens when God commands you to do something that's unpopular in men's eyes—to share Christ at a neighborhood social gathering, choose one vocation over a more highly acclaimed line of work, not participate in a questionable business deal? Proverbs 27:21 observes, "And a man is tested by the praise accorded him." Don't let praise from men be the guiding force in your life. Rather, learn how to please the Lord.

Don't Do It . . . for Salvation

Performing works to please men displeases God. But we can also displease God when we perform works for him in order to earn his favor. The biggest mistake a person can make is to go through life believing he can work his way to God, somehow earning enough "good" points to ensure his safe passage to heaven.

Until my sophomore year in college, I vaguely held the idea that "Christian" was an adjective, meaning "good, nice, and kind." When you grow up, you learn how to do Christian deeds; and you also learn the unchristian ones. The trick seemed to be

to make sure your Christian deeds outweighed the non-Christian ones. Then, and if you kept in the top 40 or 50 percent of the human race, you might earn eternal life. The frustration came in trying to evaluate where I stood with God. How could I know when I was good or "Christian" enough?

One night in my sorority house, one of the girls gave me a Christian booklet to read, after we came home from one of her Christian meetings. From the Scriptures and principles I read that night, I understood for the first time that I could never do enough good deeds to earn my salvation. Christ had already performed the only good deed necessary. He had died for my sins and paid the penalty demanded by God's righteousness. He only required that I accept what Christ had done and ask him to come into my heart and forgive my sins. Then he would be free to work his will through me. "For by grace you have been saved through faith; and that not of yourselves, it is the gift of God; not as a result of works, that no one should boast" (Eph. 2:8-9).

If you're doing your good works to earn your salvation, don't! We can't enter heaven on the basis of our own righteousness. We need to be born spiritually by the work of God's Spirit, as a result of God's grace and not our own merit.

Don't Do It . . . for Sanctification

Some of us realized we couldn't work and earn our salvation before we knew Christ. We joyfully accepted him and the free gift of eternal life. We were born into God's kingdom.

But before long, the joy disintegrated, burdens returned, and frustrations seemed to increase. We began to do good works in order to become better Christians, more holy and sanctified.

The believers of Galatia suffered the same setback. Paul ardently wrote to them: "Are you so foolish? Having begun by the Spirit, are you now being perfected by the flesh? Does He then, who provides you with the Spirit and works miracles among you, do it by the works of the Law, or by hearing with faith?" (Gal. 3:3-5).

Apparently the Galatians were drifting into legalism, a focus on what they could do and what they couldn't do. They began to concentrate on their own performance rather than dwelling on Christ and his power within them. "It was for freedom that Christ set us free," wrote Paul, "therefore keep standing firm and do not be subject again to a yoke of slavery" (Gal. 5:1).

God calls us to serve him in the newness of the Spirit, not in the oldness of the letter (Rom. 7:6). In John 15, the chapter on abiding in Christ, Jesus tells his disciples that apart from him they can do nothing. What could he mean? Couldn't they do anything without him?

I've learned that I can accomplish quite a volume of work on my own. Something within me keeps pushing, driving me to activity. But no matter how efficient this self-propelled action is, Jesus says it counts for nothing because it wasn't done in his power.

I'm continually tempted to get so enveloped in "doing things for God" that I neglect my friendship with him. God doesn't want our work. He wants us. "Abide in Me, and I in you" (John 15:4).

The art of the Christian life is determined passivity. We don't just "let go and let God," allowing whatever happens to happen. We don't just gut it out with raw strength of will, confident that we can do it! But we determine to trust and let Christ have his way in us.

God wants our obedience, not our sacrifices, in sanctification as in our salvation. The tragedy is that many zealous Christian labors will count for nothing in eternity because they were flammable works, composed of wood, hay, and straw, rather than the precious metal of God's Spirit.

It wasn't our Lord who espoused the much-misquoted axiom, "God helps those who help themselves." This saying is credited to Floruit, in Fragment 223 of Heraclitus, in 513 BC; to La Fontaine in Fable 18, 1678-79; to Sophocles in Fragment 288, 496-406 BC; and to Algernon Sidney in 1698. But God didn't say it!

Paul feared for the believers in Corinth: "But I am afraid, lest as the serpent deceived Eve by his craftiness, your minds should be led astray from the simplicity and purity of devotion to Christ" (2 Cor. 11:3).

I have the same fear for myself and for others. That's why I've included this chapter. The world needs workers like Martha who know how to sit at the Lord's feet like Mary and choose what is important. "Cease striving," the Lord pleads with us, "and know that I am God" (Ps. 46:10).

Our relationship with God supercedes any good works we might do for him. Don't be numbered among those whom the Lord described, "Many will say to Me on that day, 'Lord, Lord, did we not prophesy in Your name, and in Your name cast out demons, and in Your name perform many miracles?' And then I will declare to them, 'I never knew you'" (Matt. 7:22-23). (Wouldn't you feel terrible!)

Don't Do It . . . Out of God's Will

"Come now, you who say, 'Today or tomorrow, we shall go to such and such a city, and spend a year there and engage in business and make a profit.' Yet you do not know what your life will be like tomorrow. You are just a vapor that appears for a little while and then vanishes away. Instead, you ought to say, 'If the Lord wills, we shall live and also do this or that'" (Jas. 4:13-15).

Sometimes what the world calls work differs from God's work. A mom or housewife who doesn't "work" outside the home may qualify as a hard worker in God's eyes. At any point during the day, God might prefer that you take a playtime with the kids instead of finishing the housework. He might lead a wife or husband to lighten the workload in order to fit in with his or her spouse's plans. Being available for God's work may mean sacrificing our own work.

We already discussed spiritual hearing and doing the will of God. But Satan delights in tempting Christians out of the Father's will. We're living in the middle of a spiritual war, directly on the

battlefield. Our Chief requires us to keep on the alert for our adversary. We must constantly clear our orders with our Commander.

I've always heard that the fiercest enemy of the best is the good. With Christians who love the Lord and long to serve him, temptation may take its most effective form in the guise of something good—good, but not God's best. When King David had men carry the ark of the covenant of the Lord, one man, Uzzah, in an attempt to catch the ark and keep it from falling, touched it. As a result, God struck him down for his irreverence. What Uzzah did might have been good; but it was clearly disobedient to God's command. Good works can tempt us away from God's will.

To everything there is a season. God's truths always blend in perfect balance. His Spirit inside us can lead us and show us when to "do it" and when not to "do it." Paul could write the Corinthians (1 Cor. 15:10), "But I labored even more than all of them, yet not I, but the grace of God with me."

Study Questions

Study Passage: John 15

1. When are you tempted to please men rather than God? What will you do to purify your motives in that area?

2. In your own words explain what it means to be "saved by grace."

3. Why should we do good works if we can't earn God's favor?

4. Are you aware of any area in your life where you're settling for good rather than God's best? What can you do to align your life with God's best for you?

10
The Blessing and the Curse

Resolve to act whenever God's Spirit prompts you. Purpose in your heart to carry out God's will and daily plans for your life. Be diligent and disciplined. Obedience to God enhances our self-image, our relationship with God, and our friendships with other people. When you know yourself and know you can trust yourself—to finish a job, to be dependable, to work efficiently and effectively—you'll like yourself.

Practicing obedience to God allows his Spirit to conform you to the image of Christ. We're not slaves of sin if Christ lives in us. We don't *have* to resign ourselves to our bad habits and continual defeats. As we begin to change, to be on time, to follow through on responsibilities, to do the best work we can, excellently, our self-image will rise. We'll see ourselves as obedient children of our Heavenly Father. It may take months and years to permanently change habits that have taken years to entrench. But one day of complete obedience to God in every area makes you feel like a new person, the person God has created you to be.

Personal obedience to God will also enrich our relationship with him. Disobedience, active or passive, is sin. And sin separates us from God. Walking with God in obedience is the essence of the Spirit-filled life. Barriers of guilt that have repelled us from the Lord's presence for years, or prevented his penetration into one secret area, can dissolve as we learn to obey. God has promised that our faithfulness in little things earns us future responsibilities in greater areas.

And our obedience to God affects how we relate to others. Habitual obedience makes us stable, solid, someone on whom others know they can depend. People respect and listen to a man or woman of his or her word. The world is crying out for trustworthy people!

God has set up a system, a law, on earth for all men and women, whether or not they believe in God. The Old Testament refers to this law as the blessing and the curse. If we obey God, we shall be blessed. If we disobey God, we shall be cursed.

When Abraham prepared himself to sacrifice his son Isaac out of obedience to God, the Lord promised to greatly bless him. Because Abraham had chosen to obey God, rich blessings would be his, even to his descendants. "And in your seed all the nations of the earth shall be blessed, because you have obeyed My voice" (Gen. 22:18).

Moses met God on Mount Sinai, and God gave him a message for Israel. God promised great blessings conditioned on Israel's obedience: "Now then, if you will indeed obey My voice and keep My covenant, then you shall be My own possession among all the peoples, for all the earth is Mine; and you shall be to Me a kingdom of priests and a holy nation" (Ex. 19:5-6).

In the Law, God gave his promise of blessing to the obedient. But he also detailed the penalty for disobedience, the curse.

"See, I am setting before you today a blessing and a curse: the blessing, if you listen to the commandments of the Lord your God, which I am commanding you today; and the curse, if you do not listen to the commandments of the Lord your God, but turn aside from the way which I am commanding you today, by following other gods which you have not known" (Deut. 11:26-28).

Joshua carefully followed Moses' example by reminding God's people of the principle of blessing still in effect. Joshua built an altar to the Lord after the destruction of Ai. Achan's sins there had sharpened Israel's senses to the penalty of disobedience. Achan's

theft had brought defeat and humiliation to Joshua's men. Subsequent obedience yielded victory for the Israelites.

Now Joshua gathered the people together to bless them as God had commanded. "Then afterward he [Joshua] read all the words of the law, the blessing and the curse, according to all that is written in the book of the law. There was not a word of all that Moses had commanded which Joshua did not read before all the assembly of Israel with the women and the little ones and the strangers who were living among them" (Josh. 8:34-35).

Many of the Proverbs stem from wisdom implicit in the principle of blessings for obedience and curse for disobedience. Read 28:19-20:

"He who tills his land will have plenty of food,
But he who follows empty pursuits will have poverty in plenty.
A faithful man will abound with blessings,
But he who makes haste to be rich will not go unpunished."

The prophets continually preached the law of blessing and curse. In the first chapter of Isaiah, the prophet declared to Israel, "If you consent and obey,/You will eat the best of the land;/But if you refuse and rebel,/You will be devoured by the sword" (Isa. 1:19-20).

Sow—Reap

The writers of the New Testament expound the same principle of the blessing and the curse, in terms of what we sow and reap: "Do not be deceived, God is not mocked; for whatever a man sows, this he will also reap" (Gal. 6:7). Galatians continues to explain that the one who sows to his own flesh will reap corruption; but the one who sows to the Spirit will reap eternal life. Therefore, Paul urged the believers to do good to all men.

To the Ephesians Paul wrote the same encouragement to do

good as for the Lord and not just for men, "knowing that whatever good thing each one does, this he will receive back from the Lord" (Eph. 6:8).

Paul assured the Colossians, after exhorting them to do their work heartily, for the Lord, that they will receive the reward of their inheritance; or, if they do wrong, they will receive the consequences of the wrong they have done.

Second Corinthians 9:6 backs up the sow-reap principle: "Now this I say, he who sows sparingly shall also reap sparingly; and he who sows bountifully shall also reap bountifully."

I used to wonder how some people who were not avowed Christians could appear so happily married, while some Christian couples seemed unhappily married. God designed marriage. Christ in the center of a marriage makes it the best marriage, as God intended. Then how was it possible for any nonbelievers to have a relatively good marriage?

When I was still in college, my sister Maureen married Tom. I got the opportunity to observe first-hand what marriage was like. I was a brand-new Christian. As far as I knew, Maureen and Tom were not Christians. They were very nice and good, churchgoing people; but they hadn't yet discovered how to have a personal relationship with Christ.

So I waited for their marriage to fall apart. Then I could rush in with the good news of how Christ could save their marriage. But an awful thing happened. I waited and waited. They started their family and were the ideal American dream—one girl, one boy, their own house with a big yard, two cars.

What was wrong? The closer I observed, the more I began to realize that, although they still had not put God first in their marriage, God's principles were at work. They were working together as a team. Maureen knew instinctively that things ran more smoothly when she helped Tom function as leader of their family, instead of competing for headship. They were following God's principles for marriage, as well as they could, because those principles worked! And they reaped what they sowed—the

blessings of obedience to those principles.

Several years later both Maureen and Tom attended a conference where they understood that they needed to accept Christ by faith into their hearts. They made that commitment to Christ. Now they're enjoying more of those blessings than they knew existed. They look back on their life before Christ came into their family and see a dramatic difference. There's no doubt that Christ has improved their family. But I learned the importance of obedience and the blessings dependent on it.

Discern God's will, listen to him, and do it. Let him develop in you discipline, diligence, dependability. Sow to the Spirit, performing all works for God in his power. Set your mind and heart on God, aiming to please him, not man. Inherit the blessing.

And don't forget: *"If you know these things, you are blessed if you do them"* (John 13:17). God's blessing doesn't come to those who just *know* his will, but to those who *do it.*

Study Questions

Study Passage: Deuteronomy 28

1. In your own words, summarize the meaning of the blessing and the curse.

2. From Deuteronomy 28, make a list of consequences of obedience and consequences of disobedience.

3. In what areas of your life do you feel confident that your obedience is reaping God's blessing? Be specific. What things are you doing right? (Family, parents, roommates, friends, vocation, ministry, school, other.)

4. In what areas might you be reaping a bit of the "curse"?

What can you do to correct the situation and reap God's blessing?

5. As a result of the previous chapters, list several decisive action points you can begin to incorporate into your life.